Timothy Verdon

ART & PRAYER

THE BEAUTY OF TURNING TO GOD

mount
tabor
BOOKS

PARACLETE PRESS
BREWSTER, MASSACHUSETTS
BARGA, ITALY

2016 Third Printing
2015 Second Printing
2014 First Printing

Art and Prayer: The Beauty of Turning to God

ISBN 978-1-61261-572-1

Scripture translations and translations from other sources are the author's own, even when a source citation may be furnished in the notes.

Library of Congress Cataloging-in-Publication Data
Verdon, Timothy.
 [Arte della preghiera. English]
 Art and prayer : the beauty of turning to God / Timothy Verdon.
 pages cm
 Summary: "Prayer is natural for human beings, a spontaneous impulse common in all people. Yet, beyond instinct, there is a kind of prayer that's conscious and articulate, that we have to be taught. There is an 'art of prayer,' when faith and prayer become creative responses by which creatures made in the image and likeness of the Creator relate to him with help of the imagination. Timothy Verdon explores these essential interactions in this magnificent book. Richly illustrated, Monsignor Verdon explains that images work in believers as tools that teach them how to turn to God. Art and Prayer explores these interactions in detail, demonstrating that prayer can become a fruit of the sanctified imagination—a way of beauty and turning to God." —Provided by publisher.
 ISBN 978-1-61261-572-1 (hardback)
 1. Prayer—Christianity. 2. Prayer in art. I. Verdon, Timothy. Arte della preghiera. Translation of: II. Title.
 BV213.V4713 2014
 248.3'2—dc23 2014015216

10 9 8 7 6 5 4 3

Published by Paraclete Press
Brewster, Massachusetts and Barga, Italy
www.paracletepress.com

Printed in Korea through Tien Wah Press.

CONTENTS

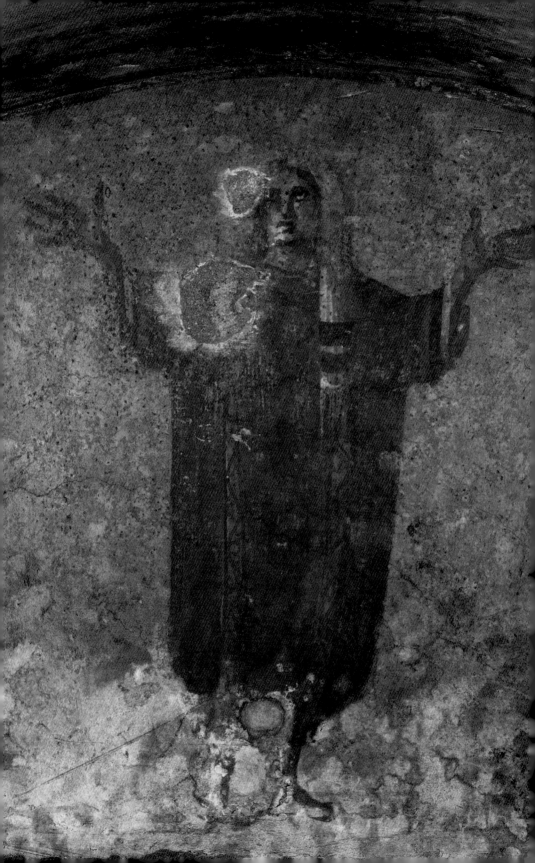

PREFACE

To pray is not difficult, nor does it require special learning. To turn to God to confess limits, to ask help, to thank and praise him is in fact natural for human beings, a spontaneous impulse in women and men of every culture and civilization in every historical period. Even when adverse circumstances—ignorance or sin, refusal of a given religious idea or of all forms of religiosity—inhibit prayer, people pray all the same; when they look around themselves with attention, open themselves to the beauty of creation, and allow themselves to be touched by the suffering of others, in a certain sense they *pray*.

Yet beyond this instinctive orientation, for which every human "I" implies a divine "Thou," there is also a kind of prayer that is conscious and articulate, "well-formulated," which men and women do not know *a priori* but have to be taught. "Lord, teach us to pray," Jesus's disciples asked, reminding him that John the Baptist had done just that for *his* followers. And Jesus then taught them the prayer-formula that Christians even today learn at their mothers' knees: "Our Father, who art in heaven, hallowed be thy name. . . ."

There is in fact an art of prayer that can be transmitted from masters to disciples as from parents to children. The places designated for its transmission are indeed, first, the family, where children initially learn words and gestures with which to enter into relation with God, and then the community of other believers: in Christianity, the Church, considered *mater et magistra* (mother and teacher) of faith. Ecclesial tradition also recognizes a "law

1. *Praying Woman*, third century, Rome, Catacomb of Priscilla

of prayer" whose function is to shape faith, as suggested by the phrase *lex orandi, lex credendi* (literally: the law of praying is the law of believing), expressing an idea that goes back to early Christianity. It is not an actual legal norm but a rule in the service of creativity, for faith and prayer in effect are creative responses by which creatures made "in the image and likeness" of the Creator relate to him with the help of imagination.

This way of describing faith and prayer—as fruits of imagination—suggests why the Church has always attributed importance to art. Images put before believers can in fact teach them how to turn to God in prayer, and the same Pope Saint Gregory the Great who stated that "painting gives the illiterate what the written word offers readers" also insisted that the faithful be led from *vision* to *adoration*. "It is one thing to adore a painting, quite another to learn from a painted scene what we should adore," he said, adding that "the brotherhood of priests is responsible for instructing the faithful so that they feel ardent compunction before the drama of the scene depicted and thus prostrate themselves in adoration before the all-powerful and most holy Trinity" (*Epistola Sereno episcopo massiliensi* 2.10). In the same spirit, Saint John Damascene held that "the beauty and color of images are stimuli to prayer; they offer a feast for the eyes, just as the spectacle of the countryside spurs my heart to glorify God" (*De sacris imaginibus orationes* 1.27).

In the long history of the Church, the "art of prayer"—the system of words and gestures with which believers turn to God—in fact has often been transmitted through the visual arts and architecture, which are "stimuli" for everyone and in every age characterize man's encounter with God as "a feast." Generation

2. *Crucifixion*, Rome, Santa Sabina, panel from the wooden doors
3. *The Marriage, Praying Woman, Woman with Child*, third century, Rome, Catacomb of Priscilla

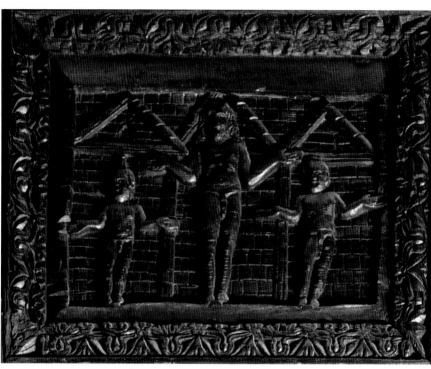

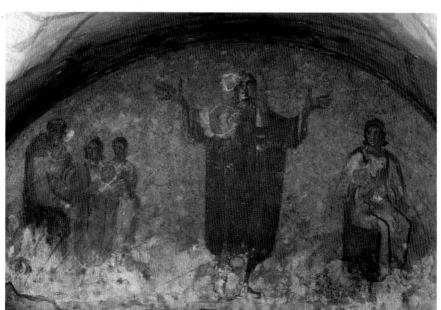

after generation, sacred images have taught believers how to behave at this feast, showing poses and facial expressions—bodily attitudes and gazes—in which even nonbelievers immediately recognize a spiritual presence. In practice, sacred images—as they describe the life of faith and illustrate its distinct aspects—also teach viewers how to pray, and, for those who see them, living, believing, and praying seem to be the same thing.

The painting that introduces this preface is an example (**fig. 1**). It shows a Christian woman of the third century with her hands raised in an ancient gesture of prayer, the same which an artist of the fifth century would attribute to Jesus in a wood panel of the doors of the basilica of Santa Sabina on the Aventine Hill (**fig. 2**). The subject of this panel is the Crucifixion, and the Savior's raised hands allude to his voluntary gift of his life for sinners, the "evening sacrifice" he offered on Golgotha. The woman in the first illustration also "offers her life," though, raising her hands between two other scenes that show her first at the moment of marriage and then with a child in her arms (**fig. 3**). The woman's prayer, that is, springs from the ordinary sacrifices and joys of family life, and her solemn, veiled figure at the center of the composition expresses the final state to which these sacrifices and joys have brought her—the painting in fact adorns her tomb.

These two early Christian works invite a reflection useful at the beginning of a volume dealing with prayer. On the cross where he gave his life, Jesus *prayed*, and it is his prayer that Christians are called to reproduce in their own lives. In every period of history, to disciples who ask him, "Lord, teach us to pray," Jesus in fact teaches how to give one's life. The art that springs from this gift of life and that describes it—Christian art—thus necessarily celebrates prayer.

I wish to dedicate the English translation of this book to Elia, Ester, Gabriele, and Giuseppe, the children of my friend the Florentine artist Filippo Rossi, in the hope that, in addition to learning how to paint, they may also learn how to pray.

MONSIGNOR TIMOTHY VERDON
Florence, Christmas 2013

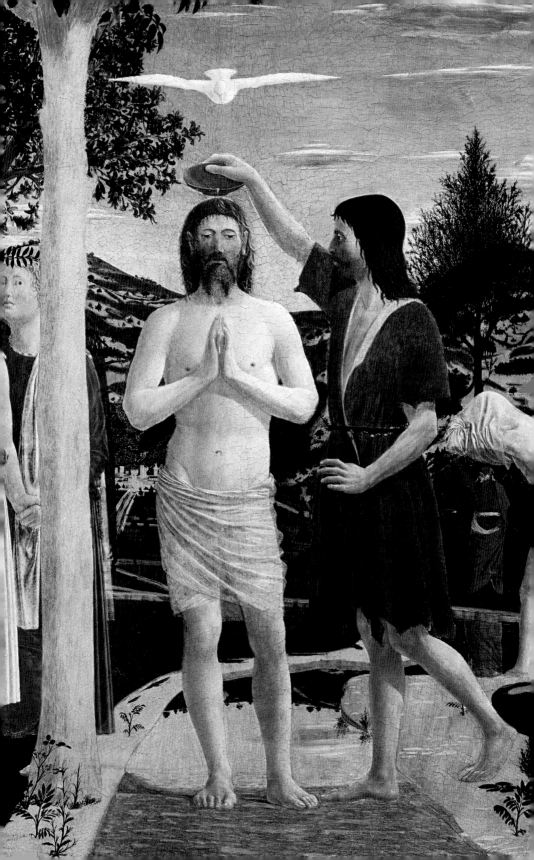

Chapter One

—•—

PRAYER, LIFE, ART

P rayer, the center of life, is often represented in art. Indeed there is a bond between prayer and life, which art exalts: that is the theme of the present book.

Women and men pray in many moments and for many things, but especially when they have to make choices, face struggles, or accept suffering. Even Jesus prayed in these situations, and the New Testament says that "during his life on earth, he offered up prayer and entreaty, aloud and in silent tears, to the One who had power to save him out of death, and he submitted so humbly that his prayer was heard" (Heb. 5:7). That is why, in a painting depicting the Savior's baptism, the artist Piero della Francesca shows Christ with his hands joined and gaze turned inward, totally focused on "the One who had power to save him out of death" (**fig. 4**). Jesus's baptism in the Jordan in fact prefigured his death on the cross, and the seriousness with which Piero characterizes his face alludes to this awful awareness, just as the young man's utter calm suggests his "humble submission" to God. Jesus's serenity here is also attributable to his knowledge that, when he accepted baptism and with it the Cross, a voice came from heaven recognizing him as God's beloved Son, in whom the Father was well pleased (Matt. 3:17; Mk. 1:11; Lk. 3:22). The fourth

4. Piero della Francesca, *Baptism of Christ*, London, National Gallery, detail

Gospel, which does not mention the voice, declares that, at the Father's bidding, John the Baptist testified then and there: "This is the Son of God" (John 1:34).

In Piero's painting, prayer is thus presented both as an occasion of existential commitment and as the place of eternal identity. This identity—in Christ's case divine as well as human—is visible in his bodily beauty, similar to that of an ancient statue; the commitment is legible in his gravely serious face and, if we look at the entire image, in the tree growing beside him, which alludes to the cross (**fig. 5**). These iconographic features translate the second part of the New Testament passage relative to the prayer and entreaty offered by Christ: the assertion that "although he was Son, he learned to obey through suffering; but having been made perfect, he became for all who obey him the source of eternal salvation and was acclaimed by God with the title of high priest of the order of Melchizedek" (Heb. 5:8–10). Christ's obedience to God—that is, the obedience for which his prayer was heard and he was saved out of death—has made him the cause of salvation for all who in turn obey *him,* within the logic of a priestly mediation of divine origin. And in fact Christ's hieratic centrality in this painting—his calm majesty—seems to qualify him as someone "acclaimed by God with the title of high priest."

High priest. Piero della Francesca's painted panel, which today hangs in a museum, originally stood on the altar of a monastic church, the no-longer-extant Priory of Saint John the Evangelist at the gates of Borgo San Sepolcro. That means that the priestly Christ shown in prayer was in fact made for a prayer community and was normally seen during their community

5. Piero della Francesca, *Baptism of Christ,* London, National Gallery

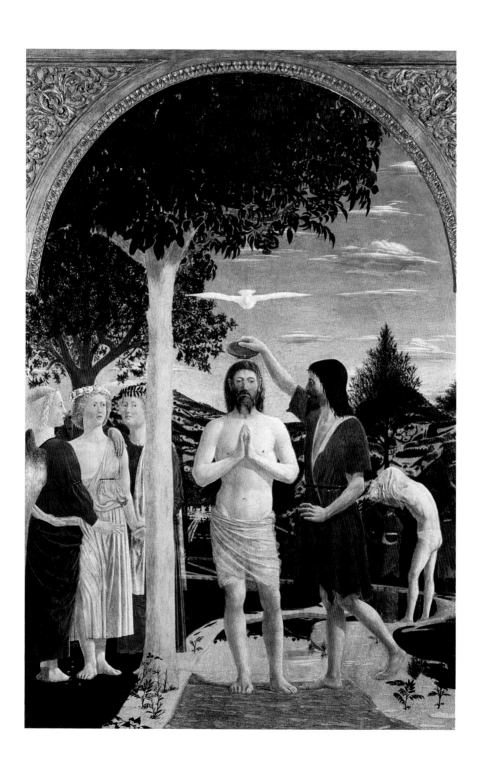

Mass and celebration of the Divine Office. It also means that the moral and spiritual criteria applied to Christ in the just quoted passage from the Letter to the Hebrews—humble submission to God, and obedience learned through suffering and achieved perfection—were applicable to those for whom the image was intended: the monks, who in this young man in prayer seen above an altar would have contemplated the sense of their own life.

What did they feel as they looked at the painting? No historical source provides such information, but we can imagine—indeed, we *must* imagine—the monks' probable reactions. In evaluating images and especially sacred images, we should always ask what their moral as well as aesthetic impact was—what power they possessed, in their original context, to lead those who saw them to measure their own lives against what they saw represented. For the Cistercian monks for whom this *Baptism of Christ* was destined, the body of the young hero seen above the raised host at Mass must have constituted a challenge, in the spirit of the New Testament, to be "in your minds . . . the same as Christ Jesus: his state was divine, yet he did not cling to his equality with God but emptied himself to assume the condition of a slave, and became as men are; he was humbler yet, even to accepting death, death on a cross" (Phil. 2:5–8).

In Piero della Francesca's painting, the monks also saw a white dove above Christ, and it would have seemed to them that the Holy Spirit was descending both on the man represented and on the bread and wine of the Mass. They would have known, moreover, that just as Christ rose from the dead in the Spirit, and the same Spirit changes the bread and wine into his body and blood, so too all who eat and drink of Christ are destined to undergo a change; according

to Saint Paul, "we who have been modeled on the earthly man, will be modeled on the heavenly man . . . [and] we shall all be changed. This will be instantaneous, in the twinkling of an eye, when the last trumpet sounds" (1 Cor. 15:49–52). Thus, rather than speak generically of moral impact, in the case of this painting we should imagine real *spiritual tension*—the monks' expectation that their lives would be changed on the model of Christ's.

Such interior transformation is indeed the hope of every baptized man and woman. Explaining the effects of baptism, Saint Gregory of Nyssa claimed that "our nature itself has undergone a change," so that we now have "a different life and a different way of living."[1] In the same vein, Saint Cyril of Alexandria affirmed that "the Spirit transforms those in whom he dwells in another image, so to speak," and quoted Saint Paul, according to whom "we, with our unveiled faces reflecting like mirrors the brightness of the Lord, all grow brighter and brighter as we are turned into the image that we reflect," thanks to the Spirit's action (2 Cor. 3:18).[2] Painted images that, like Piero's *Baptism*, are made for specific prayer contexts draw sense from this expectation, offering themselves as images of the Image in whom every believer hopes to be transformed through the action of the Spirit.

PRAYER AND NATURE

A significant component of Piero della Francesca's painting is the natural world evoked by the landscape seen in the distance. The beauty of nature in fact invites prayerful response, and Saint John Damascene would say that "the spectacle of the countryside spurs my heart to glorify God."[3] Conversely, prayer heightens our sensibility to nature, allowing human beings to perceive themselves as

part of a divine plan whose order transpires in the varied beauty of the cosmos.

Holy Scripture too, rich in images drawn from nature, teaches human beings to read their lives in relation to the cosmos. The first psalm, for instance, describes the man of God as being "like a tree that is planted by water streams, yielding its fruit in season, its leaves never fading; success attends all he does" (Ps. 1:3), and this similitude suggests a second way of interpreting the tree next to Christ in Piero's painting. Or again: the early Christian writer Tertullian recognized in the world's creatures an instinctive religiosity that serves as example for men and women. "Domestic and wild animals pray and bend their knees," he says, "and emerging from their stalls or dens look up to heaven not with closed jaws, but shaking the air with cries in their animal way. Birds too, when they awake, rise toward heaven and in place of hands lift their wings, which they open in the shape of the cross, chirping something that might seem to be a prayer." These words are part of a treatise in which Tertullian asserts the obligation to pray and the place of prayer in the order of things, concluding that "there is one fact that demonstrates, more clearly than any other, the duty of prayer. It is this: the Lord himself prayed!"[4]

A similar pairing of the world's creatures and Jesus in prayer is the subject of a highly original painting, in which the Lord, seated in a desert place, dreamily contemplates the natural world around him (**fig. 6**). The artist, Moretto da Brescia, is here illustrating the moment after the baptism, when "Jesus was led by the Spirit out into the wilderness to be tempted by the devil" (Matt. 4:1). The tempter is not shown, however,

6. Moretto da Brescia, *Christ in the Desert*, New York, Metropolitan Museum of Art

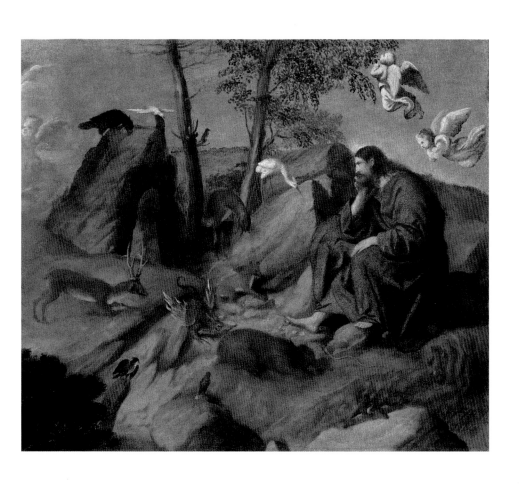

and Moretto imagines an interval between the Lord's being "led" and his being "tempted": a moment in which Christ, the Word through whom *all things were created* (see John 1:1–3), seems to rediscover the freshness of these things and their newness, as if he sensed in the world's creatures the action of that same Spirit with whom he himself was filled. The languor of Christ's body and his meditative pose indeed suggest that he feels a bond between his situation and that of the cosmos—as if he were ruminating on what Saint Paul would later say, namely, that "the whole creation is eagerly waiting for God to reveal his sons" (Rom. 8:19). As in the just quoted passage from Tertullian, moreover, the animals all assume natural attitudes of prayer, bowing and bending their knees before Christ, as if they expected something from him. And Christ, who at the moment of baptism heard himself called beloved Son of the Father, seems to grasp that the test to which the Spirit is leading him involves this variegated "creation" that "still retains the hope of being freed, like us, from its slavery to decadence, to enjoy the same freedom and glory as the children of God" (see Rom. 8:20–21). Christ here seems to understand that he must defeat the tempter not only for himself but also for every creature—that he is called to be *Salvator mundi*, literally the Savior of the world.

Jesus's most intense prayer—his prayer in the hour of anguish of the Garden of Gethsemane—will again find him alone and immersed in nature. Alone because the three disciples called to keep watch with him fall asleep, denying him their moral support, and immersed in nature because he prayed in a suburban garden on a spring evening. That is precisely how Giovanni Bellini shows him in a painting probably executed between 1465 and 1470 (**fig. 7**), where (reading from left to right) we see a city in the distance (Jerusalem); then John,

James, and Peter asleep in the foreground; then Judas in the middle ground, guiding the soldiers who will arrest Jesus; then, on a rocky mound, Jesus kneeling in prayer as he looks up at a spectral putto who offers him a chalice; and finally, at the right, beyond the garden fence, night advancing.

In this painting two elements are particularly striking: the Lord's pose and the sky that enfolds him. His pose is unusual: we have seen him standing in prayer, in Piero della Francesca's *Baptism*, and meditating in a seated position, in the painting by Moretto da Brescia; here he is shown kneeling on the bare rock, and curiously that surprises us. Although he is the only begotten Son of God, he assumes the uncomfortable position of any human being who prays, and he seems to be tense: the tension in his every muscle is in fact evident, as is the urgency of his entreaty. These details reflect Saint Luke's account of the event, which specifies that Jesus "*knelt down* and prayed. 'Father,' he said, 'if you are willing, take this cup away from me!'" The Lord added, however, "Nevertheless, let your will be done, not mine" (Lk. 22:41b–42).

This is "the art of prayer": Jesus asks his Father for something he desires with every fiber of his being—that the cup of suffering be taken away—but does not forget to add, "Fiat voluntas tua" (Let your will be done). It is what his mother had said when she conceived him and what he himself had taught others to say in the Our Father, but now he has to say it for himself, with his knees and elbows scraping the hard rock. And yet this is only the beginning, for later, according to Saint Luke, "in his anguish he prayed even more earnestly,

The two following pages:

7. Giovanni Bellini, *The Prayer in the Garden of Gethsemane*, London, National Gallery

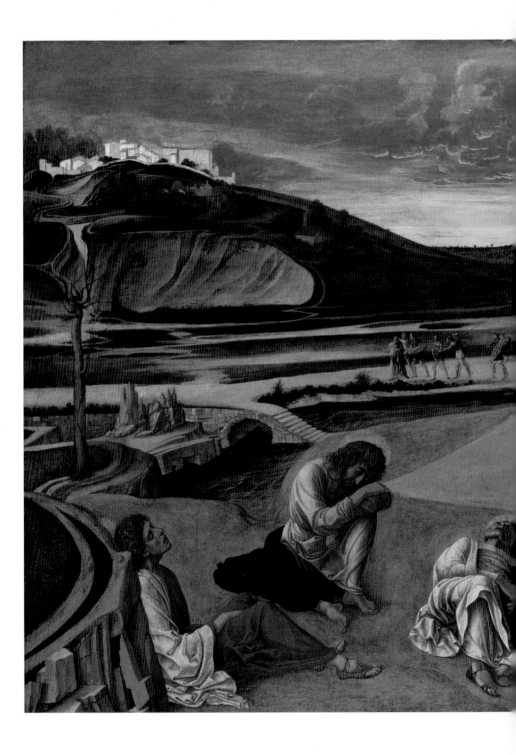

and his sweat fell to the ground like great drops of blood"
(22:44). Bellini does not show this last stage, limiting himself
to the man face to face with the chalice, for whom the rock
becomes an altar.

In Bellini's composition, the Savior's head stands above the
horizon where the last light of day gilds the clouds with its rays.
This sky in which day slowly dies enhances and intensifies the
pathos of Jesus's prayer, making it part of a cosmic waning, the
expression of a *passio mundi*. "My prayers rise like incense, my
hands like the evening offering," said the psalmist (141[140]:2),
and Saint Augustine, thinking of the agony in the garden and
the Crucifixion as a single prayer, clarified: "This then is the
evening sacrifice: the Lord's passion, his cross, the offering of a
saving victim, the holocaust pleasing to God. And Christ in his
resurrection would change the evening sacrifice into a morning
offering. In fact the prayer raised untainted from a faithful
heart rises like incense from the holy altar."[5] The agony in the
garden with which Christ's passion began comes to be considered
emblematic of perfect prayer, and a Renaissance text, the *Tractato
o vero sermone della oratione* by Girolamo Savonarola uses this
moment to illustrate the Savior's teaching that *opportet semper
orare* (it is necessary to pray always) (Lk. 18:1: see **fig. 8**).

Yet the Lord's agony in the garden is more than a didactic model.
It genuinely encompasses every other prayer that human beings
can imagine, and in its light Christ, constituted head of the body
of a new humanity, becomes, in Saint Augustine's words, "the one
who prays for us, the one who prays in us, the one to whom we
pray. He prays for us as our priest; he prays in us as our head; we
pray to him as our God." Moved by this reflection, the Bishop of

8. *Prayer in the Garden of Gethsemane*, woodcut of Girolamo Savonarola, *Tractato
o vero sermone della oratione*, ca. 1495, Florence, Biblioteca Nazionale Centrale,
Cust. C 24, c. 1r

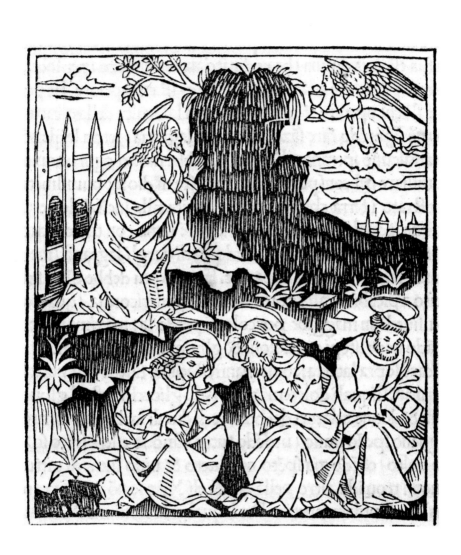

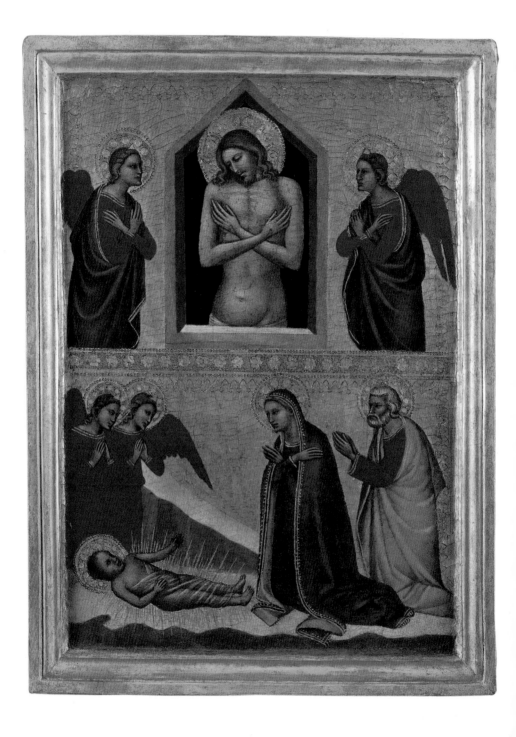

Hippo exhorts, "Let us therefore recognize our voices in him, just as we recognize his voice in us," and adds, "Without undergoing any change, he [Christ] assumed the creature which had to undergo change and made a single man of himself and us, head and body. Thus we pray to him, through him, and in him; we say things together with him, and he says things together with us."[6]

THE MOTHER'S PRAYER

If, as Saint Augustine thought, prayer is our saying things together with Christ and his saying them with us, it follows that there can be no greater teacher of prayer, after Christ himself, than his mother, Mary. "After Christ" in hierarchical order, not in the temporal, because in the order of time it was obviously Mary who taught little Jesus "his prayers," as all believing mothers do with their children as soon as they can pronounce the words, even badly. We should imagine the Virgin saying a prayer with her Son, and he then saying it with her; we have already noted that in his supreme hour at Gethsemane Jesus will reproduce Mary's original "Fiat": why not accept then that, in human terms and in the order of time, the Son of God learned other prayers too, and his style of prayer with its attitudes and gestures, from his mother?

To be sure, in theological terms the opposite is true, as we see in a small fourteenth-century painting where it is rather Mary who prays before the newborn Jesus, together with Saint Joseph (**fig. 9**). In theology time is fluid, however, and in the upper part of this image the artist in fact opens a kind of window to show us the adult Jesus, crucified and deposed from the cross with his arms arranged as if for burial: the *Vir dolorum* (Man of Sorrows). This

9. Francescuccio Ghissi, *Man of Sorrows and Madonna Adoring the Child*, Vatican Museum, Vatican City

unusual coupling of his birth and death—with the baby, below, looking up at himself thirty-three years later—translates a passage of the Letter to the Hebrews, where, speaking of Christ, the author says, "This is what he said [to God the Father] on coming into the world: 'You who wanted no sacrifice or oblation, prepared a body for me. You took no pleasure in holocausts or sacrifices for sin; then I said, just as I was commanded in the scroll of the book, "God, here I am! I am coming to obey your will"'" (Heb. 10:5–7). To avoid misunderstanding, the same text then specifies that "this will was for us to be sanctified by the offering of his body made once and for all by Jesus Christ" (Heb. 10:10). As if commenting on this passage, Saint Leo the Great said that "the only purpose of the Son of God's birth was to make the Crucifixion possible. In the Virgin's womb he assumed mortal flesh, and in that mortal flesh he celebrated his passion."[7]

In theological perspective it was not, therefore, Mary's *Fiat*—first in the order of time—to prepare that of Jesus in the Garden of Gethsemane, but rather the infinite value of his *Fiat* at Gethsemane and later on the cross that anticipated and made possible his own mother's freedom—just as the merits of his future passion had assured Mary the privilege of her immaculate conception. This complicated theological argument does not contradict the other assertion, so simple and human, that the same woman who prays before her newborn Son in our fourteenth-century painting will in fact later teach him to walk, talk, and say his prayers: for he is contemporaneously true God and true man, *outside* but also *inside* time. This point is fundamental for the theme of prayer,

10. Antonello da Messina, *Madonna and Child*, Washington, DC, National Gallery of Art, Andrew W. Mellon Collection

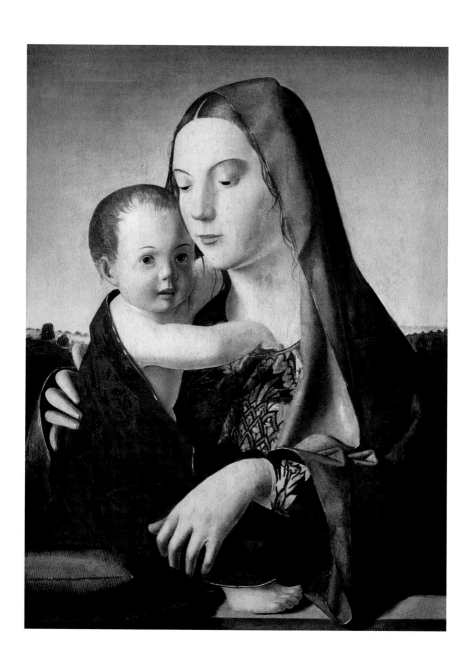

because—as all who turn regularly to God know—if on the one hand it is we who seek his help with our needs, on the other it is he who sought us first. Prayer, if properly motivated, is always *free*, and yet our freedom is itself his gift. The divinity of Christ commands the tribute of our prayer, yet it is our response that allows his humanity to pray in us: as Saint Augustine said, "We pray to him, through him, and in him; we say things together with him and he with us."

This reciprocity of prayer is the subject of an exceptionally beautiful painting, the *Madonna and Child* by Antonello da Messina, at the National Gallery in Washington, DC (**fig. 10**). The work shows a meditative Virgin Mary and little Jesus who, as he looks toward the viewer, slips his hand into his mother's dress because he wants to be fed. The contemplative inwardness of Mary, who "treasures" the things regarding her Son and ponders them in her heart (Lk. 2:19), is strangely at odds with the child's decisive movement: she is bigger, yet passive before her Son who, albeit small, clearly knows what he wants. And what does he want? The words that, many years later, Jesus will address to another woman beside a well come to mind: "Give me a drink" (John 4:7b). Here too the Son of God in fact is thirsty and wants to drink; the woman, his mother, meditates, but the baby asks for something quite concrete to which he is entitled. And that is the point: in the quiet of prayer, the human heart surrenders to God's concrete requests, recognizing that they are fair and that he has every right to ask things of us. We remain free but do not want to deprive him of what he asks; we love him but know that he loved us first (1 Jn. 4:19).

In this painting, the mother's prayerful recollection before her Son is, we said, "meditation." But it is also an answer to the demands of a real situation: she is the mother, he her baby son, and Mary in fact "prays" simply by accepting to do her duty.

Her passivity here in fact connotes acceptance. But let us look again at the child: he is so sure of himself, as babies are in these situations—he wants something, he knows his mother, and he knows she won't refuse him. That is how God is with those who love him: in the context of real situations and in the light of everyday duties, he draws near and asks things to which he has a right. We pray to him, but he too, in a certain sense, prays to us, saying, "Give me a drink." And he lets us know that the One asking this favor can make springs well up in the soul that gives him what he wants, waters of life eternal (John 4:14). Indeed it was Mary, the first time she yielded to God, who described these welling springs, saying: "My soul proclaims the greatness of the Lord and my spirit exults in God my savior; because he has looked upon his lowly handmaid" (Lk. 1:46–48a). And in those words is an important clarification, for what we have called "passivity" and "acceptance" is actually "lowliness" or humility. In fact the God who prays to us hopes to find, when in turn we pray to him, humility.

COALS, FISH, STARS, AND A BUSH

Humility in prayer consists in recognizing the objective distance that separates us from God. The prophet Isaiah, when he saw God in all his glory, said: "What a wretched state I am in! I am lost, for I am a man of unclean lips and I live among a people of unclean lips, and my eyes have looked upon the King, the LORD of hosts" (Isa. 6:5). In similar fashion, when—after an entire night in which they had caught nothing—Peter, James, and John accepted Jesus's invitation to pay out the nets again and took "such a huge number of fish that their nets began to tear" (Lk. 5:6–7), they grasped the miraculous nature of the event, and Peter threw himself at Christ's knees, saying, "Leave me, Lord,

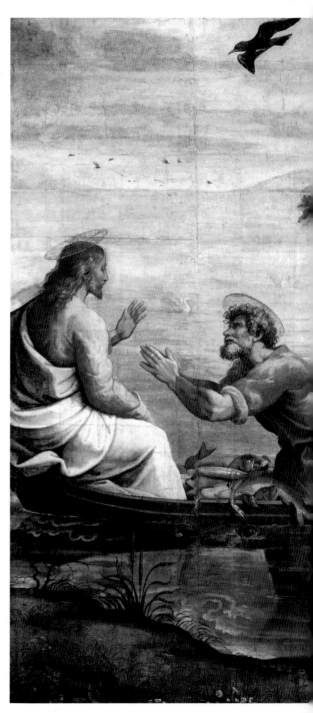

11. Raphael Sanzio, *Miraculous Draught of Fish*, London, Victoria and Albert Museum

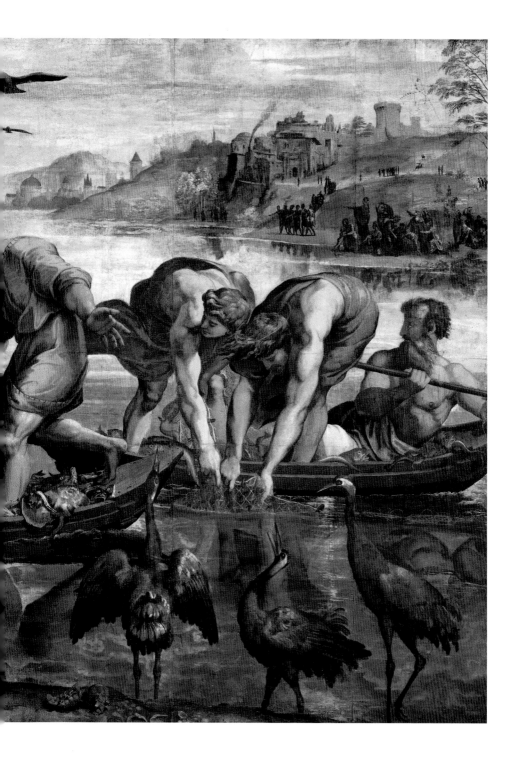

I am a sinful man" (Lk. 5:8b). Before Christ he experienced the same holy terror and sense of human inadequacy that Isaiah had felt before the God of Hosts—as Raphael suggests in a famous tapestry cartoon where Peter, kneeling, and James behind him standing, adore the Savior, while John and others in a second boat continue to gather in the fish (**fig. 11**).

Sinful human beings *are* far from the Holy of Holies, and both Isaiah and Saint Peter reacted in the right way, recognizing this fact. Yet God himself bridges the distance, purifying humankind and calling them to collaborate in the divine project of sanctification. In Isaiah's case, a seraph flew from the throne of God with a burning coal to purify the prophet's lips, so that when the Most High asks, "Whom shall I send? Who will be our messenger?" the prophet could answer, "Here I am, send me" (Isa. 6:6–8). The words with which Jesus reassured the fisherman Peter, oppressed by his own sinfulness, have similar force: "Do not be afraid; from now on it is men you will catch" (Lk. 5:10b); and in parallel with Isaiah's willingness to be "sent" by God, the Gospel underlines the decision of Peter, James, and John to become Christ's apostles, stating that "bringing their boats back to land, they left everything and followed him" (Lk. 5:11). In prayer, that is, we grasp how far we are from God and are dismayed, but we also comprehend that God purifies and calls us. And it is in prayer that we find the strength to respond to his calling, telling God, "Here I am, send me," and thus becoming his emissaries, his *apostles*.

The first step, however, is always humility. In the Gospel, the Peter who recognized Jesus's holiness in the miraculous catch of fish had just heard him preach; the Savior had indeed used the fisherman's boat as a floating pulpit from which to speak to the

12. *Abram Listening to God Who Invites Him to Look at the Stars*, sixth century, *Genesis*, Vienna, Nationalbibliothek, Theol. Gr. 31, fol. 8, detail

ΝΟΜΗϹΕΙΜΘΟΥΤΟϹΑΜΜω
ϹΟΥ · ΟΥΤΟϹΚΛΗΡΟΝΟΜΗϹΙϹΕ
ΟΝΕΖω · ΚΕΙΠΕΝΛΥΤωΑΝΑ
ΟΥΝΟΝΚΑΡΙΘΜΗϹΟΗΤΟΥϹ
ϹΗΕΖΑΡΙΘΜΗϹΑϹΘΑΙΑΥΤΟΥϹ
ΤωϹΕϹΤωΤΟϹϹΠΕΡΜΑϹΥ

crowds on the shore (Lk. 5:1–3). Yet it was neither the words heard nor the many fish caught at his command that spurred Peter to kneel before Jesus, but rather his deep sense of personal inadequacy before One who spoke in that way and gave such orders. True prayer—the adoration of God *as God*—in fact springs from an initial unease.

Take the case of the patriarch Abram, obedient to God's command to leave his native land but tormented by the desire for offspring. "I go childless," Abram complained to God, who had promised him protection and great rewards: "See, you have given me no descendants; some man of my household will be my heir" (Gen. 15,1–4). God, however, reiterated that Abram's heir would not be a servant but a son of the patriarch's own loins and to convince him took Abram outside and said, "Look up to heaven and count the stars if you can. Such will be your descendants" (Gen. 15:5). It is the episode illustrated in one of the scenes of the so-called Vienna Genesis, a sixth-century manuscript containing the first book of the Old Testament (**fig. 12**). The anonymous artist shows Abram, who, coming out of the hut at the left, studies the nocturnal sky in which a hand alludes to God's presence; seeing the firmament filled with stars, the patriarch lifts his own hands to receive what God promises, and Abram's hands are covered with a veil, like the hands of acolytes who, in the ancient liturgy, brought the gifts to the altar. The biblical text concludes by saying that, grasping the Lord's eloquent illustration, Abram "put his faith in the Lord, who counted this as making him justified" (Gen. 15:6). Thus human unease before God may consist even of distrust or doubt, to which God responds in prayer, inviting us to believe in his promises and accrediting those who do so with "justification"—pardon of their sins and even of the sin of having doubted him. Prayer is therefore an interior dialogue in which we express the disappointments that make us doubt God's love,

and he powerfully reaffirms the sense of those promises, opening
our eyes to the signs of his faithfulness with which the universe
abounds. The meaning of the signs through which God reveals
himself in fact emerges with great force in prayer.

Such signs may be ordinary or extraordinary. In the first
category are the fish that convinced the fisherman Peter of the
holiness of the One who had ordered him to cast his net and the
stars seen innumerable times by Abram the nomad but suddenly
brought into relationship with the patriarch's hope for offspring
by the One who had called him to begin his journey. By contrast,
"extraordinary" was the sign given to Moses when "the angel of
the Lord appeared to him in the shape of a flame of fire, coming
from the middle of a bush," and the future lawgiver saw with
amazement that "there was the bush blazing, but it was not burnt
up." Moses then thought: "I must go and look at this strange sight
. . . and see why the bush is not burnt" (Exod. 3:2–4).

Something out of the usual, an inexplicable phenomenon, a
strange sight or "miracle" that astounds and makes us want to
draw near: these certainly are signs that encourage prayer, leading
to the realm of the supernatural. And to anyone who stops to
observe them, God speaks and teaches the appropriate behavior;
in Moses's case, "the Lord saw him go forward to look, and called
to him from the middle of the bush. 'Moses, Moses!' he said.
'Here I am,' he answered. 'Come no nearer,' he said. 'Take off
your shoes, for the place on which you stand is holy ground'"
(Exod. 3:4–5). When Moses obeyed these instructions, God
revealed himself as already present in the experience of this man
he had chosen, saying: "I am the God of your father, the God of
Abraham, the God of Isaac, and the God of Jacob"; Moses then
"covered his face, afraid to look at God" (Exod. 3: 6).

A French painting of the later fifteenth century connects this
Old Testament story with faith in Christ. It is the altarpiece

commissioned of Nicolas Froment by Duke René of Anjou and his wife, Jeanne de Laval, for the Carmelite church of Aix-en-Provence, a triptych with portraits of the donors in the side panels.[8] The central panel (**fig. 13**) shows Moses, who, at the command of an angel, removes his sandals before drawing near to a huge bush that occupies the whole upper part of the image, with Mary and the Christ child at its pinnacle. Between Moses at the right and the angel at the left, a flock of sheep with attendant watchdog make clear the reference to the just-quoted passage in the Book of Exodus: the episode of the burning bush took place while "Moses was looking after the sheep of Jethro, his father-in-law, when he led his flock to the far side of the wilderness and came to the mountain of God, Horeb" (Exod. 3:1).

The Marian significance attributed to this passage by the Fathers of the Church, rarely illustrated in monumental art, is spelled out here: not only by the figure of Mary in the bush but also by an *Annunciation* painted on the outside of the lateral panels. When these are closed, the triptych thus immediately offers itself as a work dealing with Mary, showing the subject that focuses attention on her virginity mysteriously crowned by motherhood: the Annunciation. When the panels are then opened, the triptych shows another annunciation: the angel in front of Moses inviting him to contemplate a phenomenon, impossible in the order of nature but real, in which God is revealed. Lest we fail to get the point, the artist has inscribed the words of a medieval liturgical text on the lower rim of the illusionistic frame: *Dum quem viderat Moyses incombustum*

13. Nicolas Froment, *Mary in the Burning Bush*, Aix-en-Provence, Saint-Sauveur

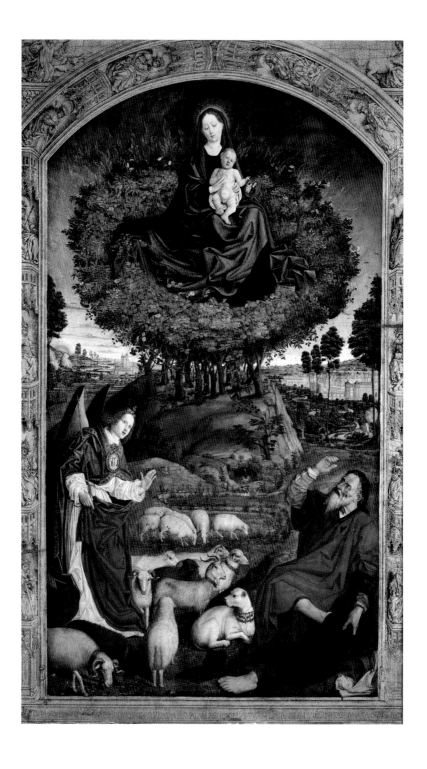

conservatam cognovimus tuam laudabilem virginitatem, sancta Dei genitrix (In the bush that Moses saw burning but unconsumed, O holy Mother of God, we have recognized the conservation of your praiseworthy virginity).

The image communicates the Christian conviction that whoever approaches the mystery of God approaches Christ. And indeed, the One who spoke to Moses from the burning bush was a merciful savior: "I have seen the miserable state of my people in Egypt. I have heard their appeal to be free of their slave drivers. Yes, I am well aware of their sufferings. I mean to deliver them out of the hands of the Egyptians and bring them up out of that land to a land rich and broad, a land where milk and honey flow" (Exod. 3:7–8a).

Stopping to look at the bush, drawing near to it, and obeying the instructions given him, Moses was introduced into a mystery of salvation that would achieve fullness in Christ, who similarly tells a people composed of believers, "I am aware of your sufferings." Stopping, drawing near, and obeying the indications of holiness, anyone who prays to Christ hears himself moreover summoned, like Moses, to collaborate with the task of salvation: "So come, I send you to Pharaoh to bring the sons of Israel, my people, out of Egypt" (Exod. 3:10). And at every hesitation, the man or woman called hears God's promise: "I shall be with you" (Exod. 3:12a). And whoever stops and approaches and conforms himself to Christ discovers the name of God, his secret identity, deep, simple, and vital: "I AM WHO I AM" (Exod. 3:14a). And whoever prays discovers the divine name not only for himself but for others, as God added in his instructions to Moses: "This is what you must say to the sons of Israel: 'I AM has sent me to you'" (Exod. 3:14b). Finally, whoever approaches Christ penetrates once and for all the mystery of the bush that burns but is not consumed, whose sense is revealed, more than in his incarnation,

in the Savior's death that becomes life, his humiliating cross that flowers into glory.

A FEW SAINTS

Thus prayer—which can spring from unease caused by the distance between God and man or from distrust occasioned by apparently disappointed hopes—leads to intimate dialogue and participation in a project. In any case, prayer changes life: Peter, from mere fisherman, became a "fisher of men"; Abram, from father of Isaac, became Abraham, the "father of many peoples"; Moses, from Jethro's shepherd, became Israel's guide to the Promised Land. Knowing the One WHO IS, anyone who prays becomes potential *being*; and if many do not pray it is perhaps because they are afraid to become what they are not yet: afraid to *change*, afraid to *live*, afraid to *be*. The saints by contrast are those brave women and men who accept the challenge to change as God wants, to live as God lives, to be as God is: those who in prayer hear and welcome God's invitation.

A good example is Saint Anthony the Abbot, whose vocation was revealed to him as he listened to the Gospel proclaimed at Mass. This event, narrated by his biographer Saint Athanasius, is described visually in a small panel now in Berlin, the work of a Sienese painter known as the Observance Master where we see the boy standing and listening as the priest reads the sacred text (**fig. 14**). Athanasius's *Vita Antonii* underlines the saint's existential situation: his parents had died less than six months earlier and Anthony wondered what he should do with his life, "reflecting on the motives which had led the apostles to follow the Lord after abandoning all else." A religious youth,

he was accustomed to go to Mass every day, Athanasius says, and "as he pondered these things, entered the church just as the Gospel was being read. He heard that the Lord had said to a rich man: 'If you would be perfect, go, sell what you own and give the money to the poor, then come follow me and you will have treasure in heaven' [Matt. 19:21]. Anthony then, as if . . . those words had been read just for him, went right out of the church, made a gift of the property he had inherited to the town's inhabitants . . . and dedicated himself to a life of asceticism near his house, bravely beginning a harsh existence, without any self-indulgence."[9]

Yet prayer not only prepares the spirit for that change of life we call conversion—it also makes conversion possible, instilling the courage to persevere in this holy purpose despite difficulties and opposition. This is the sense of a famous fresco traditionally attributed to Giotto, in the cycle that narrates the life of Saint Francis of Assisi, executed in the last decade of the thirteenth century in the basilica dedicated to Francis in his native city (**fig. 15**). The artist illustrates a moment described in the earliest biography of the saint, when, "having presented himself to the bishop, Francis neither hesitated nor delayed" to renounce his father's wealth and indeed "took off all his clothes and threw them into his father's hands, remaining naked in front of the crowd." The bishop, "struck by Francis's courage and admiring his fervor and spiritual resolve, straightaway rose and embraced him, covering the boy with his own mantle. He understood that he was witness to a gesture laden with mysterious meaning that God had inspired in his servant. Thus from that moment the bishop became Francis's helper, protector, and supporter, surrounding him with great and heartfelt love."[10]

In a later version of his text, the author of this *Life of Francis*, Brother Thomas of Celano, adds an important detail. He states that after giving back to his father, Pietro di Bernardone, a rich merchant, a sum of money taken to restore a church, Francis exclaimed, "From now on I will be able to freely say 'Our Father, who art in heaven' and not 'Father Pietro di Bernardone.'"[11] Celano associates Francis's renunciation of his father's wealth with the young man's desire to pray with authenticity, making the words of the Our Father fully his own. And in the still later official biography of the saint (the so-called *Legenda maior*, or Major Legend) the author, Saint Bonaventure, makes Francis's prayer coincide with the act of renunciation itself, describing how the saint, "inebriated with admirable fervor of soul, removed even his underwear, remaining totally nude in front of the bystanders, and said to his father: 'Until now I called you my father here on earth; from today forward I can say with full security, "Our Father, who art in heaven," because all that I own is now in him, together with all my confidence and hope.'"[12] In the definitive version of this story, that is—the one that almost certainly determined the composition of the Assisi fresco—the act expressive of a change of life and its accompanying prayer become the same thing; or, to put it differently, prayer gives meaning and force to action. That indeed is what we see in the fresco, where Francis raises his eyes and hands to the heavenly Father, while his father on earth, tightly clutching the boy's clothes, quivers with wounded pride.

In a certain sense, prayer becomes the new "form" of life of someone who has accepted conversion, as a work by Lorenzo Lotto suggests, an extraordinary fresco in the Oratory Suardi in Trescore, near Bergamo (**fig. 16**). The image represents the

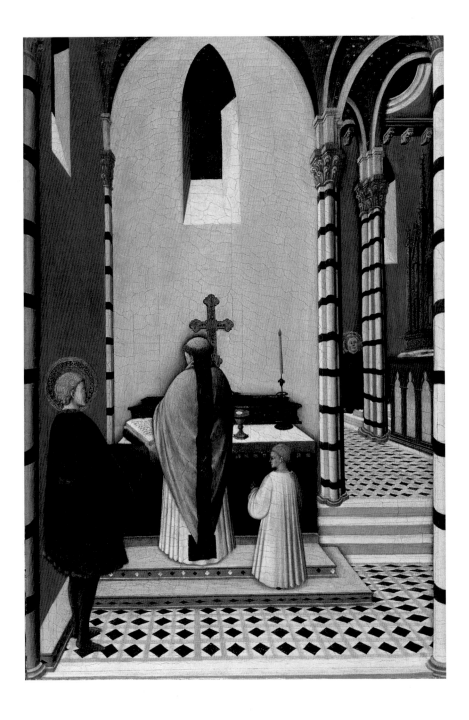

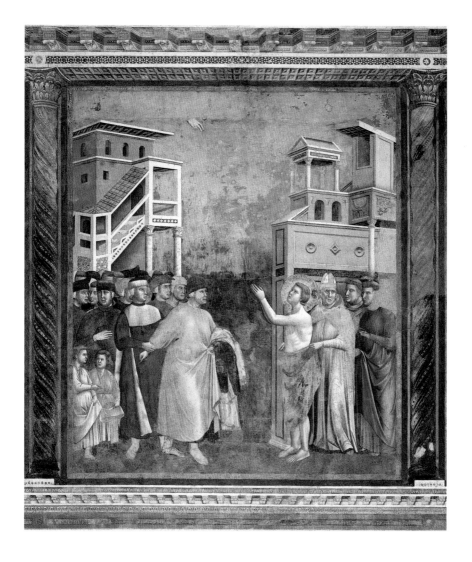

14. Osservanza Master, *Young Saint Anthony Abbot at Mass*, Berlin, Staatliche
 Museen, Gemäldegalerie
15. Giotto, *Saint Francis Renouncing his Father's Wealth*, Assisi, upper church

clothing of Saint Bridget, an Irish nun who lived between AD 450 and 523 and is venerated for her charity to the poor (here evoked by the episode depicted at the viewer's right, in the middle distance, seen through a part of the wall that seems to have collapsed). Bridget, at the center of the foreground area, kneels bowed before an altar where the bishop pronounces the words of the rite of religious consecration, holding in his right hand a white mantle that will complete her monastic habit; on the pavement beside the saint we see the worldly garments she has removed, while at right and left the men, women, and children of the Suardi family look on.

Bridget, prostrating herself before the bishop, spreads her arms to support herself on the last step of the altar. In that position she echoes the common prayer gesture of Christian antiquity (see above, fig. 1) and lets us see that this solemn commitment of her life is above all an act of prayer and, more exactly, an act of prayer *within a tradition*—a voluntary assumption of the way of prayer of the first Christians. Consecrated life in fact ideally prolongs the fervor of the beginnings of the faith, when "the whole group of believers was united, heart and soul" (Acts 4:32a). In the same way, Bridget's removal of her own clothes and donning of a common habit recalls how, in the infant Church, "no one claimed for his own use anything that he had, as everything they owned was held in common" (Acts 4:32b).

But Saint Bridget's cruciform pose has another significance, rather more important, communicated in the large Crucifixion depicted above the altar: a painting within the painting that obliges us to see the saint's prayer as profound identification with the Savior's paschal mystery, as if Bridget were saying with Saint Paul: "I have been crucified with Christ, and I live

now not with my own life but with the life of Christ who lives
in me. The life I now live in this body I live in faith: faith
in the Son of God who loved me and sacrificed himself for
me" (Gal. 2:19b–20). And, since the image of the Crucifixion
before which Bridget consecrates herself is above the altar of
this church imagined by Lorenzo Lotto, it is impossible not
to associate the saint's prayer with that pronounced by Christ
at table with his disciples, the night before he died. "I pray
for them," the Savior said, referring to those whom the Father
had given him, the men who had believed in him:

> I pray for them. I am not praying for the world, but for
> those you have given me, because they belong to you: all I
> have is yours, and all you have is mine, and in them I am
> glorified. I am not in the world any longer, but they are
> in the world, and I am coming to you. Holy Father, keep
> those you have given me true to your name, so that they
> may be one like us. . . . I am not asking you to remove
> them from the world, but to protect them from the evil
> one. They do not belong to the world any more than I
> belong to the world. Sanctify them in the truth; your
> word is truth. As you sent me into the world, I have sent
> them into the world, and for their sake I sanctify myself
> so that they too may be sanctified in truth. (John 17:9–11
> and 15–19)

Thus Saint Bridget's prayer, which already expressed her
dying to the world and identification with the Savior, becomes
the very prayer with which Christ consecrated himself to the
Father. "In your minds you must be the same as Christ Jesus,"
a first-century hymn exhorts (see Phil. 2:5), and here Bridget,
prostrate beneath the cross and with her arms spread, does just
that, making it clear that prayer consists in sharing the intimate

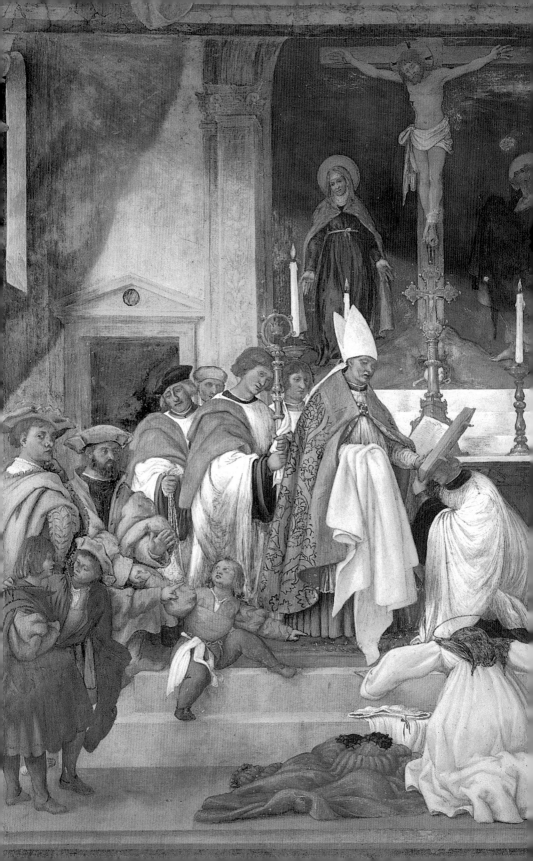

16. Lorenzo Lotto, *The Clothing of Saint Bridget as a Nun*, Trescore Balneario (BG), Suardi Oratory

intentions and actions of him who on Golgotha shared the intentions and actions of his Father. Conformed to Christ in prayer, Bridget too can say to God, "All I have is yours, and all you have is mine," knowing that she has consecrated herself in Christ to a truth that is not of this world. Consecrated before an altar, she will nourish the people of God with charity as with the Eucharist, and it is no accident that Lotto's fresco "opens" the wall beside the Eucharistic table to show Bridget feeding the poor.

Saint Bridget's prayer is thus not meant only for her personal sanctification but is part of a project involving others. So too is Jesus's prayer during the Last Supper, when he said, "I pray not only for these, but for those also who through their words will believe in me" (John 17:20), and in his fresco Lotto in fact underlines the exemplary force of the saint's prayer, directing all the attention of the men, women, and children of the Suardi family to her. The reason for this extension to others of the effects of individual prayer is explained by Christ, who immediately after praying for those who would believe in him thanks to the preaching of his disciples asked, "May they all be one. Father, may they be one in us, as you are in me and I am in you, so that the world may believe it was you who sent me" (John 17:21).

FAITH, SIN, AND REDEMPTION

"So that the world may believe." Jesus prayed that, seeing his followers' unity, the world might believe in him. The act of faith is itself prayer—or, more exactly, it is the first step toward that opening which changes the believer's life. "One enters into prayer as one enters into the liturgy: by the narrow

gate of faith," the Catechism of the Catholic Church states at part 4, paragraph 2656.

This bond between faith, prayer, and liturgy is the subject of a fresco in the Siena Cathedral baptistery, part of a cycle of images representing the articles of the Apostles' Creed, executed by Lorenzo di Pietro, known as Vecchietta, between 1450 and 1453.[13] In this cycle the doctrinal content of every article is evoked by a specific scene in the ceiling vaulting (God the Father; God the Son, Incarnate, Born, Crucified, and Risen; God the Holy Spirit; the Church; the Last Judgment, and so on), and in each of these doctrinal scenes there is also a man in the garb of the period who, in an attitude of prayer, pronounces the word (written beside his mouth) "Credo" (I believe).

The fresco reproduced here is the one situated above the baptismal font and facing the baptistery altar (**fig. 17**). It depicts the Holy Spirit descending on the gifts of bread and wine placed on an altar—the Spirit who will change these gifts into the body and blood of Christ. The vocation of the newly baptized Christian to prayer, and specifically to Eucharistic prayer, is thus made explicit; even today the Catholic rite of baptism recalls that "one day, approaching the Lord's altar," the baptized person "will take part in the table of Christ's sacrifice."[14] Here in the Siena baptistery, above the baptismal font and in front of the altar where Mass is celebrated, this image of a man professing his faith in fervent prayer perfectly translates the maxim *Lex orandi, lex credendi* (the order of public prayer determines the way in which people believe).[15] Indeed, this fresco implies an expansion of the formula into *Lex orandi, lex credendi, lex videndi* (the order of public prayer determines the way in which people believe and how people strive to live a fully Christian life)—which suggests to artists

appropriate iconographic forms. In Siena the images in fact remind citizens bringing babies to the font of the whole system of faith into which baptism initiates the children.

Prayer arising from faith is not limited, however, to good people and to ecclesiastical settings; even sinners pray, and often far from the quiet of churches. An example is offered in the parable of the prodigal son, who—after squandering his inheritance far from home—found himself in need.

> So he hired himself out to one of the local inhabitants, who put him on his farm to feed the pigs. And he would willingly have filled his belly with the husks the pigs were eating, but no one offered him anything. Then he came to his senses and said: "How many of my father's paid servants have more food than they want, and here am I dying of hunger! I will leave this place and go to my father and say: 'Father, I have sinned against heaven and against you; I no longer deserve to be called your son; treat me as one of your paid servants.'" So he left the place and went back to his father. (Lk. 15:15–20)

The crucial moment of this account is imagined by Albrecht Dürer in an engraving from the end of the fifteenth century (**fig. 18**): the prodigal son on his knees, praying to God among the pigs. To be sure, his was self-interested prayer, since the young man was more concerned with the food his father's servants had to eat than with the sin he himself had committed; yet the Gospel says that "he came to his senses," and that phrase explains why the prodigal's train of thought may be considered genuine prayer. Sin denatures a human being, alienating him from

17. Lorenzo di Pietro detto Vecchietta, *Articles of the Creed: "et in Spiritum Sanctum"*, Siena, Cathedral Baptistry, central bay

himself even more than from God; repentance, by contrast—even when based, as here, on calculation ("I was better off in my father's house")—brings the sinner back to reality and makes him human again—a son before his father, a creature before his Creator. In Dürer's engraving, the juxtaposition of the pigs' "innocent" avidity and the guilt felt by the young man who has "swallowed up" his father's property (Lk. 15:30) suggests the young man's return to a fully human state. And in fact shame for sins committed is a good starting point for prayer.

We may speak of "prayer" even in the case of people who, while not recognizing God as Father, nourish spiritual desires to which perhaps they cannot assign a name. The Old Testament philosopher Qoheleth—noting the frustration that many experience in their search for God—says that "though [God] has permitted man to consider time in its wholeness, man cannot comprehend the work of God from beginning to end" (Eccles. 3:11). It is only in Christ, the Alpha and Omega, that human beings manage to "comprehend the work of God from beginning to end": in him are satisfied "the ultimate promises toward which all our spiritual tension is oriented," as Saint Augustine called such spiritual goals, adding that "when we have achieved them we will seek nothing more, desire nothing more."[16]

A fourteenth-century miniature suggests these varying degrees of awareness, showing three men waiting for the Christ who has yet to take human flesh and descend (**fig. 19**). Painted by the Veronese master Turone de Maxio, this small scene appears in a liturgical book where it enlivens the

18. Albrecht Dürer, *The Prodigal Son in Prayer Among the Swine*, circa 1498, engraving

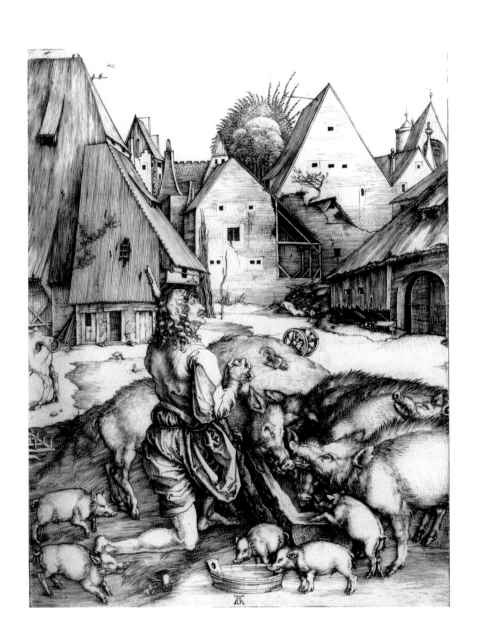

initial letter of the entrance antiphon then sung at Mass on the second Sunday of Advent, a *P*. It is the beginning of a text of the prophet Isaiah: "People of Zion . . ., when the Lord has given you the bread of suffering and the water of distress, he who is your teacher will hide no more, and you will see your teacher with your own eyes" (Isa. 30:19–20).[17] This ancient promise was then linked to Christ in the Gospel then read in the same Mass on the second Sunday of Advent: the passage in which John the Baptist from prison sends his disciples to ask Jesus: "Are you the one who is to come, or are we to wait for someone else?" (Matt. 11:2–3).

For the artist of the miniature, however, as for the clerics who, as they sang, would see the initial with the three men waiting, there was still more involved. They knew that the longed-for Messiah corresponded to the continuation of Isaiah's text, in which it is promised that God, when he finally reveals himself,

> will send rain for the seed you sow in the ground, and the bread that the ground provides will be rich and nourishing. Your cattle will graze, that day, in wide pastures. Oxen and donkeys that till the ground will eat a salted fodder, winnowed with shovel and fork. On every lofty mountain, on every high hill there will be streams and watercourses, on the day of the great slaughter when the strongholds fall. Then moonlight will be bright as sunlight and sunlight itself will be seven times brighter—like the light of seven days in one—on the day the LORD dresses the wound of his people and heals the bruises his blows have left. (Isa. 30: 23–26)

19. Turone de Maxio, *Christ Awaited by the Peoples of the World*, c. 1360–1380, Verona, Biblioteca capitolare, Corale MLVI, fol. 4v, Illuminated Initial

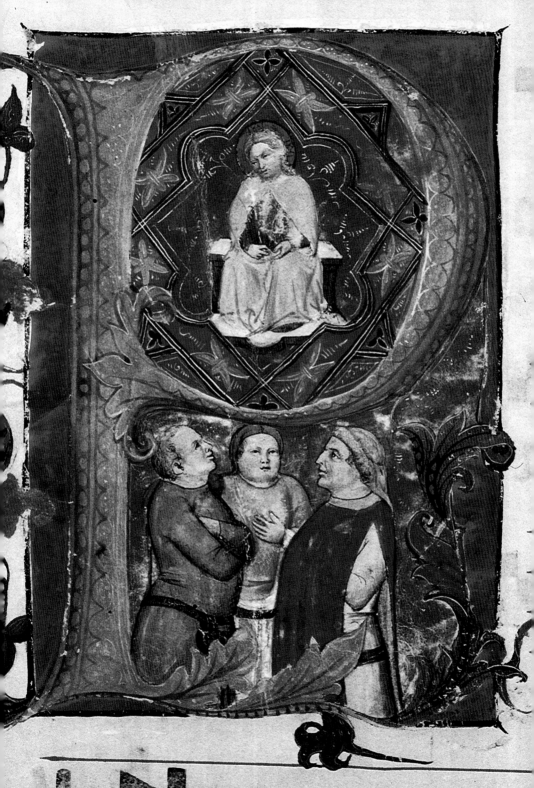

These extravagant promises of wellbeing, prosperity, revenge, illumination, and healing are humanized in the continuation of the Gospel passage read on the same Sunday, when Christ answers the question "Are you the one who is to come?" by inviting his listeners to "go back and tell John what you hear and see; the blind see again, and the lame walk, lepers are cleansed, and the deaf hear, and the dead are raised to life, and the good news is proclaimed to the poor" (Matt. 11:4–5). The meaning of the waiting shown in the miniature was thus clear: "the one who is to come"—the baby born at Christmas—is everything good, beautiful, just, and vital that human beings dream of. Their dreaming itself—their inchoate yearning for God—is in fact prayer, even if still timid and impersonal, a vague aspiration to truth, justice, and mercy rather than to God in himself. Yet it is prayer and prepares the day described by Isaiah, when a people walking in shadow will finally see a great light, allowing the prophet to say to God:

> You have made their gladness greater, you have made their joy increase; they rejoice in your presence as men rejoice at harvest time, as men are happy when they are dividing the spoils. For the yoke that has weighed on him, the bar across his shoulders, the rod of his oppressor, those you break as on the day of Midian. For all the footgear of battle, every cloak rolled in blood, is burnt, consumed by fire. For there is a child born for us. . . . (Isa. 9:2–5a)

PRAYER IN HEAVEN

"For there is a child born for us. . . ." Spokeswoman of the joy of Israel is in fact Mary, the woman who bore the child whom Isaiah called "Wonderful Counselor, Mighty God, Eternal Father, Prince of Peace" (Isa. 9:6c). And it is precisely as spokeswoman that we see her in the dome of the baptistery at Padua, where a fresco situates Mary in the midst of the heavenly assembly with her hands raised in the ancient gesture of prayer, much bigger than the other saints (**fig. 20**).[18] The artist of this grandiose composition, Giusto de' Menabuoi, in fact presents Mary's prayer as the culmination of all history: beneath her, around the edge of the cupola, are scenes drawn from the book of Genesis depicting the creation of the world, and around her we see the "huge number, impossible to count, of people" described in the Apocalypse (Rev. 7:9). Apocalyptic also is the enormous Christ, depicted at the apex of the cupola, with a book in which we read "EGO SUM A Ω": the phrase pronounced by him whom the author of the Apocalypse saw seated on the throne of heaven—the phrase that fulfils the sense of every other word ever uttered. "I am the Alpha and the Omega, the Beginning and the End" (Rev. 21:6a). In the continuation of this verse, the Savior then says: "I will give water from the well of life free to anybody who is thirsty; it is the rightful inheritance of the one who proves victorious; and I will be his God, and he a son to me" (Rev. 21:6b–7)—words, these, intended for all the saints but in a special way for Mary, daughter of the Son who, as a baby, drank from her breast.

The figure of Mary leading the prayer of the saints below the Alpha and Omega Christ of this apocalyptic cupola has, above all, a *nuptial* meaning. The last book of the New Testament in fact concludes with a plea addressed to the bridegroom by his bride, the Church, who with the Spirit says, "Come"

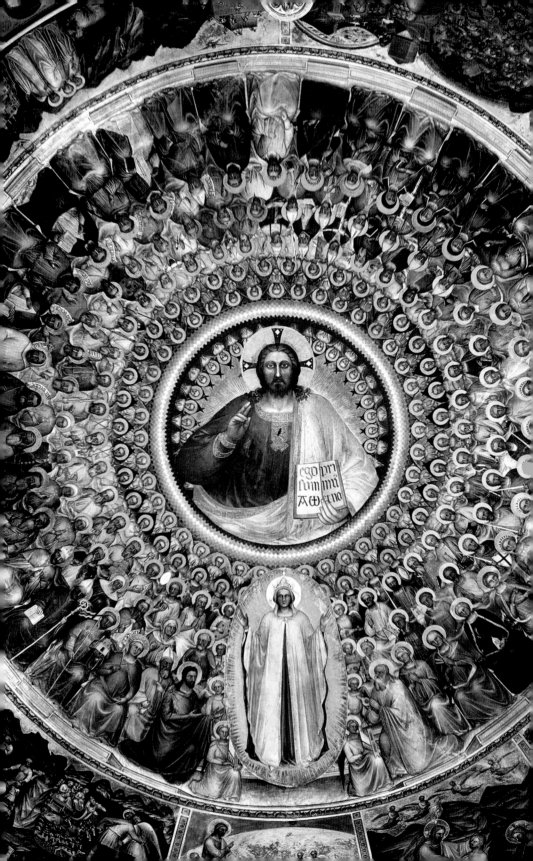

(Rev. 22:17a). The Spirit and the Church invoke the final and definitive coming of that Jesus who, in the preceding verse, identified himself as being "of David's line, the root of David and the bright star of the morning" (Rev. 22:16b), and the text invites whoever is listening or reading to repeat: "Come." The text adds, moreover, "Then let all who are thirsty come: all who want it may have the water of life and have it free" (Rev. 22:17b).

In the fresco in Padua, Mary, a figure of the Church, thus embodies the primordial impulse of every prayer, which is *thirst, yearning, desire* intense as that of the bride when "the fig tree is forming its first figs and the blossoming vines give out their fragrance" (see S. of S. 2:11–13a). Prayer in fact is confident expectation of bridegroom's response, "I shall indeed be with you soon" (Rev. 22:20), and of his invitation—*his* prayer to *us*: "Come then, my love, my lovely one, come. My dove, hiding in the clefts of the rock, in the coverts of the cliff, show me your face, let me hear your voice, for your voice is sweet and your face is beautiful" (S. of S. 2:13b–14). The One who addresses us in that way that is same who gave his body "in the bridal chamber of the cross" (*in thalamo crucis*)—at Padua the cupola fresco in effect is above a grand *Crucifixion* on the baptistery wall—and in Christ's case we can say literally that "love is strong as death, jealousy relentless as Sheol. The flash of it is a flash of fire, a flame of the LORD himself" (S. of S. 8:6b). This is the prayer of heaven: a burning answer in a shared dialogue—the harmony of a love song.

Just this kind of prayer is the theme of a special kind of Christian image, the so-called sacred conversation, developed

20. Giusto de' Menabuoi, *The Virgin Mary in Prayer in the Midst of the Saints and Christ in Glory*, Padua, dome of the Baptistery

with particular poetry by Venetian masters of the fifteenth and sixteenth centuries. Normally, in a sacred conversation, saints of different periods are shown together, grouped around the Madonna and Child. They do not actually converse—they do not speak among themselves or with Mary, that is—but their poses and expressions suggest individual prayer enlivened by shared love of Christ. These paintings are usually altarpieces, meant to be seen during the Eucharistic celebration, and thus the assembled personages around the central group allude to the *Communio sanctorum*, just as the baby's body in his mother's arms alludes to the sacramental *Corpus Christi* offered by the Church. Sacred conversations often include music-making angels, and this feature invests the silent main figures with a sense of harmony, as if they were listening together to music that we cannot hear; our illustration reproduces one of the first large-scale examples of this kind of image, the altarpiece executed around 1480 by Giovanni Bellini for a Venetian convent church, San Giobbe (**fig. 21**).

Figures of angels or young men playing instruments were not entirely new in fifteenth-century altarpieces, but Bellini puts the musicians right at the center of the composition, and the dreamy interiority pervading the picture suggests that everyone is in fact listening to them. Bearing in mind that this image was meant to be seen during Mass, we can say that music here becomes the cipher of a communion flowing from the Body of Christ and touching those brought together in prayer in different ways. We should note how Bellini gives a sense of natural variety to the group around the throne, avoiding the predictable symmetry of such scenes; the two groups of three saints are organized differently, with the middle figure on the left almost hidden, while the

21. Giovanni Bellini, San Giobbe Altarpiece, Venice, Galleria dell'Accademia

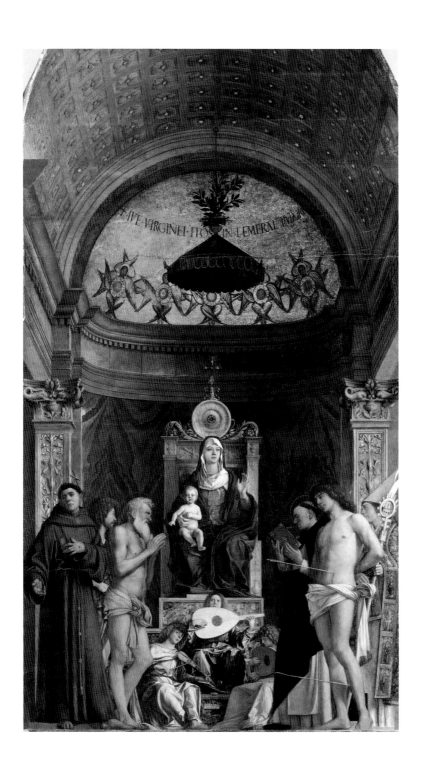

comparable figure on the right is in the first plane. So too the nearly nude figures, which another artist would have balanced, putting them in complementary positions, here are asymmetrical, with Saint Job right next to the throne and Saint Sebastian, on the other side, removed from it.

Bellini could allow himself this asymmetry because he possessed an insuperable instrument of visual unification: light, which here functions as visual "music," perceptible pictorial harmony. Unlike Tuscan masters, who situated their figures in full midday light, the Venetian Bellini in fact preferred the suffused luminosity of late afternoon, which, as it spreads, gently caresses people and objects, enlivening every surface with its warmth. He had learned from Antonello da Messina's activity in Venice in 1475–76 how to suggest an indirect light that pervades and envelopes volumes and masses, and—again thanks to Antonello—how to handle effectively the oil-painting technique developed by Flemish masters and by that time already known in northern as well as in southern Italy. It was this technique that enabled him to abandon the bright but opaque tones of tempera, seeking effects of chromatic transparency and surface movement through glazes and pigment buildup: the warm flesh tones and resonant deep-hued fabrics, like the light-points in the brocades and in the mosaic pieces of the apse, are a feast for the eyes! The light that unites his personages is moreover a metaphor for their prayer.

Queen of this natural universe caressed by light is again the woman through whom our human nature welcomed the God who illumines, Mary, set above other women and men—above the other saints in Bellini's altarpiece—because she is the daughter of Light, the mother of Light, the bride of the Light. Human "seat"' of a divine Wisdom recognizable in her Son, and above all in his sacrifice, Mary sits on a high throne with

a solar disk holding a cross at its pinnacle; and, as the human "space" within which Wisdom built his dwelling, Mary here occupies a marvelously delineated ecclesial space, becoming a figure of the Church in whose womb Christ is formed and, with him, all who follow Christ to holiness. Physical "place" of the unimaginable encounter between virginity and maternity, she rises above the bread and wine that, fecundated by the Spirit, become Christ's body and blood; humble and exalted, she suggests the final harmony of all things, their reciprocal "conversing" in the mystery of her Son's body.

Mary, who knew how to listen and to say yes to Almighty God, magnifying him in her soul for the "great things" he did in her life, is, again, a teacher of prayer, and it is fitting to conclude this first chapter with an image of her canticle in the Gospel of Saint Luke, the twenty-first-century *Magnificat* painted by Filippo Rossi in 2008 (**fig. 22**). The three large panels comprising a single scene evoke Mary's giving of thanks to her Creator, a gratitude that the artist interprets in musical terms. In Rossi's painting, the prayer of this young woman chosen to bear Christ to the world rises strong and sweetly melodious to God.

It is a song in two parts. In the lower part of the composition, the thoughts overflowing with joy of this woman "full of grace" gleam with various kinds of gold as they rise to the One who invests them with splendor, the God who is also *sol justitiae* (the sun of justice)—harmonic notes that irradiate from three musical staves disposed in the separate panels of the triptych. These are differentiated: in the central panel, as if suggesting the musical movement in the song, the staff is interrupted, while in the lateral panels the staffs unite the creature to the Creator without interruption. Mary indeed hesitated for a moment, asking the angel: "But how can this come about,

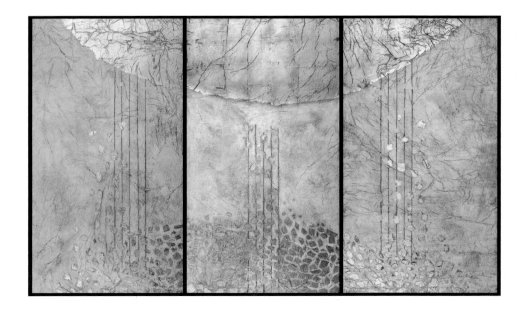

22. Filippo Rossi, *Magnificat*, Florence, Church of the Transfiguration, Orleans, MA

since I am a virgin?" (Lk. 1:34); God, by contrast, loves this creature chosen as the tabernacle of his only begotten Son *ab aeterno* (from all eternity). The three panels together compose a symphony that expands to fill the entire image—indeed, the music seems to overflow the three panels, enfolding the viewer with its embrace.

In this chapter we have claimed that prayer is central to human life and above all to the life of faith. But Filippo Rossi goes further, suggesting that prayer *is* life. He makes us see as pure music the woman who said: "My soul proclaims the greatness of the Lord"—a woman who sings in the sun as Christ, the light of mankind, rises in her womb.

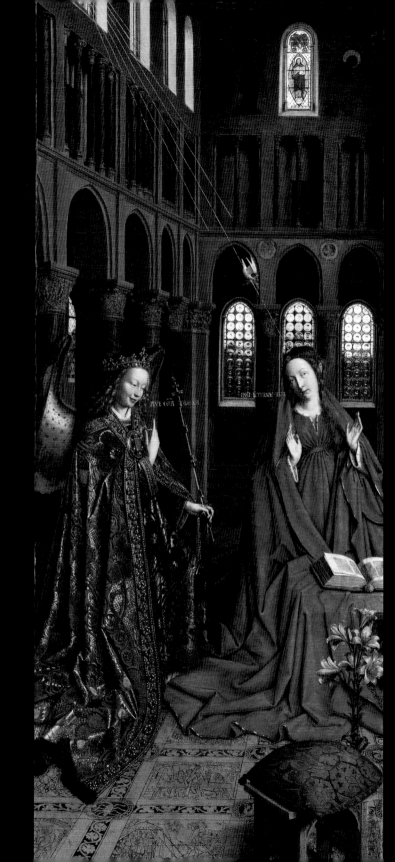

Chapter Two

———◆———

SPACES OF PRAYER

P eople pray everywhere and in all circumstances, but certain physical and spiritual spaces are particularly suitable, offering themselves as "designated spaces" for prayer.

In physical terms, the first of these is the temple or church, earthly image of the "house of God." "Hear the entreaty of your servant and of Israel your people as they pray in this place," the builder of the first Jerusalem temple, Solomon, asked the Most High, distinguishing, however, the material place of human prayer from the spiritual place where God truly resides: "From heaven where your dwelling is, hear, and, as you hear, forgive" (1 Kgs. 8:30).

The temple made of stone is only a sign, therefore, and Jesus, the new Solomon, energetically shifts the emphasis from the physical space to the moral one, teaching that "God is spirit, and those who worship must worship in spirit and truth" (John 4:24); he never speaks of architectural structures but indicates his own risen body as the "temple" of those who believe in him (John 2:19–22). Perhaps inspired by this idea, a Father of the Church, Saint Irenaeus, imagined the whole *historia salutis* (the history of God's activity to accomplish salvation) as a "place of prayer," affirming that "for those who were pleasing to him, God designed the edifice of salvation as an architect would do."[19]

An image evocative of these concepts is the *Annunciation* by a collaborator of Jan Van Eyck, now in Washington, DC (**fig. 23**).

23. Jan Van Eyck (?), *Annunciation*, Washington DC, National Gallery of Art, Andrew W. Mellon Collection

Although the setting is that of a church (which logically must represent the Jerusalem temple), various iconographic features insist on the spiritual and moral character of Mary's prayer, quite apart from the formally sacred space in which she is found. In addition to the angel, the dove, and a number of conventional signs such as the book of the Scriptures, alluding to the incarnation of the Word, and the vase of lilies alluding to Mary's virginity, the artist here fills the foreground of his image with a red cushion on a stool. What is more, the cushion, a traditional symbol of lust, is seen *beneath* the vase of white lilies, which in turn is *beneath* the book of the Scriptures, which then is *beneath* Mary's womb; viewers who read the image from the top down thus grasp that in the *body* of the Virgin the *Word* became flesh with no compromise to his mother's *purity* through *lustful desires.*

This victory of purity over lust is then qualified in biblical terms by two scenes in the figured pavement, visible between the hem of Mary's robes and the red cushion: Samson overturning the column in the Philistine palace (see Judg. 16:29–30) and David beheading Goliath (1 Sam. 17:51). These violent events situated in the foreground and beside the cushion clearly are meant to suggest the heroic nature of that humble obedience through which Mary allowed God to do "great things" in her life, as she herself will say in the Magnificat (Lk. 1:49). Albeit set in a church, this *Annunciation* that presents Mary as the supreme figure of Israel's history seems in effect to echo the words of the Magnificat, where Mary affirms that God's name is holy and

> his mercy reaches from age to age for those who fear him. He has shown the power of his arm, he has routed the proud of heart. He has pulled down princes from their thrones and exalted the lowly. . . . He has come to the help of Israel, his servant, mindful of his mercy—according to the promise he

made to our ancestors—to Abraham and to his descendants forever. (Lk. 1:49–55)

And all of this comes about in the context of prayer: Mary's raised eyes and hands make it clear that she is praying. Rereading the whole image in this key, various observations come to mind: in prayer, those who are pleasing to God inhabit "the edifice of salvation" built like a temple or cathedral; in prayer believers defeat temptations; in prayer the reading of Scripture bears fruit; in prayer God's invitation to bring Christ to the world reaches us; in prayer the Holy Spirit descends upon us; in prayer we can say yes to the Father (Mary's answer to the angel is written beside her mouth in upside down letters: "ECCE ANCILLA DNI" [Behold the handmaid of the Lord]). Clearly the true "space of prayer" here is not the temple but the human person full of grace.

Another space of prayer is suggested by the beautiful *Madonna of the Meadow* of Giovanni Bellini (**fig. 24**). I do not mean the meadow itself, even though the lovely landscape invites reflection on the relationship between cosmic nature and human nature, and in this case on the relationship between the creation and Christ, the Father's creative Word. The main space of prayer illustrated here is again Mary, shown in profound meditation, her head bent, eyes almost closed and hands slowly coming together. This interiority, which puts us in mind of the evangelist Luke's statement that Mary treasured the things that regarded her Son "and pondered them in her heart" (Lk. 2:19 and 2:51b), is here associated with Mary's humility: we see her seated directly on the ground, not on a throne—an iconographical *typus*, known as "the Madonna of humility." The young mother's inwardness and humility appear to be linked to the air of sadness that pervades the image, touching even the baby, whose face has a weary look and whose pose alludes to death. The meaning of this detail should be sought, again, in

24. Giovanni Bellini, *Madonna of the Meadow,*
London, National Gallery

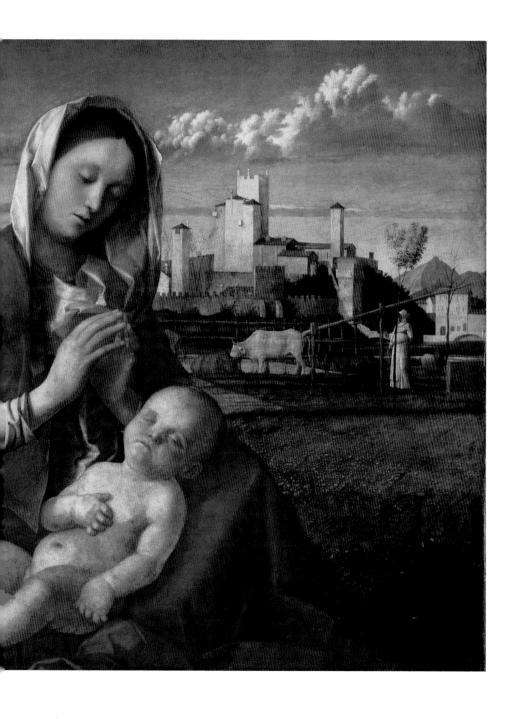

the passage of the Letter to the Hebrews where it is stated that "on coming into the world" Christ said to the Father: "You who wanted no sacrifice or oblation prepared a body for me. You took no pleasure in holocausts or sacrifices for sin; then I said, just as I was commanded in the scroll of the book, 'God, here I am, I am coming to do your will'" (Heb. 10:5–7); leaving no room for ambiguity, the text specifies that "this will was for us to be made holy by the offering of his body made once and for all by Jesus Christ" (Heb. 10:10).

As already noted in the first chapter, this phrase attributed to the Savior as he is born, "God, here I am, I am coming to do your will," not only prepares the way for Jesus's prayer as an adult in the Garden of Gethsemane, but echoes Mary's response to the angelic messenger: "I am the handmaid of the Lord . . . let what you have said be done to me" (Lk. 1:38). In similar fashion, in Bellini's painting the sadness of the mother suggests her acceptance of her Son's intention to offer himself in sacrifice. Her interiority serves indeed to treasure and ponder her Son's will, and her humility consists in seconding it. Her prayer is an adherence to this divine plan so absolute that the young woman's legs cannot support her weight, and Mary sinks into the dust.

Prayer is thus also a capacity to inhabit someone else's suffering. This the New Testament teaches, in the episode of the massacre of the Innocents, where—to describe the anguish of the babies' mothers—the evangelist Matthew evokes an ancient grief; when the mothers see their babes murdered, he says: "The words spoken through the prophet Jeremiah were fulfilled: 'A voice was heard in Ramah, sobbing and loudly lamenting: it was Rachel weeping for her children, refusing to be comforted because they were no more'" (Matt. 2:17–18). The mothers of the Innocents murdered in the first century of the Christian era inhabited a grief recalled by Jeremiah in the seventh century

before Christ, but which even then was remote, going back to Rachel, the daughter-in-law of Isaac—as if the sense of grief, its ultimate rationale, which, if known, somehow makes it bearable, has to be sought at the beginning of our collective memory. In this spirit, a Father of the Church identifies Christ as "the one who in Abel was murdered and in Isaac bound at the ankles; who in Jacob wandered the earth and in Joseph was sold. He was exposed on the waters in Moses and in the lamb was slaughtered; in David he was persecuted and in the prophets dishonored." The same writer carries Christ's "inhabitation" of others' ills right back to the Savior's birth, saying: "He descended from heaven to earth for suffering humankind; he clothed himself in our human nature in the Virgin's womb and was born as man, assuming the sufferings of suffering mankind through a body subject to suffering."[20]

Our prayer, therefore, like that of Mary in Bellini's painting must draw on memory and imagination. It must open itself to sentiment, seeking God in those human experiences that everyone remembers in his own life and imagines in the lives of others. In Bellini's painting Mary remembers Rachel and the times of Jeremiah and of Israel's exile; perhaps she also thinks of the murdered Innocents; certainly she imagines her own Son's future suffering, feeling for him both the love of mothers for their babies and the adoration of the redeemed for their redeemer. Daughter of her own Son, in the flow of these memories and sentiments and presentiments Mary touches for a moment the timeless mystery of a God who is Father, Mother, Son, and Victim, and—like the created world around her in the painting—"groans" as she awaits the freeing from death of the Son she loves (see Rom. 8:19–23).

FAMILIAL AND FRATERNAL SPACES

If the experience of strong feelings can establish contact with God, it follows that among the spaces of prayer there is also the family, first school of affectivity. Very beautiful in this respect is a representation of Mary as *Mater misericordiae*—"Mother of Mercy"—painted for a Swiss family in the early sixteenth century: the altarpiece by Hans Holbein the Younger depicting one Jacob Meyer with his family under the Virgin's mantle (**fig. 25**). Meyer was a banker and mayor of the Swiss city of Basle, and after the death of his first wife in 1511 he had remarried, creating a second family.[21] The painting in fact includes a posthumous portrait of his first wife, Magdalene Bauer, shown in profile right next to Mary, together with Meyer's second wife, Dorothy Kannengiesser, shown in a three-quarter view. The girl kneeling in the foreground in front of the two women—the eldest of the children, already wearing a *Jungfernbandel* (the cap of a maiden of marriageable age)—is probably daughter to the deceased first wife, whose straight, strong nose she clearly inherited! The adolescent boy and little baby, on the other hand, must be Meyer's children by his second wife. We are looking at an image of a father who places himself and his dear ones under the protection of the woman who held little Jesus dear.

The aura of sadness that envelops this scene and the urgency with which Jacob Meyer directs his gaze toward Mary are due to the historical circumstances of the years in which the image was made: 1525–28, when the Protestant reform raged in Basle. Meyer and his family wanted to remain Catholics, as their commissioning of an altarpiece that puts them under the protection of Mary, figure of the Church, suggests. It was a threatening time, however, for the old faith and for its images.

25. Hans Holbein, *Madonna of Mercy with the Family of Jacob Meyer*, Darmstadt, Schlossmuseum

The painter, Holbein the Younger, himself just back from England and bearer of a drawing sent by the future Catholic martyr, Thomas More, to Erasmus, must have understood Jacob Meyer's moral anguish, which he moreover shared, being similarly obliged to choose sides. This work indeed is one of the last masterpieces of sacred art produced in what was then becoming Protestant Europe. Some years later Holbein would himself make the difficult decision to go over to the new faith.

Just as the family is a space of prayer, so too are those forms of Christian associative life with familial features, such as confraternities. This is suggested in a fourteenth-century fresco done for the Confraternity of Mercy in Florence, on a wall in their residence in Piazza San Giovanni, between the baptistery and the cathedral. Painted by a collaborator of Bernardo Daddi, the work shows the brothers and sisters of the confraternity kneeling in prayer before Mary (**fig. 26**).[22] Beneath Mary's feet we see a view of the Florence city center, in which the baptistery is perfectly recognizable and, just beyond it, the then rising new cathedral of Santa Maria del Fiore (**fig. 27**).

In addition to various charitable activities, the members of this confraternity in effect dedicated themselves to prayer, and the ground level of their headquarters had an oratory with a portico open to the street, at the corner between Cathedral Square and the main city street connecting Cathedral Square and Piazza della Signoria, the square of the town hall. Thus for those coming from the town hall, the porch of the confraternity's oratory marked the passage from the civic to the spiritual center of Florence—to the square where the old baptistery and the (then) new cathedral stood.

26. Circle of Bernardo Daddi, *Madonna of Mercy with the Members of the Confraternity of Mercy*, Florence, Loggia del Bigallo

27. Circle of Bernardo Daddi,
 Madonna of Mercy with the
 Members of the Confraternity
 of Mercy, Florence, Loggia
 del Bigallo , detail

FLORENTIE

This way of looking at it—the Confraternity of Mercy as a portal connecting the world of power, on one side, with the world of faith, on the other—helps us grasp the function of this edifice and the character of the association that built it. Together with the oratory and meeting rooms, the new structure contained a hospice for abandoned children on the upper floor; a fresco done in 1386 for the exterior of the building (now inside) shows the confraternity's captains (directors) entrusting abandoned children to women paid to look after them. A second fresco, in the main meeting room, evokes the group's other activities: the care of the sick and burial of the dead, suggested by twelve scenes from the life of Tobias, the biblical personage who, notwithstanding an official prohibition, gave religious burial to his Hebrew brethren during the Babylonian exile.

But the masterpiece of this iconographic program is the fresco reproduced here, the *Madonna of Mercy* with the men and women of the confraternity in prayer. At the center is Mary, clothed in a cope and with a headpiece that looks like a bishop's mitre, as if she were that *sacerdotissa justitiae* of whom Saint Antoninus Pierozzi would speak in the fifteenth century—a "priestess of social justice" with a ministry to the needy.[23]

The ministry is illustrated in roundels adorning the border of her cope, where the seven works of corporal mercy are represented. And around this figure of Mary, as if she were speaking to us, are words that describe these works: *visito, poto, cibo, redimo, tego, colligo, condo.* On behalf of the confraternity, that is, Mary says: "I visit the lonely, feed the hungry, and give to drink to the thirsty, ransom prisoners, give a roof to the homeless." And all of this is then visually associated with the city, represented beneath Mary's feet. The two images together—Mary, invoked by the members of Misericordia and the city under construction—make it clear that the obligations assumed by the members of the confraternity

(the obligations of every Christian toward the marginalized and disadvantaged) were accepted in a spirit of civic solidarity. The men and women shown kneeling here prayed but also intervened in practical ways, and their works of mercy were done in the service of their city, shown here under Mary's mantle. This Madonna in fact presides over a kind of public liturgy with angels with incense in the upper right and left corners—and with the confraternity members kneeling at her sides, men to the right and women to the left. Seen this way, the city houses and churches beneath Mary's feet seem like flowers strewn along the processional route, and the inscription on the centermost roundel of Mary's cope, *Misericordia Domini plena est terra* (the earth is filled with the Lord's mercy) confirms that even if its palaces are made of stone, Florence has a compassionate heart. The overall message is that active charity flows from shared prayer, allowing believers to shape physical spaces of fraternal care.

CHURCH SPACE

The inclusion of the baptistery of Florence and its rising cathedral in the Misericordia fresco invites a final reflection: church buildings too are born of the prayer from which charity flows, even if charity is more important than buildings (in the fresco the figures of Mary and the confraternity members are in fact bigger than the religious monuments). But churches too are fruits of the charity that Christians cultivate in prayer.

The sense of this statement transpires in the legend associated with a Roman church founded in the mid-fourth century, the Basilica of Santa Maria Maggiore. According to an account cited a thousand years later by the writer Fra Bartolomeo da Trento, a wealthy Roman patrician—a senator named John—together with his wife decided to leave their earthly possessions to the Church, since they were childless. And in the night between August 4 and

5 of the year 358, the Virgin Mary appeared simultaneously to John and to the pope, Liberius (352–66), asking that a basilica be dedicated to her at Rome, in the place where abundant snow would fall in that same summer night. The next morning the senator and the pope both went to the Cispian Hill, where a miraculous snowfall had occurred, and in the snow Pope Liberius traced the shape of the basilica to be constructed. This event is depicted in a late sixteenth-century painting, whose artist, Jacopo Zucchi, stresses the intense prayer of the patrician John and his wife, shown with Pope Liberius in the foreground (**fig. 28**). [24]

Beyond its individual history, though, every church structure represents the entire history of the relationship between God and humankind, offering itself as a figure of that "edifice of salvation" that Saint Irenaeus believed God had designed "as an architect would do." [25] In Santa Maria Maggiore itself, rebuilt on a more monumental scale and decorated in the fifth century (**fig. 29**), forty-three mosaic scenes above the nave colonnade narrate "structural" episodes of Judeo-Christian faith: the stories of Abraham, Moses, Joshua. Thus believers, as they advance toward the altar, perceive themselves inserted in a historical and meta-historical process that leads them toward the "city founded, designed, and built by God" (Heb. 11:10). At the end of this journey—at the right and left of the wall closing the nave—two cities are in fact represented: "Jerusalem" and "Bethlehem" as they are identified in inscriptions, before whose open gates flocks of sheep are gathered, six animals in front of each portal. In the arch of each of the two city gates a golden cross is hung, and the avenue stretching away from the gate has a noble colonnade similar to

28. Jacopo Zucchi, *Miracle of the Snow*, Vatican City, Vatican Museum

The two following pages:
29. Roma, Basilica of Santa Maria Maggiore, interior, view toward the altar

that in the nave of Santa Maria Maggiore. These city views are on the arch framing the altar of the basilica, so that the twelve sheep represented become an image of the Church, which had grown from the original twelve apostles. And in effect the "flock" that gathers to worship in Santa Maria Maggiore, just like the sheep in these mosaics, looks down two lines of columns through a "gate" toward a "temple": Christ present in the Eucharist.

The idea of looking at church buildings as expressions of the faith and prayer of the community goes back at least to patristic times. In a homily for the consecration of a new African church, Saint Augustine assured his listeners that "what was happening here when this church of yours was rising has its counterpart when those who believe in Christ are brought together. By becoming Christians they are like stones newly quarried in the mountains or timber felled in the woods. When they are catechized, baptized, formed, they are, as it were, hewn at the hands of workers and craftsmen, they are set in line and evened up."[26] Then, as if afraid his hearers might not understand the need for individual spiritual commitment, Augustine recalled that, despite these various preliminary operations, Christians "do not constitute a house of God unless they are cemented together by love."[27] Returning to the simile of the physical building, he continues: "If the beams of wood and stones of this church were not joined to one another in a definite pattern, if they were not peacefully intertwined, if they did not by mutual attachment in a certain sense 'love' one another, no one would dare to put a foot inside. In a word, when you see the stones and wood beams in any building securely fastened to each other, you enter there without dread, you fear no collapse. Our Lord Jesus Christ, wishing to enter and dwell in us, used to say, as though by way of building: 'A new commandment I give you, that you love one another" (John 13:34).[28] From Augustine's words it is thus clear that the

meaning of a building intended for prayer is tied to the identity of a community called to live in love—in that communion which the Lord himself gives, "as though by way of building."

The continuity of these ideas in the life of the Church is evident as we turn to an image at once ecclesial and ecclesiological of a thousand years after Augustine's time: a *View of the Cathedral of Antwerp* by Pieter Van Neefs the Elder (**fig. 30**). Together with the structural interest of the building's Gothic architecture and the iconographic interest of the altarpieces in its interior, Van Neefs offers episodes of church life as actually lived then: a low Mass said for a small group of people; others who move about and converse in the church; alms given to a beggar. The painting, which seems to equate the complex yet unitary architectural structure to these multiple expressions of the one faith housed in it, anticipates Friedrich Hegel's parallelism between a great medieval church building and the Christianity it served: "In such a cathedral there is room for an entire people," the philosopher would later say. "All the various life interests that have anything to do with religion find place here simultaneously. . . . Here someone is preaching, there a sick person is brought in, and at the same time a procession passes. A baptism gets celebrated, a corpse is borne through the church, in another part of the building a priest is saying Mass or blessing a marriage, and all around assorted individuals are kneeling in front of altars and the images of saints. One and the same building encloses all these things." Inspired by this idea, Hegel continues in a romantic vein, insisting that "given the breadth and grandeur of the building, nothing completely fills it, every activity unfolds rapidly, individuals with

The two following pages:

30. Peeter Van Neefs the Elder, *View of the Cathedral of Antwerp*, Brussels, Musées Royaux des Beaux-Arts de Belgique

their individual needs dissolve like points of light in the grandiose interior, and that which is merely momentary becomes perceptible only in its fluid passage. Looming above all these people and their activities, the building's vast spaces seem infinite, with their solid form and unvarying structure."[29]

THE SPACE OF PURIFICATION

Hegel's phrases suggest a parallelism between the immensity of the cathedral and the boundless space of prayer. Prayer in fact enfolds all of man and all of men, and one of the reasons for which cathedrals are huge is the universality of the welcome they must offer; in truth they deserve the name the prophet Isaiah attributes to the ancient Jerusalem temple, "a house of prayer for all the peoples" (Isa. 56:7). This designation is cited by Jesus when he asks: "Does not Scripture say: 'My house will be called a house of prayer for all the peoples'?" (Mk. 11:17a). Yet Jesus cites Isaiah's designation in a particular moment: shortly before his passion, when he expels vendors and money changers from the Jerusalem holy place, and his full phrase in fact is: "Does not Scripture say: 'My house will be called a house of prayer for all the peoples'? But you have turned it into a robbers' den" (Mk. 11:17; see also Matt. 21:12–13; Lk. 19:46). Every space meant for prayer must therefore be free of vice, purified of sin, open to holiness.

This in fact is the sense of the ascetic tradition, which aims to free, purify, and sanctify the human heart, true "space" and "house" of prayer. And this explains why, since the third and fourth centuries—since the period that saw the large-scale spread of Christianity in ancient society—the Church has accepted the will of some of its members to dedicate themselves to prayer by renouncing all that could distract them from that purpose: possessions, family, individual autonomy. First in Egypt, Syria, and

Greece, then in Italy and the south of France, single hermits and communities united under an *abba*—a spiritual father—defined a style of life totally focused on God, the chief components of which were prayer, study, and work. [30]

The attraction of this "monastic" life (from the Greek *monos*, meaning "alone") is apparent in a painting that evokes the experiences of the hermits of the Egyptian desert, known in the Church from the early centuries thanks to texts recounting their spiritual struggles. This image, attributed to the Florentine Paolo Uccello, shifts the setting to fifteenth-century Tuscany but at the same time maintains the spirit of the ancient eastern texts, showing monks who—alone or in groups—pray, read or listen to reading, and do penance before a crucifix (**fig. 31**). These scenes also bring to mind the ascetic handbook of Western Christianity, the *Regula monasteriorum* (Rule for Monasteries) written by Saint Benedict of Nursia in the sixth century, where—speaking to all who wish to embark on this way of perfection—the author advises: "Listen, my son, to your master's precepts and incline the ear of your heart; accept willingly your good father's counsel and put it into practice, so that you may return, through the labor of obedience, to him from whom you distanced yourself through the sloth of disobedience."[31] Then, comparing the monastic commitment to military service "under Lord Christ, the true King," Saint Benedict teaches his spiritual son the value of prayer, insisting that "first of all you must, with constant and intense prayer, ask him to bring to completion everything good you set out to do."[32] Further on in the Rule, explaining the reverence that should characterize a monk's prayer, the saint says: "If, when we ask something of powerful people, we do not dare to do so except with humility and respect, how much more

The two following pages:

31. Paolo Uccello, *The Way of Perfection ("Thebaiade")*, Florence, Galleria dell'Accademia

should we not direct our pleas to God, the Lord of all things, with absolute humility and purity of devotion. We know, moreover, that we are not heard for the many words we employ, but for our purity of heart and tearful compunction."[33]

Among the paschal paradoxes of Christian monasticism is the fact that the ascetic emphasis that distinguishes monastic spirituality has not mortified the intellectual and artistic creativity of monks. Especially in the West, the communitarian character of monastic life has favored the development of the sciences and arts, thanks to the fact that Benedictine monks, by a special vow of *stabilitas*, neither leave their monasteries nor are transferred but stay together for life. In these circumstances it easily happens that, within the religious brotherhood, a sort of scientific or artistic brotherhood develops—as numerous monastic achievements in various fields attest (agriculture, forestry, apiculture, architecture, miniature painting, sacred music, and so on).

Thus, as in the Church generally, so too in monasteries: art, although not the primary objective, becomes a natural, all but inevitable reflex. Indeed monastic life, structured through acquired forms of discipline and aimed at interior "perfection," is itself an *art*: a carefully cultivated expression of the ordinary Christian commitment. In his Rule for Monasteries Saint Benedict in fact compares the monastery to an artisan's workshop, where *die noctuque incessabiliter* (night and day without ceasing) the brethren bring to perfection a work ordered by God, with the moral precepts of Christian life as their "tools": *instrumenta artis spiritalis*.[34]

The intimate bond between the monks' life of prayer and the art they produce is made clear in the magnificent cloister of the abbey of Saint Paul's Outside the Walls (**fig. 32**), executed in the early thirteenth century by Nicola d'Angelo and Pietro Vassalletto, the

32. Nicola d'Angelo and Pietro Vassalletto, cloister, early twelfth century, Rome, Saint Paul outside the Walls

most important marble workers in Rome at that time, where a
long mosaic inscription describes the mix of aesthetic enjoyment,
study, and prayer typical of monastic spirituality.

Playing on the root of the term *cloister* (*claustrum*), this text
affirms that *Claustrales claudens claustrum de claudo vocatur, cum
Cristo gaudens fratrum pia turma seratur* (The cloister that encloses
the monks takes its name from the verb 'to close': it in fact closes
the pious band of brothers in joyous intimacy with Christ). The
inscription, which runs along the cornice of all four sides of the
cloister, recalls moreover that here the monks study, read, and
pray (*Hic studet atque legit monachorum cetus et orat*), and that—if
the eyes of outsiders admire above all the architecture of the new
cloister—what seems beautiful to the monks is rather the Rule
of Saint Benedict: *Hoc opus exterius pre cunctis pollet in Urbe. Hic
nitet interius monachalis regula turbe.*[35] A similar inscription in the
cloister at Saint John Lateran, of the same period and also realized
by the Vassalletto family, reminds the Regular Canons who then
resided there of their vows of poverty, chastity, and obedience,
expressing the hope that "the structure of this cloister may be
your ideal model, and your souls may gleam [like its marbles
and mosaics], your behavior be as honest, and you Canons have
souls as firm [as this architecture], and—as if bonded with these
stones—may you be equally well finished" (*Claustri structura sit
vobis docta figura ut sic clarescant animae moresque nitescant et
stabiliantur animo qui canonicantor ut coniugantur lapidesque sic
poliuntur*).[36]

LOCA SANCTA, HOLY PLACES

The aspiration to holiness that in monasticism becomes
a project of community life can assume temporary and
individual expressions as well—expressions that do not call for

a commitment of the believer's entire life, that is, and that do not imply membership in a consecrated community. The most ancient of these is the pilgrimage, in which persons of both sexes and of all social conditions set out for a given destination—a "holy place": Jerusalem, Compostela, Rome—to pray in physical spaces corresponding to important events and to venerate relics of particular religious significance. Pilgrimage itself is a privileged "space of prayer," as are the topographical destinations to which pilgrims direct their steps.

Among great historical destinations there is the same complex of buildings in Rome decorated by the Vassalletto family, Saint John Lateran, comprising a basilica and a pontifical palace.[37] "Mother of all churches," the Lateran Basilica is the pope's *cathedra* (the church containing his episcopal throne), and in the past the papal blessing was given to pilgrims from the lateral loggia of this building. Equally fascinating to medieval pilgrims was a chapel in the Lateran Palace, constructed at the behest of Pope Nicholas III in the late thirteenth century to contain important relics: the so-called *Sancta Sanctorum* (Holy Place of Holy Places), the name of which equated it with the innermost chamber of the ancient Jerusalem temple, where only the high priest might enter.[38] On the architrave of the Lateran Sancta Sanctorum we read moreover the disconcerting affirmation: *Non est in toto sanctior orbe locus* (There is no holier place in all the world) (**fig. 33**). Yet that incomparable sanctity is not an intrinsic feature of the place (of medieval construction), deriving rather from the prayers which for centuries pilgrims have lifted in the presence of the relics conserved in the chapel, before an image of Christ "not painted by human hands" once carried in procession through the city streets. The sanctity of the Sancta Sanctorum resides, that is, not in the place as such but in the prayer-community that originally produced the martyrs and which still venerates their relics.

Equally interesting is the entry to the Sancta Sanctorum: a
stairway of the ancient papal palace, which has been identified,
at least from the Middle Ages, with the stairway in the house
of Pontius Pilate that Jesus ascended and descended the night
before he died.[39] These stairs, which according to tradition had
been brought to Rome in the early fourth century by the Empress
Helena, were originally in quite another area of the palace, being
transferred to their present position during the rebuilding of that
structure under Pope Sixtus V in 1589. They were transported
to the new location by night, accompanied by candles and the
singing of litanies![40]

That means however that the pilgrims who, still today, ascend
this "holy staircase" on their knees to glimpse, beyond the grate,
the untouchable space of the "Holy of Holies" are people who
have come from afar to mount stairs that have been moved in
order to see relics brought from elsewhere and a portable icon.
In this case especially it is clear that the "space of prayer" is that
which pilgrims themselves define as they relive in their hearts the
passion of One who presented himself as the new "temple" and
personal "holy place" of all who believe in him, Jesus Christ. A
Renaissance treatise on the Rome pilgrimage, *De tribus peregrinis,*
confirms this interpretation.[41] Under the heading *Hierusalem
multiplex* (the multiple Jerusalem) the author presents the three
places that can be designated with this name. The most important
is the first, which the other two in fact symbolize: it is the *mystica
Hierusalem, quae est anima ad imaginem Dei, illustrata gratiae et
scientiae, quae est templum Spiritus Sancti et recetaculum donorum*
(the mystical Jerusalem, which is the soul created in God's image
and ennobled by grace and knowledge, so as to become the temple
of the Holy Spirit and treasury of his gifts).[42] The true "holy city"

33. Rome, Saint John Lateran, interior of the chapel called the "Sancta Sanctorum"

is constituted not of stones, that is, but of people; and the true goal of every pilgrimage is the incipient holiness that every pilgrim bears in his heart.

In second position, in the order defined by *De tribus peregrinis*, is the *terrena Hierusalem*: the "earthly Jerusalem," city of the historic temple and the Hebraic priesthood in which are located the tomb of Christ and the places of his passion. And in third place there is the *traslata Hierusalem quae nunc Roma est*, the transposed Jerusalem that now is identified with Rome, capital of the ancient pagan empire, which became the capital of all the churches and rightful seat of spiritual authority, as the text of the treatise puts it.

This sixteenth-century text interprets the pilgrim's journey to Jerusalem, Rome, or any other destination as a dynamic metaphor of the soul's inner journey to the "mystical Jerusalem"—a journey of prayer in communion with God and with one's brothers and sisters. It thus also helps explain the attraction that, from the year 1300 until the present, the pilgrimage to Rome has exerted in Jubilee years—a declared Holy Year—an attraction documented in a print of the same period, illustrating the visit to the eternal city's seven basilicas (**fig. 34**).

This image of pilgrims going from one church to another highlights an important connection: that between *prayer* and *visibility*. Every journey undertaken in a spirit of prayer leads in fact to something visible: a mountain, a grotto, a temple, seven churches. On arrival, the pilgrim's experience is structured through rites nicely calculated to satisfy his desire to see something: processions, the exhibiting of relics, the veneration of images. Interesting, in this respect, the language used by the Florentine Giovanni Villani, present in Rome in 1300 for the first Jubilee, who tells us that "for the consolation of Christian pilgrims, every Friday and solemn feast day, the Veil of Veronica was exhibited"—

34. Antoine Lafréry, *Visit to the Seven Churches of Rome*, 1575, engraving

the veil bearing the imprint of Christ's face, that is (**fig. 35**). But this rite served for "the consolation of Christian pilgrims," because human beings yearn to see God and are thus consoled in seeing his image. That is the connection: images presented to pilgrims at journey's end console them. Like the first disciples, pilgrims set out in response to One who says, "Come and see" (John 1:39a), and in Veronica's Veil or some other relic—as in the architecture and art they find on reaching their destination—they contemplate his face and behold his abode under the form of images.

This desire to see God is not mere curiosity but a deep impulse of Christian faith. "The Word was made flesh, he lived among us, and we *saw* his glory," the prologue to the fourth Gospel affirms (John 1:14), and another text attributed to Saint John insists that, in Jesus Christ, "Life was made visible: we *saw* it and we are giving our testimony, telling you of the eternal life which was with the Father and has been made visible to us" (1 Jn. 1:2). Similarly, speaking of Christ, the Pauline Letter to the Colossians states simply: "He is the *image* of the unseen God" (Col. 1:15). Our point is that visibility itself is a "space of prayer" for those who believe in the incarnate Word.

Thus it is no coincidence that Christians imagine their ultimate "destination" in visual terms, as a vision giving perfect happiness: the *visio beatifica*. A Father of the Church, Saint Peter Crysologus, relates this goal to the love that God pours into believers' hearts, reminding us that "love generates desire and increases ardor, which tends to want to lift veils. And what more? Love cannot keep itself from wanting to see what attracts it—for this reason all the saints considered that they had achieved little indeed if they did not succeed in seeing God. That is why the love that yearns to see God, albeit lacking in discretion, nonetheless has the ardor of

35. Stephan Planck, *Pilgrims Venerating Veronica's veil*, woodcut from the *Mirabilia urbis Romae*, c. 1486, Vatican Library

piety; that is why Moses went so far as to say [to God]: 'If I have found favor in your sight, let me see your face.'"[43] Desire for God satisfied by the sight of him is indeed the theme of the last cantos of Dante's *Divine Comedy*, where Beatrice tells the poet: "And you should know that all experience delight /in the measure in which their gaze penetrates / the truth in which every mind is calmed. / Thus it is clear that the state of blessedness / depends on the act of seeing, / not on that of love, which comes later; / and the measure of vision depends on mercy, / born of grace and holy desire: / and thus one rises from level to level."[44]

These words, written in the period of the first Holy Year, provide a key to the relationship between the Jubilees and art. To the pilgrim Dante, Beatrice explained that the purpose of all human existence is to *see God*; love itself is a means leading to this end. In analogous fashion, the Holy Years—times particularly dedicated to God—perfect the means and lead to the end. An indiscreet love that, according to Peter Chrysologus, nonetheless has the "ardor of piety" drives millions of people to undertake the pilgrimage to Rome, and at the end of the pilgrimage they want to see something; they have made the trip in order to taste, here on earth, a blessedness rooted in "the act of seeing." This is the logic of the system of great signs that accompany the life of believers— the sacramental system, that is; and it is the logic of pilgrimage, which is a "sacrament" of the individual's search for God.

POPULAR PIETY

If pilgrimage is prayer, prayer also is somehow a pilgrimage, an interior journey that anyone may undertake; and while in the first case stamina and economic means are required, in the second willpower and perseverance suffice. The traveler does however need clear directions, detailed road maps, and official itineraries,

and these are the functions of those practices of piety which the Church recommends: practices that allow all—healthy and sick, young and old—to travel the road leading to God.

Among the most widely employed practices of prayer is the rosary, which from its first appearance in the Christian West in the later Middle Ages has attracted believers, as a famous altarpiece by Caravaggio suggests, showing people reaching out to Saint Dominic, to receive from his hands the rosaries that Mary orders to be distributed (**fig. 36**). Right from the start of the order the Dominicans promoted praying the rosary, and this work of 1606–07 was probably intended for their church in Naples, San Domenico. For reasons that are not fully clear, the painting never reached its destined altar in Naples but traveled to Holland, where a group of artists led by Rubens bought it to donate to the Dominican church of Antwerp, Saint Paul's; from that location it went finally, in 1786, to Vienna, as part of the collection of Emperor Joseph II.

What is the appeal of the form of prayer evoked in Caravaggio's painting? A first answer, suggested by the image itself, is that the rosary is accessible to all, even to the simple folk of all age groups represented in the canvas. It is accessible because it is composed of formulas that everyone knows from childhood—the *Our Father*, *Hail Mary*, and *Glory Be to the Father*—and thus presents itself as a prayer that takes people back to the beginnings of their faith, when perhaps it was their parents who taught them to pray. At the same time, however, the rosary is an elevated form of prayer, and it is no accident that along with Mary and the Christ Child Caravaggio shows us members of a religious family famous for its theologians, the Dominican Order; the Our Father, Hail Mary, and Glory Be to the Father are in fact prayers drawn from the New

Testament, which, when people say the rosary, are recited against the backdrop of the "mysteries" of Christ and Mary studied by theologians. The rosary thus represents an extreme synthesis of Christian Scripture and theology.

The rosary moreover is a repetitive prayer, which in its full form requires 150 Hail Marys, 15 Our Fathers, and 15 Glory Be to the Fathers, and it is precisely this repetitiveness that assures its widespread success. In all religions there are in fact reiterative prayer formulas that underline through *repetition* the authenticity of the impulse to pray and through *patience* the sincerity of the praying individual; such formulaic prayers often employ objects that, like the rosary, facilitate recitation by precisely defining duration. In Christianity such formulas are not considered demeaning, a kind of prayer fit only for the ignorant, because Jesus himself preferred the prayerfulness of ordinary people to that of the elite, praising his Father "for hiding these things from the learned and clever and revealing them to mere children" (Matt. 11:25). The repetitiveness of the Christian rosary moreover fulfils Moses's command to Israel when he transmitted the Tablets of the Law: "Let these words I urge on you today be written on your heart. You shall repeat them to your children and say them over to them whether at rest in your house or walking abroad, at your lying down or at your rising; you shall fasten them on your hand as a sign, and on your forehead as a circlet; you shall write them on the doorposts of your house and on your gates" (Deut. 6:6–9).

As these Old Testament admonitions suggest, the element of repetitiveness in popular piety creates an identity that is at once individual and collective, inserting believers in a space of prayer so vast as to become coextensive with their entire life, if indeed they repeat God's words in their houses and walking abroad, when

36. Caravaggio, *Madonna of the Rosary*, Vienna, Kunsthistorisches Museum

37. Friedrich Wasmann, *A vineyard at Merano*, Winterthur, Oskar Reinhart Foundation

38. Thomas Uwins, *The Saint Manufactory*, Leicester, New Walk Museum & Art Gallery

they lie down and when they rise. In traditional cultures this vast "space" is often in fact adorned with images or objects meant to stir people to prayer: that is what we see in the Old-World scene depicted by Friedrich Wasmann in a canvas of 1831 showing a vineyard near Merano, where a crucifix erected beside a country lane invites wayfarers to associate the fatigue of travel, the toil of labor, and the beauty of the mountains with the mystery of Christ who suffered, died, and rose (**fig. 37**). A youthful work of the artist born in 1805, this painting suggests that the convulsions of the Napoleonic wars and the early Industrial Revolution had created nostalgia for a simpler and more peaceful way of life: in fact nineteenth-century Romanticism often treats the theme of rural religiosity, with evident regret for the passing of a world in which prayer was "natural." A year after finishing this painting, Wasmann, one of the lesser masters of the Nazarene movement, moved to Rome and converted from Lutheranism to Catholicism.

It is interesting to juxtapose this nostalgic reading of the popular piety with a work of the same period by a young English artist, Thomas Uwins, where the phenomenon is treated with condescending irony (**fig. 38**). The small canvas, which Uwins exhibited at the London Royal Academy with the title *The Saint Manufactory,* conveys the contempt of this painter, then just returned from a trip to the south of Italy, for what he called "the machinery of Neapolitan devotion"; Uwins's intention is clearly to show the artisan who makes the holy images and the young women with him as gullible, whereas the fat Capuchin friar represents a clerical caste that the artist considers clever and grasping—in fact the friar seems to be haggling over the price of the wooden statue that the craftsman, at the center of the composition in a posture of patient listening, is carving.[45] Throughout the craftsman's shop, moreover, colorful images of Christ, Mary, and various saints communicate an impression of simple Catholics as idolatrous—

practically pagan—their lack of genuine faith denounced by the small crucifix abandoned on the pavement in the foreground, near a flask of wine and a dog napping amid the shavings.

This British irony, which reflects the Protestant bent of Anglicanism before the rapprochement with Roman traditions promoted by the Oxford Movement, is however an anomaly in nineteenth-century Europe, where Catholic popular piety was represented with respect and indeed as a paradigm. The most famous example of this process of idealization is Jean-François Millet's painting entitled *Angelus*, where two peasants interrupt their work in the fields to pause in silent prayer at the hour of the evening Angelus (**fig. 39**). Executed between 1858 and 1859, this work showcases the ancient Catholic identity of France at a time when the Second Empire was in fact providing military support to Pope Pius IX against the Piedmontese advance on the papal states. Above all, however, it openly and unabashedly celebrates the nostalgia for a good and simple world in which faith gave meaning to work and family relationships—the peasants, a man and a woman, in fact seem to be a married couple, and their youth brings to mind the possibility of children. The work exalts, that is, an old-fashioned way of life that had endured right up to the present, projecting it toward the future.

And at the heart of this way of life based on perennial values we see prayer, humble and devout, that inserts men and women in God's grand plan. Millet, who came from the country and loved farm life, in effect practically fuses the couple with the earth they work, in warm evening light that models both the human forms and the clods of soil. Prayer here becomes a space of cosmic communion, illuminating humble folk as sunset gilds the broad horizon.

The two following pages:
39. Jean-François Millet, *The Angelus*, Paris, Musée d'Orsay

Chapter Three

—•—

LITURGICAL PRAYER

At the heart of Christian prayer life is the liturgy, in which—according to Saint Augustine—Christ "prays *for* us as our priest; prays *in* us as our head; is prayed *to* by us as our God."[46] And at the heart of the liturgy is the Eucharistic celebration, or Mass, in which Christ becomes truly present as priest but also as victim and altar. In every holy Mass the faithful listen to his word and partake of his paschal mystery, receiving — if they so wish—his body and blood.

An anonymous Bolognese painting of the seventeenth century, executed for a country parish near the city, can suggest the importance of the Mass as prayer in the life of Christians (**fig. 40**). It represents an episode of the life of a Spanish saint, Isidore the Farmer, who lived between the eleventh and twelfth centuries but was canonized only in 1622. According to tradition, Isidore usually prepared for work by attending morning Mass, and, when criticized for preferring this act of piety to the tilling of his fields, won the admiration even of his detractors because at the very hour when he went to Mass an angel was seen doing Isidore's farm work in his place. That is what we see in the work reproduced here: in the foreground, a priest elevates the host after the consecration and Isidore, kneeling behind the priest on the first step of the altar, crosses his hands on his chest and turns an ecstatic gaze toward Christ present in the bread; meanwhile,

40. A Carracci school painter, *Saint Isidore the Farmer*, Rubizzano di San Pietro in Casale (BO), Santi Simone e Giuda

through a broad window an angel is seen taking the saint's place behind the team of oxen.

Despite its modest artistic quality, this painting provides a number of precious hints for the present chapter. The first of these clearly regards the choice of subject matter for the altar of a country church: a farmer saint able to give farmers of that area the good example of faithful fulfillment of the obligation to attend Mass on Sundays and holy days, without worrying about the demands of their work. Equally significant is the date of the work, probably a few years after Isidore's canonization in 1622: in the late sixteenth and in the seventeenth century the Church reiterated its faith both in the Eucharist as the real, corporeal presence of Christ and in the Mass as a true representation of the sacrifice of the Cross; thus it is no accident that the painting underlines the adoration of priest and people and shows the host raised level with the gold cross on the altar. The artist's emphasis on the accurate depiction of liturgical objects and vestments—of the crucifix and candlesticks, the missal and Mass cards, the chalice and paten, the priest's alb, chasuble, stole, and maniple—reflects the ritualism of seventeenth-century Catholic spirituality, developed in response to the radical simplification of the liturgy in Protestant churches.

Yet our painting offers still other and more important insights. It tells of a Spanish peasant for whom daily Mass was possible and indeed normal and presents as pertinent in the seventeenth century events going back almost seven hundred years. In this way, the image makes clear that devout participation at Mass is a universal form of prayer that touches the life of even the simplest members of the Church, and that it has been so for a very long time: not only since the time of Saint Isidore, the eleventh century, but if we recall the daily Mass during which Saint Anthony of Alexandria recognized his vocation (see chapter 1, fig. 14), from at least the third century! Indeed, one can unhesitatingly affirm

that in the life of the Church the Eucharistic liturgy has been the chief form of official public prayer for almost two thousand years, without interruptions or alterations.

Without alterations. Early Christian communities met in private houses to celebrate the rite of thanks to God later known as the Eucharist, and they did so in a ritual form already codified in the mid-first century (**fig. 41**). To the Corinthians, among whom he had preached in the years 50–52, Saint Paul would in fact give a series of behavioral rules for the gatherings in which they celebrated "the Lord's supper," commanding them to continue using the formulation he had taught them, and which he legitimated by affirming: "This is what I received from the Lord and in turn passed on to you: that on the same night that he was betrayed, the Lord Jesus took some bread, and thanked God for it, and broke it, and he said, 'This is my body, which is for you; do this as a memorial of me.' In the same way he took the cup after supper and said, 'This cup is the new covenant in my blood. Whenever you drink it, do this as a memorial of me.' Until the Lord comes, therefore, every time you eat this bread and drink this cup you are proclaiming his death" (1 Cor. 11:23–26).

This is the most ancient formulation of Jesus's words at the Last Supper, and such is Saint Paul's insistence that it be repeated exactly "every time" Christians celebrate the Eucharist that, if it was not already in use at Rome before he arrived, it is reasonable to suppose the apostle introduced it during the years he lived in the imperial capital. Thus it is not surprising that one of the earliest source texts of Christian liturgical history is of Roman origin: toward the end of the first century the Roman Church intervened in an internal dispute of the sister Church of Corinth with a letter (attributed to the then bishop of Rome, Saint Clement) in which the need to find a peaceful solution to ecclesial problems is presented in language allusive to the Eucharist, as a return to "communion."[47]

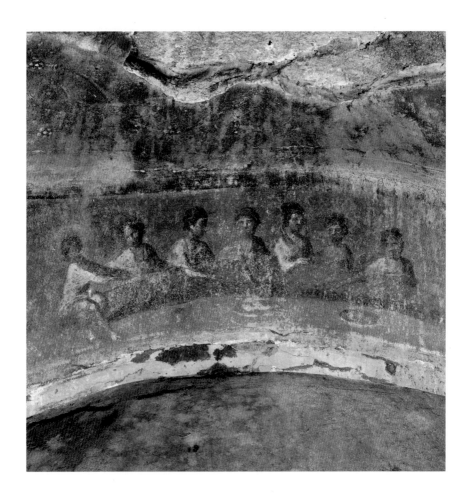

41. *Fractio Panis*, third century, Rome, Catacomb of Priscilla, "Greek Chapel"

This Letter of Clement of Rome, developing the idea of a divine order comparable to what we see in human institutions such as the army, describes a Church structured hierarchically on the model of the ancient people of Israel and with rites that perfect those mentioned in the Old Testament. The sacred authority of priests who celebrate the liturgy is underlined, and that of the bishop is conceived as an expression of the governance of the universe exercised by the Creator, who is explicitly called "bishop." This text has extraordinary interest not only for the institutional development it documents in the Roman Church of the time, but also for its identification of the structure of ecclesial authority with the liturgy; the concluding chapters of the Letter seem to constitute a long Eucharistic prayer.

Some sixty years later, but once again Roman in origin, is the first description of the Christian Sunday liturgy. The author, Justin Martyr, was a Greek born at Nablus in Palestine—a pagan scholar and teacher of philosophy who had converted to Christianity. Around the year 150 he transferred to Rome and, five years later, wrote a *Prima apologia* for Christian life and ritual practice in which, in chapters 65–67, he describes the Eucharistic liturgy. He says that bread and wine mixed with water are brought to the one presiding over the rite, who offers prayers of praise, thanking the Father in the name of the Son and of the Holy Spirit. When he speaks of "a long thanksgiving to the Father who has made us worthy of these gifts," does Justin have in mind the prayer contained in the final chapters of the Letter of Clement of Rome fifty years earlier? It seems possible. In any case, after the thanks offered by the presider of the assembly, all say "Amen," and the deacons distribute the bread and wine blessed in this way to those present, bringing some to the absent brethren as well.[48]

Justin articulates an extraordinarily developed Eucharistic theology. He states that this food called "Eucharist" is not received

by Christians as ordinary nourishment, but "we are taught that, just as Jesus Christ our Savior became incarnate by God's word and took flesh for our salvation, so too, through the words of prayer that come from Christ, the food over which thanks have been said becomes the body and blood of the incarnate Christ, to nourish and transform our flesh and blood."[49] Openly mentioning "the memoirs composed by the apostles which we call 'Gospels,'" Justin then recalls the words Jesus pronounced on the bread and wine at the supper: "Do this in memory of me, this is my body . . ., this is my blood." Finally he says that "from that time onward, among ourselves we continually remember these events and, if we have material goods, help those who are in need, remaining forever united."

The role of tradition is evident in the phrases "we are taught," "from that time onward," and "we continually remember these events." Justin then describes how "on the day dedicated to the Sun [that is, Sunday], all who live in the city and in the neighboring countryside come together in the same place. There the memoirs of the apostles or the writings of the prophets are read for as much time as may be available. Then, when the reader has finished, the presider speaks, admonishing and exhorting all to imitate those noble deeds." Then bread and wine are brought, over which the presider pronounces the words of consecration and everyone receives the Eucharist, after which the wealthy, if they wish, make donations that the presider of the assembly uses to help orphans and widows, the sick and needy, prisoners, and foreigners passing through.[50]

The last stage of this precocious articulation of the liturgy at Rome is a text of the early third century, the *Traditio apostolica* written by Hippolytus, a learned priest of the capital. It develops more fully various aspects indicated above, furnishing a number of verbal formulas that still echo in Christian ritual practice. And

as its title suggests, Hippolytus's work presents itself as the con-
tinuation of customs passed down from the times of the apostles
themselves.[51]

REMOTE PAST AND DISTANT FUTURE

As the Church understands it, the Eucharistic liturgy belongs
not only to the present but to the remote past and distant future
as well. Foreshadowed in the primordial sacrifices narrated in the
Old Testament, it will assume its definitive form in the grandiose
heavenly liturgy described in the book of Revelation, and since
the fifth and sixth centuries Christian art in fact associates the
Mass with these two temporal poles. In the church of San Vitale at
Ravenna, for example, mosaics illustrating Old Testament events,
at right and left of the altar, connect the sixth-century believer's
"present" with the "past" described in the book of Genesis: on
one side Abraham's encounter with three mysterious travelers at
Mamre (when the birth of Isaac was promised) and the sacrifice
of Isaac on Mount Moriah; and on the opposite side, united in a
single scene, the sacrifices, respectively, of Abel and of Melchizedek
(**fig. 42**). Thanks to these scenes, the liturgy actually celebrated at
the altar is revealed as a continuation in the present of a remote
past in which the offerings of certain men were pleasing to God,
who—in the context of liturgical sacrifice—blesses and gives life.

Abraham, who, serving God at table at Mamre, received the
promise of a son, and who, when he was about to offer his son
on an altar, heard God say: "Because you have done this . . . I
will shower blessings on you" (Gen. 22:16b–17a); Abel, who,
offering a lamb became a figure of the Church that offers the
Lamb Christ; and Melchizedek, who offered bread and wine: all
three personages and the events regarding them foreshadow the
Eucharist. Thus it is no accident that in both mosaics we see tables

42. *The Sacrifice of Abram and Melchisedek*, sixth century, Ravenna, San Vitale

that look like Eucharistic altars: the table at Mamre with three circular pieces of bread signed with the cross, and the splendidly adorned altar at which Melchizedek practically "sings Mass," with a big host and a chalice. It is moreover significant that, in this period when the rites of the Church reached maturity and many liturgical texts assumed definitive form, the mosaics present precisely those personages remembered in one of the most ancient Mass texts, the so-called Roman Canon, in which the Church asks the Father to act in the present as he has in the past and to "look with favor on these offerings and accept them as once you accepted the gifts of your servant Abel, the sacrifice of Abraham, our father in faith, and the bread and wine offered by your priest Melchizedek."[52] This request to God—to behave in the present as he has in the past—is made in the name of One who is "the same today as he was yesterday and as he will be forever" (Heb. 13:8), Jesus Christ: the phrases just quoted in fact immediately follow the affirmation that "we, your people and your ministers . . . offer to you, God of glory and majesty, this holy and perfect sacrifice: the bread of life and the cup of salvation." Thus the Roman Canon situates both the ancient sacrifices and those made in the present in relation to Christ, the "holy and perfect sacrifice," suggesting an uninterrupted continuity of prayer from the dawn of history to the present moment.

Together with its primordial starting point, the Mass has an eschatological destination, inserting believers in the liturgy described in the last book of the New Testament, called Revelation and the Apocalypse. Celebrated for all eternity in heaven, that liturgy is the subject of a famous painting: the enormous altarpiece executed for the Cathedral of Ghent by the Van Eyck brothers, where—in the panel set directly on the altar in front of the celebrant—saints of all times and places gather around an altar on which the Lamb of God pours blood from his side into a chalice,

while to right and left adoring angels perfume him with incense (**fig. 43**). This image translates the vision in which the author of the Apocalypse contemplated "Mount Zion, and standing on it a Lamb who had with him a hundred and forty-four thousand people, all with his name and his father's name written on their foreheads . . . they were singing a new hymn . . . that could only be learned by the hundred and forty-four thousand who had been redeemed from the world" (Rev. 14:1–3). It is a true liturgy, and in an earlier chapter the author of this text describes several of its ritual features: how four animals that he saw in heaven, together with twenty-four elders, "prostrated themselves" before the Lamb, and "each one of them was holding a harp and had a golden bowl full of incense made of the prayers of the saints." Addressing the Lamb Christ, they sang a new hymn, affirming that "because you were sacrificed and with your blood you bought men for God of every race, language, people, and nation and made of them a line of kings and priests" (Rev. 5:8–10). In the vision that the author of the Apocalypse beheld, alongside the saints there were moreover angels—"ten thousand times ten thousand of them and thousands upon thousands"—who cried out: "The Lamb that was sacrificed is worthy to be given power, riches, wisdom, strength, honor, glory, and blessing"; and shouting with the angels were "all the living things in creation—everything that lives in the air, on the ground, and under the ground, and in the sea"—and which in similar fashion praised God the Father and Christ the Lamb (Rev. 5:11–13).

Now, every single Mass—even Mass celebrated in a remote country church like that of Saint Isidore in figure 40—unfolds between these two temporal poles, uniting those come together to pray with both the beginning and the end of salvation history—with the patriarchs and saints, and with the angels and all of natural creation. Every holy Mass sunders the veil of time to

reveal him who exists since before time began and to whom time is in fact ordered, Christ, the definitive high priest foreshadowed in the service of the ancient Jewish priesthood. His "life on earth," as we have seen, is presented as the unceasing offering of "prayers and supplications, with a strong cry and tears" (Heb. 5:7), and the place where this 'liturgy' coextensive with the life of the priest was celebrated is not thought of as an earthly sanctuary like the Tent of Exodus or the Jerusalem Temple, or even as a church in which the Christian community celebrates—but rather as "the greater, the more perfect tent, which is better than the one made by men's hands because it is not of this created order" (Heb. 9:11), in which Christ himself, "the high priest of all the blessings which were to come . . . has entered the sanctuary once and for all, taking with him not the blood of goats and bull calves, but his own blood, having won an eternal redemption for us" (Heb. 9:11–12).

The visionary liminality that every holy Mass communicates is suggested in a painted panel conserved in the Vatican Museums—the back support of an abbot's or episcopal throne—where, at the center, we see the risen Christ celebrating Mass behind an altar on which a cross stands (**fig. 44**). The nudity of this "priest" and his prayer posture (arms spread and raised: the posture of a priest saying Mass) translate the bodily sacrifice of Calvary into ritual terms; a second representation just above this "priest-victim" shows Christ in glory, thus translating another passage of the Letter to the Hebrews, where the text affirms that Christ endured the cross "for the sake of the joy that was still in the future . . . disregarding the shamefulness of it, and from now on has taken his place at the right of God's throne" (Heb. 12:2).

In the right hand of the glorious Christ depicted in this panel we see the orb of his power, and on the orb the words: *Ecce vici mundum* (Behold, I have conquered the world) (John 16:33c). Whereas the cross he holds in his left hand is gold, this orb is

43. Jan and Hubert Van Eyck, *Adoration of the Mystic Lamb*, Ghent, Cathedral of Saint Bavo, detai

44. Johannes et Nicolaus, painted back of an abbatial throne, eleventh century, Vatican City, Vatican Museum, detai

white, with the result that—seen above the priestly figure at the altar—it looks like the consecrated host—and in fact the humble bread that becomes the Savior's body is also a sign of his victory over the world of matter; here it is Christ himself who holds up the sign, as if offering the sacrament of his victorious body to be adored by the faithful. In the later Middle Ages the Church would in fact elaborate the liturgical rite of adoration of the consecrated host, discussed in our sixth chapter, "Contemplative Prayer," but here already we are reminded that Christians have always recognized the sense of their new identity in the Eucharistic bread. As Saint Paul said, "The fact that there is only one loaf means that, though there are many of us, we form a single body because we all have a share in this one loaf" (1 Cor. 10:17). This is perhaps also the sense of the invitation that Saint Peter Chrysologus imagined Christ extending to believers: "Behold—behold *in me*—your body, your limbs, your heart, your blood. And if you fear that which is God's, why not love at least what is your own? If you flee from the overlord, why not seek out your own kinsman?"[53] Moved by this idea, Chrysologus then exclaims:

> Oh, the immense dignity of the Christian priesthood! Man has become victim and priest for himself. He does not seek outside himself that which he should immolate to God, but carries his sacrifice in his own person. [And the saint exhorts:] O man, be yourself both the sacrifice and the priest . . .; make your heart an altar, and thus with full confidence present your body as a sacrifice to God. God seeks your faith, not your death; he is thirsty for your prayer, not your blood. He is placated by your free will, not by your death.[54]

An unusual sixteenth-century Italian image meditates on these themes: the Holy Trinity altarpiece painted by Gasparo Narvesa

for the main altar of a church dedicated to the Trinity in the artist's native city, Pordenone, commissioned by a confraternity also dedicated to the triune God (**fig. 45**). In the lower part of the picture—and thus just above the table of the altar on which the work stood—we see a kneeling priest vested for Mass holding a consecrated host, as if he had interrupted the celebration of the rite to give himself to pure adoration. Around him, also kneeling in adoration, are the members of the confraternity in their red habits and with their banner and processional candles.

When Mass was still said before this altarpiece for the confraternity brothers, at the elevation of the host a double image took shape: a real celebrant at the real altar before real worshipers in the real church, and then the same persons—confraternity members and priest—*shown in adoration in the painting!* The whole lower part of the altarpiece in effect "photographs" the prayerful absorption of the priest and confraternity members before the Eucharistic Christ, making manifest their Catholic faith in the Savior's "real presence." Moreover, the painting was executed in *1611*, barely fifty years after the Council of Trent, and *at Pordenone,* in a northern Italy then concerned to fight the advance of Protestantism, with its so different interpretation of the Eucharist.

Despite their attitude of adoration, the priest and a number of the brothers do not look at the host but rather raise their eyes to heaven, where they see Christ nailed to the cross and presented by angels to his Father; the suffering face of the Son is turned toward the compassionate gaze of the Father and their eyes meet, while just above their heads the Holy Spirit hovers in the form of a dove. It is in fact at this second level of the composition that the painting's true message becomes clear: not only the Eucharistic faith of

45. Gasparo Narvesa, *The Holy Trinity, Mary in glory, the Expulsion of the Demons and the Adoration of the Eucharist*, Pordenone, Museo Civico

the confraternity members, but the Mass celebrated at the altar in their church as the earthly expression of a heavenly liturgy in which the Son's crucified body is eternally offered to the Father as a pleasing sacrifice. The specifically *sacrificial* character of Christ's offering of himself (and thus also of the Mass, which makes the contents of this offering present in the bread and wine) is emphasized by the priestly cope that the Father wears.

The obvious timeliness of this doctrinal emphasis—of this presentation of the Eucharist as a sacrifice, that is, in a period when many contested that definition—is not however the main novelty of this altarpiece. Genuinely new here is the intense interpersonal relationship between the Son and his Father above the host held by the priest in the lower part of the painting (originally seen above the host and chalice elevated by a real priest saying Mass before the image). In an era when Protestantism branded the Catholic Mass mere spectacle, and Catholicism, reacting to that accusation, risked theological and liturgical reification of the Eucharist, Gasparo Narvesa presents the host adored by the confraternity members as the real presence of a drama deeply felt by two Persons. The components of this drama are the obedience of the Son, who had prayed that the cup of suffering be removed from him, accepting however to do the Father's will (Lk. 22:42); and the love of the same Father, who to save humankind refused the grace his Son begged of him. Saint Paul explains the Father's refusal, saying that the God who had spared Isaac, the son of Abraham, "did not spare his own Son, but gave him up to benefit us all" (Rom. 8:32), and the fourth Gospel specifies that "God loved the world so much that he gave his only Son, so that everyone who believes in him may not be lost but may have eternal life" (John 3:16). It is surely not an accident that Narvesa shows the Father holding a large crystal globe, as if he

were saying to his Son: "I ask you to accept death so that the world I created and love may live!"

Thus the Eucharist, the evident subject of the altarpiece, is revealed as a "place of prayer" not only for Christians, but for Christ himself and even for the Father—a place of profound, often difficult communion. The priest in the lower part of the picture and the brothers who lift their eyes understand that the Eucharist contains the whole mystery of God: of the Father who asks his Son to give his life; of the Son who does so; and of the Spirit who unites them and who, in the painting, is the visible form of their communion.

The Spirit. At the Mass once celebrated before this altarpiece, the Spirit seemed to descend not only upon the offerings—upon the bread and wine—but also on those who made the offerings—on the celebrant and on the confraternity brothers, that is; the raised eyes and attitudes of prayer of many of the men in the lower part of the composition refer to this: to their expectation of the effusion of the Spirit. The full meaning of the image thus has to do with the Mass as the main Christian place of prayer, since in the Mass the Spirit descends, and—as Saint Paul teaches—"the Spirit . . . comes to help us in our weakness. For when we cannot choose words in order to pray properly, the Spirit himself expresses our plea in a way that could never be put into words; and God who knows everything in our hearts knows perfectly well what he means, and that the pleas of the saints expressed by the Spirit are according to the mind of God" (Rom. 8:26–27). In the Mass, the Spirit teaches us to be of the same mind as Jesus Christ (Phil. 2:5), and, in fact, descending upon the bread and wine to make them body and blood of Christ, the Spirit descends also on all who eat and drink of Christ, in order to make them *like Christ*—to make them able to live the same communion with the Father that he lives: a communion of prayer in which the Father asks certain things of us, and we ask other things of him,

accepting however (as Christ accepted) to do not our own will but that of God. Such prayer is authentic and sure, the prayer of which Jesus said: "Ask, and it will be given to you; search, and you will find; knock, and the door will be opened to you. For the one who asks always receives; the one who searches always finds; the one who knocks will always have the door opened to him" (Matt. 7:7–8). Anyone who asks to become like Christ will receive that grace; anyone who seeks Christ will find him; anyone who knocks at the door which Christ *is* will find the way to the Father open.

The uppermost level of Gasparo Narvesa's painting expresses the same idea of prayer. It shows Mary, at the viewer's left, kneeling before a Trinity of ghostly figures, while on the right the Archangel Michael uses his drawn sword to expel demons from heaven. The scriptural source seems to be the twelfth chapter of the Apocalypse, in which the author, John, sees a pregnant woman in labor, crying aloud in the pangs of childbirth; he also sees a dragon that threatens to devour the baby as soon as the woman gives birth. When the baby, a male child, was born, he "was taken straight up to God and to his throne," while the woman escaped into the desert, where God had made a place of safety ready. "And now war broke out in heaven, when Michael with his angels attacked the dragon. The dragon fought back with his angels, but they were defeated and driven out of heaven" (see Rev. 12:1–8).

In the painting we see the woman, in the place of safety prepared for her, as she adores God the Father, God the Son, and God the Spirit; we see the victory of Michael and his angels over the dragon and his followers; and we see the woman's Son, Jesus Christ, "taken straight up to God and to his throne" (face to face with the Father in the obedience of the Cross), while, below the Son's crucified body, grouped around the host that encloses this cosmic drama, are the sharers in his victory described in the Apocalypse: "Victory and power and empire forever have been won by our God and all

authority for his Christ, now that the persecutor, who accused our brothers day and night before our God, has been brought down. They [the accused brothers] have triumphed over him by the blood of the Lamb" (Rev. 12:10–11a). The confraternity brothers, that is—who in the Mass share both Christ's struggle and his victory—in the mystery of the communion of saints are also associated with the victory of the martyrs; in fact, the altar on which this painting stood would have contained relics of martyrs of the early Christian centuries.

TIME AND MATTER

In the liturgy, believers are simultaneously *outside* and *inside* of time: while they seek the testimony of the past and a hope for the future, in reality they walk in the present. And prayer, which in the Eucharist frees them from time's limit, in the other sacraments gives value to the specific "times" of human life: to infancy and the beginnings of personal faith (baptism and confirmation); to adult commitments (matrimony and holy orders); to old age and death (the anointing of the sick, or extreme unction). Even the weakness that marks every season of human life receives light from Christ's paschal mystery (the sacrament of reconciliation, or confession).

The rites of the liturgy build a kind of house around Christians, as a southern Italian miniature suggests: an image in a manuscript roll used at the Easter Vigil for singing the Exultet, the hymn that accompanies the blessing of the paschal candle (**fig. 46**).[55] As in other manuscript rolls with this function, the images are upside-down in relation to the text, so that—as the deacon read from the high pulpit—the parchment that unrolled before the eyes of the faithful allowed them to see images that gave the sense of the text. In this case, within the inverted *V* of the phrase *Vere dignum et justum est* is a majestic figure of Christ, below which

appears the Father's hand sending the Spirit on a baptismal font at the moment when the bishop blesses the water that will be used to baptize; on the other side of the font a deacon holds the paschal candle symbolizing the risen Christ. The inverted *V* becomes a kind of dome, so that the "house" of which we spoke is revealed as a temple inside which the community lives *in Christo*, experiencing both the Father's intervention and the sanctification given by the Spirit *in Christ*—in the mystery of his death and resurrection, that is, to which the water of the font and the lit candle allude.

"The candle." Through the use of material things whose function is part of daily life—a bit of bread and wine, water, a candle—the liturgy unites the experience of life in the present to the past and future, consecrating to Christ not only the single seasons of existence with their particular aspirations, but all of time and all of life. In the nocturnal celebration illustrated in the miniature, for example, the candle is blessed with the words: "Christ yesterday and today, the beginning and the end, Alpha and Omega; all time belongs to him and all the ages." This "belonging" of time to the Savior is explained then in the Exultet, sung after the candle is lit (**fig. 47**), when the deacon, addressing himself to God, affirms: "This is the night when first you saved our fathers: you freed the people of Israel from their slavery and led them dry-shod through the sea. This is the night when the pillar of fire destroyed the darkness of sin!" In practice, the deacon invites those who take part in the rite to believe that the same salvation realized in the past for the people of Israel is being realized here and now, in the Christian Easter Vigil. "This is the night when Christians everywhere, washed clean of sin and freed from all defilement, are restored to grace and grow together in holiness," he continues. "This is the night when

46. *Christ in Glory Above a Baptismal Font*, Blessing Roll, eleventh century, Bari, Museo diocesano

Extritur ex matre ecclesia eterni luminis adornatur
fulgoribus. Et magnis populorum uocibus hec eu lo
iubilatur.

Jesus Christ broke the chains of death and rose triumphant from the grave." The night of Israel's exodus from Egypt, the night of Jesus's resurrection from the sepulcher, and the night in which a given Christian community celebrates Easter become, in these words sung by the deacon, a single moment in time stretching out to eternity. The Exultet hymn concludes with the prayer: "Therefore, heavenly Father, in the joy of this night receive our evening sacrifice of praise, your Church's solemn offering. Accept this Easter candle . . . let it mingle with the lights of heaven and continue bravely burning to dispel the darkness of this night! May the Morning Star that never sets find this flame still burning: Christ, the Morning Star who came back from the dead and shed his peaceful light on all mankind, your Son who lives and reigns forever and ever. Amen."

The capacity of the liturgy to bridge the distance between past and future while remaining rooted in the present is underlined, in this case, by the specific object of the prayer: the lit paschal candle, which at one and the same time is the "pillar of fire" of the Exodus, the "new star" in the firmament of the Parousia, and the functional illumination in the dark of a church where the rite is celebrated. It is never a question of merely symbolic light, for the text recalls the work of the bees and "the wax which the queen bee produced to feed this precious lamp," and in medieval versions of this hymn the reference to the bees was considerably more detailed. Indeed, a typical medieval edition of the Exultet adds what sounds like a treatise on beekeeping, specifying that *Apis ceteris, quae subiecta sunt homini animantibus antecellit . . .* (The bee is above all other living creatures subject to man. While small in size, it nurtures high projects in its little breast; it is physically weak but mentally strong. Sensing the change of the seasons, when cold

47. The *Lighting of the Paschal Candle* and *Fratres carissimi, Exultet* Roll from
Montecassino, c. 1060–1070, Vatican Library, Vat. Lat. 3784

winter begins to thaw and spring's more moderate climate sweeps away ice-bound torpor, the bee immediately feels the urge to set to work; and throughout the countryside, lightly moving their wings, bees light for a moment with delicate extremities to gather with their mouths the small flowers of the field, and then, full of this food, return to their hives, where some of them, with inestimable skill, build little cells of a sticky glutinous substance, while others fill them with fluid honey, others transmute the flowers in wax, and still others shape their young, licking them with their mouths, and others store the nectar from the gathered leaves.")[56]

A thirteenth-century synthesis of this passage, added in Italian to an Exultet roll of the eleventh century, suggests the perennial appeal of this reference to the bees in the solemn *benedictio cerei* (blessing of candles on Holy Saturday); written in a calligraphy easily distinguishable from that of the eleventh century, the gloss informs readers that "in this part are described the bees, who feed and gather and make offspring and honey, for—notwithstanding their small body size—their work and training offer an excellent example, in which, as the weather changes with the passing of the season of the snows, for their nourishment the bees gather a food that generates wax, from the which pure substance, the holy pillar of God that is the candle, can be made."[57]

AT THE SOURCE OF THE LONGEST RIVER

Not only the "things" exterior to man, but also and above all his inner "things"—his hopes and disappointments, joys and sorrows—are woven into the Church's liturgical prayer. Moving proof of this interweaving is provided by Luca della Robbia's choir gallery, done for the Cathedral of Florence in the fourth decade of the fifteenth century (**fig. 48**). The iconographic program of this *cantoria* meant to hold an organ and a group of young singers is

developed in four carved reliefs on each of two levels, plus another two at the sides, all illustrating the letter and the spirit of Psalm 150, the text of which appears in a running inscription. The choice of this joyful text, which describes a concert of praise in the Jerusalem temple, was made in the celebrative climate of the years in which Brunelleschi's dome was coming to completion, and with it the whole cathedral project: the iconography of the cantoria equates the new *duomo* built by the Florentines with the famed "house of prayer" built by David's son, Solomon. The use of this text also underlined the remarkable continuity between the prayer of the Church and that of Israel: Psalm 150 in fact concludes the collection of liturgical hymns of the chosen people still used in the Catholic Divine Office, the liturgy of the hours sung by the clergy of the Florence Cathedral right down to the present day.

Surprising in this program is the decision to interpret the psalm using figures of children, shown in the various musical expressions to which the text refers. The more than fifty babies and adolescents carved in relief, represented by Luca della Robbia with extraordinary attention to the physiological and psychological nuances of their different ages, comprise a unique picture gallery of infancy and adolescence—a celebration of the human body and personality in the early stages of life without equal in ancient or medieval art; in their grave joy, these young singers incarnate the spirit of the early Renaissance.

In the fifteenth century they probably communicated another meaning as well. In an age of frequent infant and child mortality, these babies and adolescents seen above the main altar of the cathedral (the *cantoria* was made for a

The two following pages:

48. Luca della Robbia, Cantoria, Florence, Museo dell'Opera del Duomo, reconstruction with casts of the reliefs

LAVDATE DNM IN SCIS EI LAVDATE EVM IN FIRMAMENTO VIRTVTIS EI

LAVDATE EVM IN SONO TVBAE · LAVDATE EVM IN

ET CHORO · LA EV IN CORDIS ET ORGANO LA EV IN CIMBA

RTVTIBVS EÍ · PÆV SECVNDVM MVLTITVDINEM MAGNITVDINIS EIVS

ERIO ET CYTHARA · LAVDATE EVM · IN · TIMPANO

NATIBVS · PÆV IN CIMBALIS IVBILATIONIS OIS SPS LAVDET DNM

raised position in the liturgical space of the church) would have caught the gaze of those in the assembly who had lost children, presenting the joy of heaven as the harmony of a youthful choir singing ancient hymns to a Father who, like many human fathers and mothers, had also lost his Son.

At first glance, this interpretation may strike readers as sentimental and anachronistic, better suited to the nineteenth than to the fifteenth century. But in at least one case contemporary with the cantoria we know of both the suffering of a father who had lost a young son and the consolation that the man found in his faith. I refer to the events described by the Florentine humanist Giannozzo Manetti in his *Consolatory Dialogue for the Death of a Son,* written first in Latin and then in an Italian version.[58] The text recounts how, in the spring of 1438, Manetti had unexpectedly lost his son Antonio, at barely four years of age. Overwhelmed with grief, the father shut himself up in his villa on the slopes of Mount Fatucchi in the Val d'Ema, hoping to find consolation in reading the ancient classics. As a humanist he knew that, in the order of nature, *sunt lacrimae rerum, et mentes mortalia tangunt* (sad things happen in life, and must be borne). And as a Christian he must have believed that the child had gone to a better life. Yet Manetti suffered all the same and asked himself whether the weight of grief he felt was a natural reaction, and therefore unavoidable—an "evil of nature," as he put it—or the fruit of an affective disorder, a "moral evil." He was ashamed of the depth of his own grief.

Some friends then invited him to abandon "that solitude which augments and feeds the soul's passions" and to join them at the nearby Charterhouse of Galuzzo. When Manetti arrived, the small group of gentlemen began to stroll "among the pines and cypresses with which the cloisters were adorned," finally sitting

"in the high shade of these pines and cypresses in a beautiful broad meadow." They discussed "how and in what spirit one should, without either offending God or doing violence to human nature, bear the suffering that fathers normally feel at the death of beloved children, which are the fairest and happiest mortal possession which one may have," as the *Dialogue* specifies. His friends adduced ancient examples from the writings of the Stoics but did not succeed in restoring peace to Manetti's soul.

Finally these Christian humanists and *literati* summoned the prior of the Charterhouse, Don Niccolò of Cortona, who spoke to them of the human sentiments of the saints, giving the example of Saint Augustine, who wept for the death of his out-of-wedlock son Adeodatus, and recalling Jesus's grief before the sepulcher of his friend Lazarus. According to Don Niccolò, the Lord allowed his affliction to be seen so that "men, seeing his emotion, might understand that to be moved by the loss of someone near to us is part of our nature, not to mention the burning grief we feel for the loss of children, our love and affection for whom knows no bounds. And neither the greatest men of the past, nor even Christ himself could contain their feelings or avoid being moved by this natural grief at the loss of dear ones and especially of small children."

This discussion took place on April 11, which was Good Friday in that year of 1438. Manetti's friends had gone to the charterhouse precisely to spend Holy Week in a religious context, taking part in the monks' liturgy, and the grieving humanist recounts that, at his arrival, he found them "in the consecrated church of that holy place . . . devoutly listening to the solemn prayers for the annual commemoration of the Holy Day"—the day, that is, when all Christians remember the death of another well-beloved Son. The liturgical chants, the psalms, and readings of Good Friday must in fact have helped shape the conclusion that Manetti finally reached,

his realization that—in the face of certain dolorous events—"we are not made of stone."

It is at this point I wanted to arrive, at this confluence of diverse realities: a humanly sensitive moment conditioned by the divine moment—Good Friday—and illuminated by the "solemn prayers" of the liturgy. The humanist and his friends, conversing like philosophers in the "spacious meadow" of the monastery, did not base their arguments on reason alone but, through a tradition of faith, sought the deeper rationale of experience. And at the end of their research they had an intuition that illuminated, an interior synthesis that may seem absurdly obvious to those who do not suffer: it is permissible to weep for a deceased child because *we are not made of stone.*

Liturgical prayer, which builds a bridge between past and future remaining in the present, transmits from the past a humanity straining forward toward fulfillment and yet able to accommodate today's joys and sorrows. "We are not made of stone": how obvious! But obvious because true, and, as every adult knows, it is often difficult to grasp obvious truths. Joys and sorrows require time, have to be understood in the light both of past and future— indeed, to fully understand them one needs a whole lifetime. Yet the final synthesis will always be simple, for as the great twentieth-century Christian poet T. S. Eliot wrote: "We shall not cease from exploration / And the end of all our exploring / Will be to arrive where we started / And know the place for the first time. / Through the unknown, remembered gate / When the last of earth left to discover / Is that which was the beginning; / At the source of the longest river / The voice of the hidden waterfall / And the children in the apple-tree / Not known, because not looked for / But heard, half heard, in the stillness / Between two waves of the sea. / Quick now, here, now, always— / A condition of complete simplicity / (Costing not less than everything)."[59]

"GOD, YOUR PROCESSION CAN BE SEEN"

In great liturgical celebrations, individual lives receive light from collective faith, and joys and sorrows that, taken singly, seem futile acquire dignity and the weight of universal experience. Obviously that is true not only of Christianity but of every religious culture known to history; one sees it clearly in Athenian sculpture of the fifth century before Christ, where the idealized naturalism of Phidias celebrates the Greek victory over the Persians (**fig. 49**), and in the mosaics of Ravenna a thousand years later, where Byzantine impassivity celebrates the victory of Christianity over paganism (**fig. 50**). Among the masterpieces of every ancient culture there are images of liturgical processions expressing a collective ethos and a social order based on humans' relationship with their gods. "Happy the people who learn to acclaim you! O LORD, they will live in the light of your favor" (Ps. 89[88]:15), said the psalmist. Another psalm of Israel describes a liturgical cortege: "God, your procession can be seen, my God's, my King's, procession to the sanctuary, with cantors marching in front, musicians behind, and between them maidens playing tambourines. 'Bless God in your choirs, bless the LORD, you who spring from Israel!' Benjamin, the youngest, is there in the lead, the princes of Judah in brocaded robes, the princes of Zebulun, the princes of Naphtali" (Ps. 68[67]:24–27).

Similar ritual events, in which a people's deep identity appears and communicates itself, give meaning to places of worship, and this explains why both the Athenian relief and the Ravenna mosaic reproduced here were ideated for temples: the relief is a part of the frieze that once adorned the Parthenon and which evoked the annual procession on the goddess's annual festival; and the parade of female martyrs (with, facing it, an analogous male parade) is situated above the nave arcade of the church of Sant'Apollinare Nuovo, where it mirrors the procession of living men and women

49. *Procession of the Maidens,* fragment of the Parthenon frieze, fifth century BC, Paris, Louvre, detail

50. *Procession of Woman Martyrs*, mosaic, sixth century, Ravenna, Sant'Apollinare Nuovo

51. Gentile Bellini, *Procession in the Piazza San Marco*, Venice, Gallerie dell'Accademia

at the offertory of the Mass. In Israel too the ritual of public procession was conceived as an occasion to manifest and transmit collective identity, as a biblical invitation to march around Jerusalem suggests: "Go through Zion, walk round her, counting her towers, admiring her walls, reviewing her palaces; then tell the next generation that God is here, our God and leader, forever and ever" (Ps. 48[47]:12–14).

One of the best known images of this kind of collective liturgy is *The Procession in Piazza San Marco* painted by Gentile Bellini for a Venetian confraternity, the Scuola di San Giovanni Evangelista (**fig. 51**). Part of a cycle of canvases that narrate the miracles associated with a relic of the holy cross owned by the confraternity—canvases which thus illustrated historical, not ideal, events—Bellini's enormous work (25 feet, or 7.5 meters long) documents the appearance of Piazza San Marco at the end of the fifteenth century, with brick paving, all the basilica's original mosaics, and the Gothic architectural decoration of the monuments gleaming with gold leaf. Even the Porta della Carta, partially visible between the basilica and the Doge's Palace, is enriched with gilding. In the foreground, then, we see the brothers of the confraternity in procession in their white habits, carrying the miraculous cross under a canopy.

At our right of the canopy, a man in red genuflects as the relic passes. This is an allusion to a miracle that had happened in 1444, when the father of a sick child, adoring the cross, obtained his son's recovery. Yet the true subject of this painting, obviously, is the magnificent piazza and the confraternity, the facial features of whose members Bellini, who was himself a brother, accurately reproduces. The same collective and celebratory emphasis we noted in the classical relief and in the Byzantine mosaic is operative here too—to such a degree, indeed, that the episode of the miracle—the formal subject of this work—practically

disappears: the kneeling man is lost in the crowd; we barely notice him, and we do not see his son's healing.

Why would that be? Viewing this work made for the meeting hall of a confraternity and painted by one of its members, it is hard to imagine some kind of indifference to the Christian significance of the miracle. Rather it is a question of emphasis: "miraculous" here is the faith of the brothers and the prayer that flows from it; "wondrous" is the fact that a wealthy and powerful city like Venice adores Christ's cross; "marvelous" is the divine order that, in the liturgy, structures and informs human society. Past and future flow together in the eternal present of ritual, and the brothers of the confraternity make their own the psalmist's words: "This is the day made memorable by the LORD, what immense joy for us" (Ps. 118[117]:24), and on behalf of their fellow citizens they ask: "Please, LORD, please save us! Please, LORD, please give us prosperity!" (Ps. 118[117]:25). And they say to all present, including the man whose son was sick: "Blessings on him who comes in the name of the LORD! We bless you from the house of the LORD. The LORD is God, he smiles on us. With branches in your hands draw up in procession as far as the horns of the altar (Ps. 118[117]:26–27).

Bellini here represents a Western Christian procession organized in the Renaissance fashion. But "liturgical prayer" is not only monastic interiority and military orderliness; it is also lively exultation and joy in the Lord, as a Russian painting of the later nineteenth century suggests (**fig. 52**). "Shout for joy to honor God our strength, shout to acclaim the God of Jacob!", the psalmist exhorts: "Start the music, sound the drum, the melodious lyre, and the harp; sound the new moon trumpet, at the full moon, on our feast day!" (Ps. 81[80]:1–3).

The two following pages:

52. Il'ya Repin, *Religious Procession in the District of Kursk*, Moscow, Tret'yakov Gallery

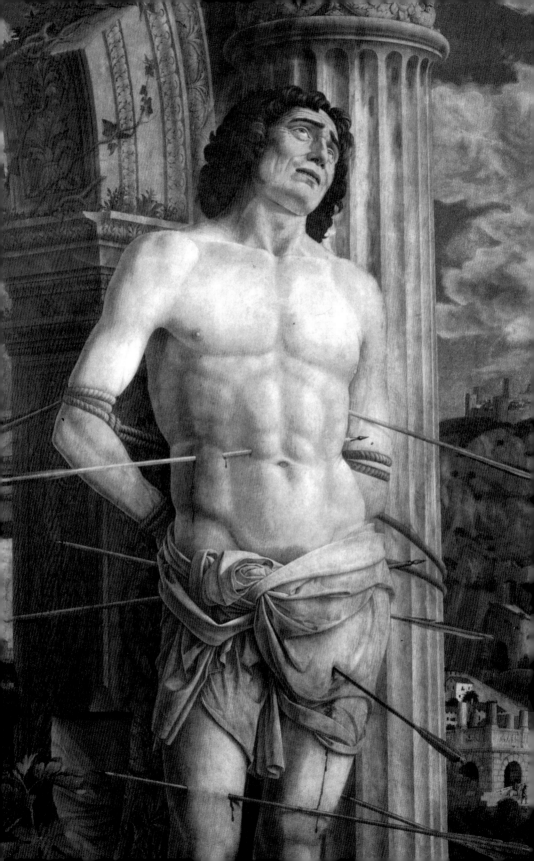

Chapter Four

———•———

THE PRAYER OF PLEADING

The most natural form of prayer is the plea: the spontaneous cry for help that the creature raises to the Creator. Man in fact, as Saint Augustine said, is "God's beggar,"[60] needy in every way, and it is thus no surprise that the most dramatic expressions in the book of Psalms, the Old Testament prayer anthology, convey heartfelt pleas. "Save me, God, the water is already up to my neck. I am sinking in the deepest swamp, there is no foothold; I have stepped into deep water and the waves are washing over me" (Ps. 69[68]:1–2); "I call on God the Most High, on God who has done everything for me: to send from heaven and save me, to check the people harrying me, may God send his faithfulness and love. I am surrounded by lions greedy for human prey, their teeth are spears and arrows, their tongues sharp swords" (Ps. 57[56]:2–4); "Take pity on me, O Lord, I am in trouble now. Grief wastes away my eye, my throat, my inmost parts" (Ps. 31[30]:9). This is the literary tradition that the author of the Letter to the Hebrews had in mind when he affirmed that "during his life on earth, [Christ] offered up prayer and entreaty, aloud and in silent tears, to the one who had the power to save him out of death" (Heb. 5:7a); and when the evangelist Luke, describing Jesus at Gethsemane, said that "in his anguish he prayed even more earnestly, and his sweat fell to the ground like great drops of blood" (Lk. 22:44), he meant to suggest this level of

53. Andrea Mantegna, *Saint Sebastian*, Paris, Louvre, detail

mental agony. We can suppose that the martyrs—Saint Sebastian in the work reproduced in **figure 53**, for example—echoed the plea of the psalmist: "O LORD, hear my prayer, let my cry for help reach you; do not hide your face from me when I am in trouble; bend down to listen to me, when I call, be quick to answer me!" (Ps. 102[101]:2–3).

There is, however, a fundamental difference between the cry for help of the poets of Israel and the pleading of Christians. Where the psalmists usually asked for the punishment of their tormentors— "O LORD, God of revenge, God of revenge, appear! Rise, judge of the world, give the proud their deserts!" (Ps. 94[93]:1–2)—Jesus *prayed for* those who crucified him, saying: "Father, forgive them; they do not know what they are doing" (Lk. 23:34a). This too is pleading prayer—or, rather, it is the Christian face of a single plea for salvation, which must include not only the person offended but the offender as well. This double intention characterized the first martyr for Christ, Saint Stephen, who, as his enemies stoned him, "said in invocation, 'Lord Jesus, receive my spirit.' Then he knelt down and cried out, 'Lord, do not hold this sin against them'" (Acts 7:59–60).

In the crowd that murdered Stephen there was a young man named Saul, at whose feet the murderers laid their cloaks in order to have their hands free. This young man must have heard the words just cited: significantly, his presence is mentioned in Acts 7:58, the verse that precedes Stephen's prayer for his murderers. And, even if on that occasion Saul approved the killing of the saint and later "worked for the total destruction of the Church," going "from house to house, arresting both men and women and sending them to prison" (Acts 8:1–3)—even if he subsequently asked the high priest "for letters addressed to the synagogues in Damascus that would authorize him to arrest and take to Jerusalem any followers of the Way, men or women, that he could find" (Acts

9:2)—it was ultimately he who proved that Jesus *had* accepted Saint Stephen's plea (which in any case simply reformulated the Lord's own at Golgotha, "Father, forgive them; they do not know what they are doing"). As Saul himself affirmed years later, in a letter bearing his new name, Paul: "I used to be a blasphemer and did all I could to injure and discredit the faith. Mercy, however, was shown me, because until I became a believer I had been acting in ignorance" (1 Tim. 1:13).

The mercy shown to Saint Paul is the subject of a famous canvas by Caravaggio in the church of Santa Maria del Popolo, at Rome, identified in the contract drawn up in the year 1600 as "the mystery of the conversion of Saint Paul" (**fig. 54**). And that is exactly how Caravaggio represents this event described in the ninth chapter of the Acts of the Apostles: as a mysterious inner moment wrapped in light and silence. Unlike others who had represented the scene—among whom Raphael, Michelangelo, and Lodovico Carracci, all with terrified soldiers and servants, rearing horses and heavenly apparitions—Caravaggio reduces the narrative elements to two men, a horse, and the light that here dominates the scene. He adds a detail of the highest possible significance, however, showing Saint Paul's arms raised in the ancient gesture of prayer! Knocked to the ground, blinded and terrified, the converted persecutor *prays*; in fact he utters but a single phrase, a question, but that question is *prayer*.

> Suddenly, while he was traveling to Damascus and just before he reached the city, there came a light from heaven all round him. He fell to the ground, and he heard a voice saying, "Saul, Saul, why are you persecuting me?" "Who are you, Lord?" he asked, and the voice answered, "I am Jesus, and you are persecuting me. Get up now and go into the city, and you will be told what you have to do." The men traveling

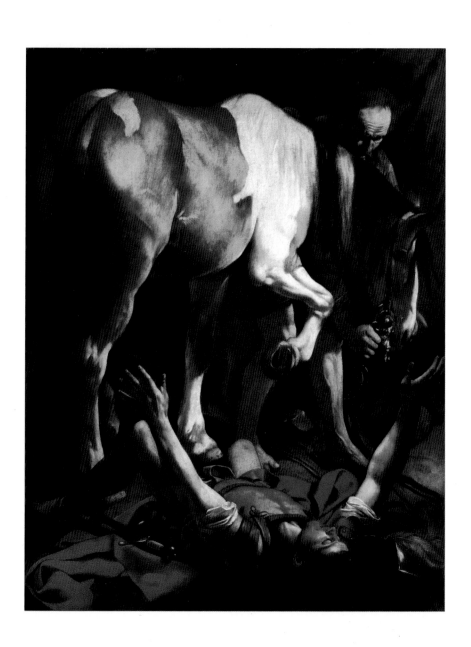

with Saul stood there speechless, for though they heard the voice they could see no one. Saul got up from the ground, but even with his eyes wide open he could see nothing at all, and they had to lead him into Damascus by hand. For three days he was without his sight, and took neither food nor drink. (Acts 9:3–9)

"Who are you, Lord?" was Saul's question. And in the blinding light Caravaggio makes us feel the disorientation of this man who realizes he's gotten it all wrong. Saul is literally "down"— everything he was so sure of is reduced to rubble; he gropes in the darkness of an overwhelmingly great light. The One he had opposed, had refused, had believed dead, was right after all and now, alive, was calling Saul by name and asking his obedience! The words heard as he watched Stephen die finally penetrate Saul's spirit, and the question he asks anticipated the answer he receives: "Who are you, Lord?": "I am Jesus, and you are persecuting me!" There: when our inner world collapses and the only words left are, "Who are you, Lord?" those words constitute prayer and are a plea, for they also mean: "Who am I? Who do you want me to be? What should I do?"—questions, these, to which in Paul's case Christ responds within the same episode. He assures a certain Ananias, a Christian, that the man who until then had persecuted the Church was to be "my chosen instrument to bring my name before pagans and pagan kings and before the people of Israel. I myself will show him how much he himself must suffer for my name" (Acts 9:15–16). This is perhaps the full meaning of the raised arms: Saul already feels himself crucified with Christ (see also Gal. 2:20).

54. Caravaggio, *Conversion of Saul*, Rome, Santa Maria del Popolo

PENANCE AS PRAYER

Saint Paul, who admitted he had been "a blasphemer" and had done all he could "to injure and discredit the faith," is one of the first Christian examples of radical change of life. Another is Saint Mary Magdalene, the woman Christ freed of seven demons (Lk. 8:2) and to whom he revealed himself on Easter morning as risen (John 20:11–18). She it was who, before Jesus's passion, had anticipated his burial by anointing his head with precious oil (John 12:1–8; see also Matt. 26:6–13 and Mk. 14:3–9); tradition moreover identifies her with the sinful woman mentioned in the Gospel who washed the Lord's feet with her tears, drying them then with her unbound hair in sign of penance—the woman of whom Christ said: "Her sins, her many sins, must have been forgiven her, or she would not have shown such great love" (Lk. 7:36–50).[61] Mary Magdalene is also mentioned among the women present on Calvary at the foot of the cross (Matt. 27:55–56; Mk. 15:40; John 19:25) and again on Easter morning (Matt. 28:1; Mk. 16:1; John 20:1).

Hagiographic legend adds a curious fact: Mary Magdalene, who after Christ's ascension went to Marseille, became a preacher of the gospel and a penitent hermit; early medieval sources in fact include a *Vita apostolica* of this saint as well as a *Vita eremitica*.[62] As "apostle" Mary Magdalene preached the good news of pardon for sins: in a thirteenth-century painting in the Accademia Gallery in Florence—a work whose author is in fact called the "Magdalene Master"—she is shown with her right hand raised as if preaching and with a scroll in her left hand with these words: *Ne desperetis, vos qui peccare soletis, exemploque meo vos reparate Deo* (Do not lose hope, you who often sin; follow my example and make reparation to God).

The most famous image of the penitent Magdalene is a wood statue carved by Donatello, probably for the Baptistery of Saint

John in Florence where it was housed until 1966 (**fig. 55**). The artist represents her in prayer, her hands joined and her gaze turned inward; the external signs of penitence—of fasting and sleepless nights—are evident, and yet a great peace pervades this woman freed by Christ of her demons who became a witness to his death and resurrection. In fact, as a pope of the twentieth century, John Paul II, taught, "Anyone who does penance is reconciled with himself in the deepest reaches of his own being, where he recovers his own inner truth; is reconciled with his brothers and sisters, somehow offended and damaged by him; and is reconciled with the Church and with all creation."[63]

Penance as prayer is a fundamental part of Christian heritage. When his disciples ask Jesus to teach them to pray, the formula he proposed includes the request "forgive us our sins" linked to the affirmation "for we ourselves forgive each one who is in debt to us" (Lk. 11:4). In this prayer—in the prayer in which we both ask for and give pardon for sins, that is—we come to know personally One who revealed himself to Moses as "the LORD, the LORD, a God of tenderness and compassion, slow to anger, rich in kindness and faithfulness [who] for thousands . . . maintains his kindness, forgives faults, transgressions, sin" (Exod. 34:6–7a). And, if these assurances from the Father were insufficient, Christians moreover believe that the Son was "put to death for our sins and raised to life to justify us" (Rom. 4:25), so that "we too might live a new life" (Rom. 6:4). Giving his spirit to the apostles, the risen Christ said in fact: "Receive the Holy Spirit. For those whose sins you forgive, they are forgiven; for those whose sins you retain, they are retained" (John 20:22–23).

It is significant, finally, that Donatello's *Mary Magdalene* was made, as seems certain, for the Florence baptistery. The patron saint of Florence is Christ's precursor, John the Baptist, who proclaimed "a baptism of repentance for the forgiveness of sins"

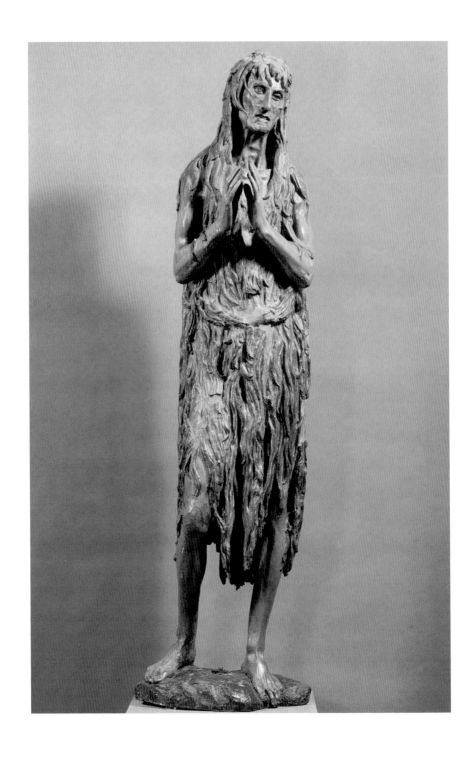

(Mk. 1:4b). Penance is so important a part of the experience of baptized Christians that a Father of the Church called it "a laborious baptism"[64]; in the same spirit the tradition considers the sacrament of reconciliation to be a "baptism of tears." Donatello's figure of a repentant woman in prayer, in the place where—in his day—all Florentines received baptism, was thus an invitation to identify Christian life itself with the prayer that expresses penance—or, rather, that *is* penance. And since this woman had been a witness both of Christ's death and of his resurrection, her carved figure near the font also illustrated Saint Paul's teaching that "when we were baptized in Christ we were baptized in his death" and we "went into the tomb with him and joined him in death, so that as Christ was raised from the dead by the Father's glory, we too might live a new life" (Rom. 6:3–4).

The theme of penitential prayer is thus inseparable from the Christian's new life and typical of the iconography of almost all the saints. A few, however, like Mary Magdalene, become veritable icons of that prayer in which sinners plead for God's forgiveness. Among these, from the late Middle Ages on, particular importance attached to Saint Jerome, the great literary figure of the fourth to fifth centuries who, abandoning his studies of pagan writers, became the authoritative translator of the Bible into what then was the common idiom of the West, Latin. In the first phase of his conversion, Jerome chose a life of penance, spending several years in the Syrian desert where he forced himself to imitate the lifestyle of the early Christian monks, famed for their ascetic practices. Precisely that aspect of the *Vita Hieronimi* would be dramatized eight hundred years later in the thirteenth-century devotional tract known as the *Golden Legend*, which

55. Donatello, *Saint Mary Magdalene*, Florence, Museo dell'Opera del Duomo

attributes to Jerome himself the following description of his desert years: "My days passed in tears and laments, and occasionally if I was overcome by importunate sleep, the bed on which I laid my withered bones was the bare earth. . . . My only companions were scorpions and wild beasts, nor did I desist from beating my breast until the Lord had restored my peace of mind."[65]

This very scene is evoked by Leonard da Vinci in an unfinished panel painting today in the Vatican Museum, where the saint is shown beating his breast (**fig. 56**). Jerome's physical penance expresses an impulse of mental prayer, the effort of which is visible in his gaze, fixed on a crucifix at the viewer's right, summarily drawn but legible above a church seen in the distance. The saint's penance flows, that is, from his prayerful contemplation of the crucified Savior, as if Jerome applied to himself the Pauline promise that those whom God calls and chooses are "intended to become true images of his Son, so that his Son might be the eldest of many brothers" (Rom. 8:29). The saint prays while beating his breast in order to become a "true image" of Christ who on the cross offered a sacrifice pleasing to the Father. Saint Paul's text confirms the efficacy of this system, insisting that God "called those he intended for this, those he called he justified, and with those he justified he shared his glory" (Rom. 8:30). Jerome, a converted sinner, has been justified and indeed glorified by the God who called him, thanks to the sacrifice of Christ with which the saint physically associates himself.

We should perhaps underline that, albeit *physical*, such association constitutes a highly *spiritual* action. Jerome beats his breast while looking at the crucified Christ because he believes, with Saint Paul, that "there is no necessity for us to obey our unspiritual selves or to live unspiritual lives" and that whoever does so is

56. Leonardo da Vinci, *Saint Jerome Doing Penance*, Vatican City, Vatican Museum

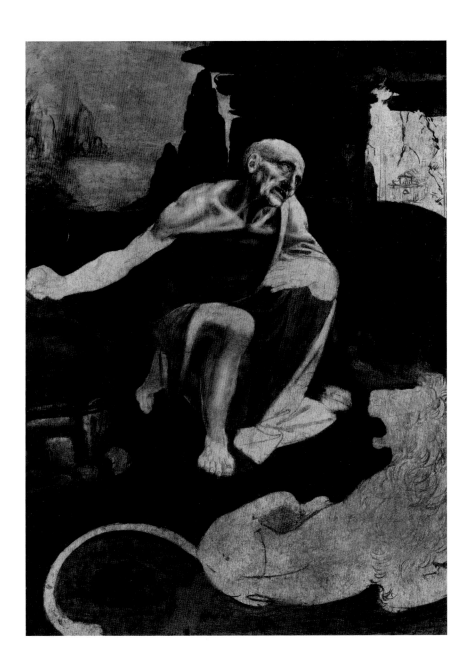

doomed to die, whereas "if by the Spirit you put an end to the misdeeds of the body you will live" (Rom. 8:12–13). Guided by the Spirit in this ascetical program, Christians grasp that they are children of God, "and if we are children, we are heirs as well: heirs of God and coheirs of Christ, sharing his sufferings so as to share his glory" (Rom. 8:17). Thus penance is a gift of the Spirit, "for when we cannot choose words in order to pray properly, the Spirit himself expresses our plea in a way that could never be put into words, and God who knows everything in our hearts knows perfectly well what he means, and that the pleas of the saints expressed by the Spirit are according to the mind of God" (Rom. 8:26b–27). Here Saint Jerome is guided by the Spirit to become an image of Christ through penitential asceticism.

PRAYING FOR OTHERS

Not only sinners are guided by the Spirit to do penance, though, but also holy men and women of whom God asks *prayer for others*. This was the situation of Saint Catherine of Siena, for example, who was called to pray for the Church and received the stigmata in a spiritual manner; a beautiful eighteenth-century painting shows her in prayer with the wounds fully visible and crowned with thorns (**fig. 57**). This woman, who deeply felt the ills of Christ's "mystical Body" in her time, experienced the wounds of his physical body as well, making her own Paul's words: "My sorrow is so great, my mental anguish so endless, I would willingly be condemned and be cut off from Christ if it could help my brothers" (Rom. 9:2–3a). Doing penance for others, raising prayers for their conversion, in fact makes a man or woman a particularly accurate "image" of Christ.

57. Giambattista Tiepolo, *Saint Catherine of Siena in Prayer*, Vienna, Kunsthistorisches Museum

The prayer of saints has great power, as is suggested by an episode in the life of Francis of Assisi illustrated in one of the frescoes in the basilica dedicated to him on the edge of his native city (**fig. 58**). The scene shows another city, Arezzo, from which demons are being expelled thanks to the preaching of a friar (an allusion to the resolution of civil disorders caused by factionalism). At the viewer's left, behind the preaching friar, stands the new cathedral of Arezzo, begun just a few years prior to the execution of the fresco, and beside it, kneeling in prayer, we see the one responsible for sending the peacemaker, Francis of Assisi. The artist, probably Giotto, documents the social reality of the time by placing men of different classes in the two city gates: an elegantly attired burgher and a countryman with a donkey.

This work of the last decade of the thirteenth century is based on literary sources then already in circulation in the Franciscan order: the two lives of the founder by Thomas of Celano and the official biography that the order had commissioned of Saint Bonaventure, known as the *Legenda maior*. In this last, however, the event shown here, described in colorful language, serves above all to illustrate Francis's supernatural power: the text stresses that the saint worked the miraculous liberation from afar, being lodged not in Arezzo itself but in a suburb. From that location "he saw above the city a mass of demons enflaming the already agitated citizens to massacre one another. To expel these spirits of the air who fomented sedition, Francis sent Brother Silvestre, a man as simple as a dove, telling him: 'Go up to the city gate and, in the name of Almighty God, command the demons, under obedience, to quickly leave Arezzo.'" At that point, Silvestre "ran, obedient as he truly was, to carry out Father Francis's orders . . . and, when he reached the city gate, started bravely shouting: 'In the

58. Giotto, *Saint Francis Expels the Demons from Arezzo*, Assisi, upper church

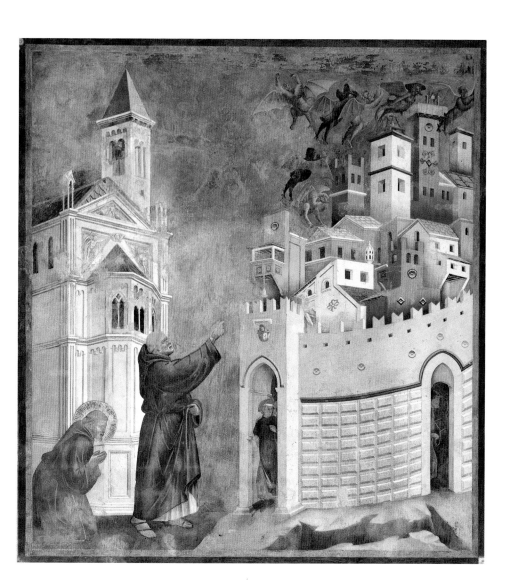

name of Almighty God and by order of his servant Francis, go away, far from here, all you demons!'" Thus was Arezzo freed from civil war thanks to the wise humility of Francis, who "simply by appearing there restored peace to the city and saved it."[66]

Bonaventure's version of the event does not speak of the saint's prayer but only of his Christlike authority over demons. So too an alternative version, by Thomas of Celano, stresses the power of Francis, who with his word alone overcame the factional divisions of the citizens of Arezzo; there however the author adds that, "speaking to the people later, Francis began his sermon by saying: 'I speak to you as to people once subjugated and enslaved by demons. I know however that you have been freed by a poor man's prayers.'"[67] "By a poor man's prayers": that is exactly what the Assisi fresco shows, obliging us to begin the reading of the scene at the left, where Francis kneels in intense oration. This allusion to the role of prayer in the pacification of Arezzo will be taken up in the so-called *Perugia Legend* of Saint Francis, written in the same years the fresco was painted, whose author concludes that the people of Arezzo made peace among themselves "thanks to God's mercy and Francis's prayer." Nor is the coupling of "God's mercy" and "Francis's prayer" mere coincidence, for the paragraph of the *Perugia Legend* that closes with this phrase in fact opens with the affirmation that, when he saw the pitiful state to which civil discord had reduced Arezzo, Francis "was moved to compassion." And that is the point: God's mercy, the human reflection of which is compassion, leads saintly people to pray for sinners. We are indeed still speaking of sinners, and when Francis spoke in the first person to the citizens of Arezzo he did not conceal this fact: "I speak to you as to people once enchained by demons. Because of your iniquitous behavior, you had bound yourselves and sold yourselves like animals at market. You had thrown yourselves into the arms of the demons, exposing yourselves to the power

of beings that destroyed and can still destroy themselves and you with them, and that want to reduce the whole city to ruins."[68]

The emphasis on Francis's *power* present in all three accounts of the liberation of Arezzo is thus meant to suggest an alternative to "the power of beings that destroyed and can still destroy themselves and you with them"—an alternative to the power of evil, that is. Prayer, where it is explicitly mentioned, emerges as an instrument of God's beneficent power placed in the hands of saintly persons to fight the maleficent power of Satan—a weapon in the combat against evil. In this perspective, special importance attaches to the prayers of those called by God to guide and protect others—the prayers of pastors and kings, as an early fifteenth-century miniature suggests, showing Pope Saint Gregory the Great with his hands raised to God to implore cessation of the pestilence that raged at Rome in the year 590 (**fig. 59**); in front of the pope, two clerics bear relics, and behind him the people of Rome (among whom a monk who has fallen, stricken with the plague) follow in procession. Above Saint Gregory, atop a high structure that represents Castel Sant'Angelo, we see the archangel Michael sheathing his sword as a sign that the divine punishment has in fact ceased.

Saint Gregory the Great's posture of prayer, hands raised to heaven, although alluding to the ancient gesture that we see in catacomb paintings, is somehow more urgent, more dramatic. It reminds us of the raised arms of Moses, in the battle between the people of Israel and the Amalekites, when—as Joshua led the battle on the field—Moses, Aaron, and Hur ascended a nearby hill and "as long as Moses kept his arms raised, Israel had the advantage; when he let his arms fall, the advantage went to Amalek" (Exod.

The two following pages:

59. Limbourg Brothers, *Procession of Saint Gregory the Great to Free Rome from the Plague of the Year 590*, miniature from the Très riches heures du Duc de Berry, 1488–1490, Chantilly, Musee Condé, ms 65, pages 71v–72r

cabis me in equitate tua.
Et dixas de tribulacio
ne animam meam et
in misericordia tua di
spides omnes inimi
cos meos.
Et pides omnes q
tribulant animam
meam quoniam ego
seruus tuus sum.
Gloria patri et filio
et spiritui sancto.
Sicut erat in princi
pio et nunc et semper z
in secula seculorum. amen.
Pes reminiscans Ant.
dne delicta nostra uel parentum
nostrorum neqz uindictam su
mas de peccatis nostris parce do
mine populo tuo quem redemisti
sanguine tuo proprio ne in eter
num irascaris nobis. lett.

yrieleison.
Xpileleison.
yrieleison.
piste audi nos.
ater de celis deus
miserere nobis.
ili redemptor mu
di deus miserere nobis
pirtus sancte ds
miserere nobis.
ancta trinitas
unus deus miserere n.
ancta maria ora
pro nobis.
ancta dei genitrix
ora pro nobis.
ancta uirgo uir
ginum. ora pro nob.
ancte michael. ok.
ancte gabriel. ok.
ancte raphael. ok.
mnes sancti an

geli z archangeli dei. ok.
ancte iohannes
baptista ok.
mnes sancti priar
de et prophete dei ok.
ancte petre ok.
ancte paule ok.
ancte andrea. ok.
ancte iacobe ok.
ancte iohes ok.
ancte philippe. ok.
ancte thoma ok.
ancte iacobe ok.
ancte mathee. ok.
ancte thadee ok.
ancte bartholome
ora pro nobis. ok.
ancte mathia. ok.
ancte marce ok.
ancte luca. ok.
ancte barnaba. ok.
ancte symon ok.

17:11). Since Moses's arms grew heavy, however, Aaron and Hur supported them, "one on one side, one on the other; and his arms remained firm until sunset. With the edge of his sword, Joshua cut down Amalek and his people" (Exod. 17:12–13). And just as, for this victory, it was essential that Moses himself pray, so too victory over the plague at Rome required the prayer of Pope Saint Gregory; God, who chooses for his people pastors according to his own heart, is especially attentive to the prayers that these men raise for the wellbeing of the sheep entrusted to them. In papal iconography, above all, images of the pontiffs in prayer always communicate the awareness of the popes that they enjoy a privileged relationship with Christ, similar to that of the apostle whose successors they are, Peter (**fig. 60**).

The same logic applies to the aura of sacralization surrounding reigning monarchs, who are called by God, among other things, to pray for the people at whose head they are placed—as is suggested by the chapel founded by the first king of Sicily, Roger II, in 1130, the year in which the antipope Anacletus II conferred his regal title, subsequently recognized by the legitimate pontiff. Situated in the royal palace built around the nucleus of an earlier Arab castle, the chapel perfectly fuses various artistic orientations of the new kingdom, with a wooden ceiling of Fatimid manufacture, decorated figures, and kufic inscriptions, the work of Arab artisans, and sustained by columns that are ancient or that imitate the antique.

Particularly interesting is the chapel's royal loge: the raised area reached by five steps where Roger II and his family stood during the liturgy (**fig. 61**). Facing the altar, this ceremonial dais situated the king opposite the celebrant of the Mass, thus suggesting the

60. Filarete, *Eugenius IV Kneeling Before Saint Peter*, Vatican City, Saint Peter's Basilica, detail of the bronze door

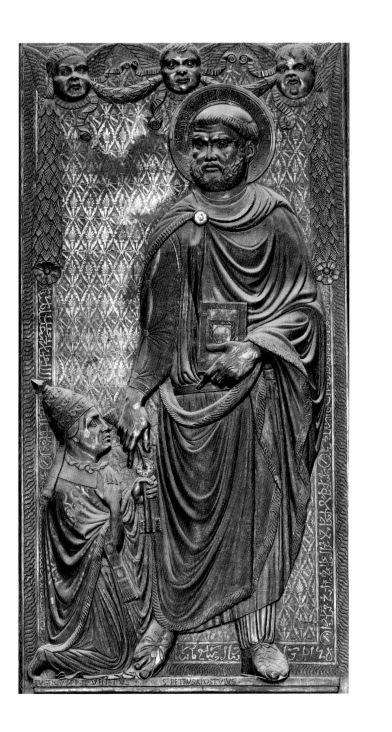

monarch's near-priestly function; it also situated him beneath a grandiose mosaic of the enthroned Christ flanked by figures of Saint Peter and Saint Paul. Clergy and nobles present in the chapel thus saw the king on his dais as an emanation on earth of the power of Christ and the apostles in heaven—a concept of monarchy common to all the cultures of that time, *mutatis mutandis*. The figure of Saint Peter at Christ's right recalls the dedication of the chapel to the Prince of the Apostles and the papal origin of Roger's title; the presence of the missionary apostle Paul may allude to that Middle Eastern world that Roger II hoped to annex to his kingdom.

The splendor of the official art of the kingdom of Sicily expresses the astounding ambition and extraordinary capacity of its rulers. Roger II, son of the younger brother of Robert Guiscard, Count Roger I of Sicily, in fact unified under his personal control his uncle's possessions in mainland Italy and his father's on the island; Roger II's full title was "King of Sicily, Puglia, Calabria, and Capua," with a realm stretching from above Naples to below Modica, which he sought to expand to northern Africa and the Byzantine possessions in the Mediterranean, conquering Corfu in 1147.

The iconography of the royal loge suggests the origin of these ambitious projects *in Christo*, inviting us to see the monarch's prayer as trust in the One who sits on the throne of heaven, the Lord Christ. In such a context the archaic expressions that the liturgy applies to the Savior apply as well to the prince who presents himself as Christ's ally and protégé: "Hero, strap your sword at your side, in majesty and splendor; on, ride on, in the cause of truth, religion, and virtue! Stretch the bowstring tight,

61. Palermo, Cappella Palatina, interior looking toward the royal loge, with the mosaic of *Christ as Pantocrator*

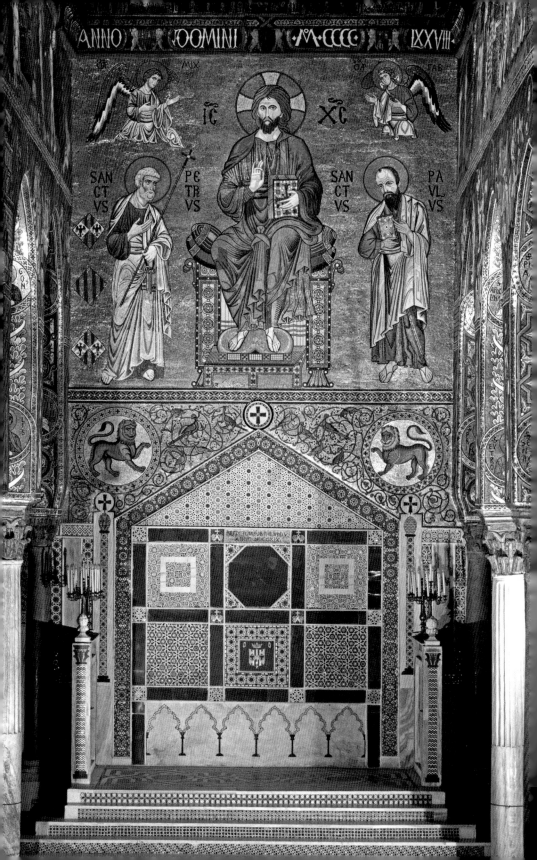

lending terror to your right hand. Your arrows are sharp, nations
lie at your mercy, the king's enemies are losing heart. . . . Your
royal scepter is a scepter of integrity: virtue you love as much as
you hate wickedness. That is why God, your God, has anointed
you with the oil of gladness above all your rivals" (Ps. 45[44]:4–7).

The idea of a privileged relationship between Christian princes
and the King of Heaven would remain formally operative until the
French Revolution, and among the ruler's duties there was always
participation in the public prayer of the Church. In addition, in
given situations monarchs made personal prayer gestures of great
impact, such as the public vow by which, on February 10, 1638,
Louis XIII consecrated France to the Virgin Mary; the event
is evoked in a famous painting of the 1820s by Jean-Auguste
Dominique Ingres (**fig. 62**). From the point of view of history,
it is not easy to evaluate this gesture, which should probably be
interpreted in the context of the Franco-Spanish War then in
progress, even though contemporaries associated it rather with
the king's gratitude for the pregnancy of his wife, Anne of Austria,
after twenty-three years of marriage without children. In religious
terms, the king's vow bound French Marian devotion, traditionally
strong, to the Crown, establishing annual processions on the Feast
of the Assumption during which the people were asked to pray for
the monarch; in addition, all churches of the realm not already
dedicated to the Mother of God were supposed to dedicate at
least their main chapel to her. Ingres's painting, realized during
the Bourbon Restoration following the turmoil of the Revolution
and of the Napoleonic period, reflects the nostalgia of Catholics
of that time for a world in which throne and altar were again
united, and prayer was still a part of the national identity.

62. Jean-Auguste-Dominique Ingres, *The Vow of Louis XIII*, Montauban, Cathedral

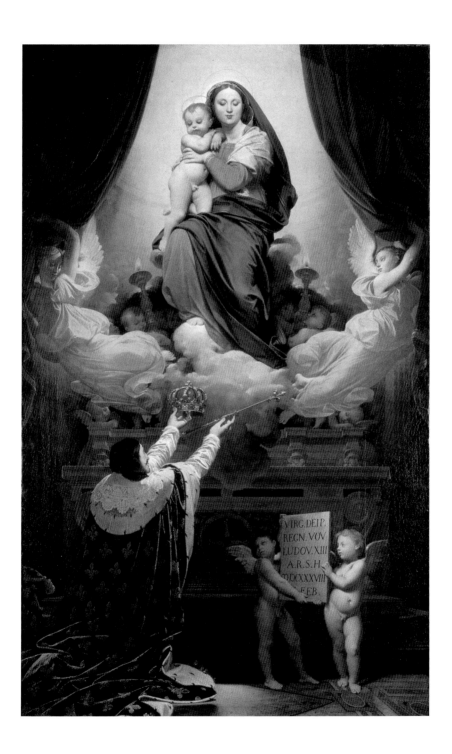

PRAYING FOR DEAR ONES

The simplest form of prayer for others—the most spontaneous, the most natural—is the plea that believers raise for their dear ones. A charming Florentine altarpiece, *Our Lady of Succor*, illustrates the dynamics of this kind of entreaty, showing a mother on her knees who asks the Virgin's help for her child, seen threatened by a devil (**fig. 63**). The popular, practically tongue-in-cheek tone of this image—with its humorous red demon, the child's bare backside, and the club held by a gigantic Mary figure— is belied by the gravity of the situation, communicated by the facial expressions of the mother and the Madonna, respectively desperate and stern. The young woman's raised hands suggest prayer but also extreme urgency: the visceral attachment to their children that the Bible attributes to mothers; the young woman's loosened and disheveled hair makes it clear that, anxious to seek help, she has left home without any thought for public decency. And the Virgin's large scale, together with her stern look and the decisiveness with which she brandishes her club, identify her as *powerful*: a maternal figure of the protection that God the Father offers his adoptive children—a figure of the Mother Church called to defend Christians from the assaults of the Evil One, that is. Significant, in this sense, is the physical nearness of Our Lady of Succor to the child and to the young mother, and the naturalness with which the child seeks refuge under the Virgin's mantle.

The prayer of pleading can, however, also consist simply in calm recommendation of our dear ones to God, as Titian's splendid *The Pesaro Madonna* suggests (**fig. 64**). In this large canvas elaborated between 1519 and 1526 for the altar of that noble Venetian clan in the basilica of the Frari, Mary's high pedestal is

63. Follower of Cosimo Rosselli, *Our Lady of Succor*, Florence, Santo Spirito

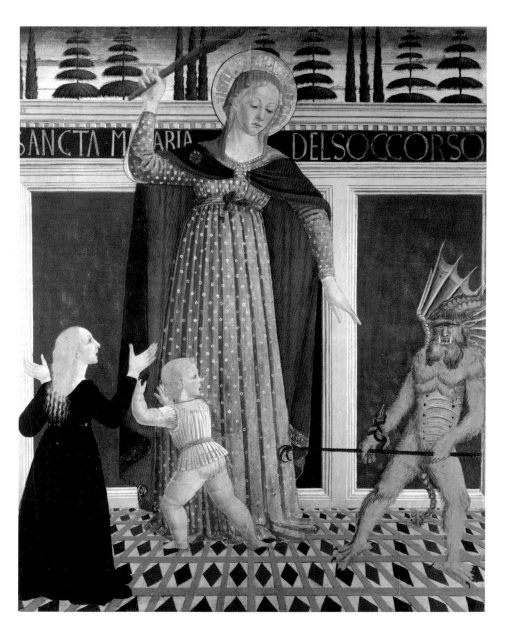

moved from the center (where Venetian tradition normally placed it: see **fig. 21**) to the right, and the standard format of the sacred conversation is enlivened by gazes and gestures that animate both the physical composition and the psychological interrelationship of the figures. Here the prayer of a family that entrusts itself to Mary and the Christ Child becomes the occasion for lively responses from the Madonna herself, from little Jesus, and from the saints who accompany them.

The painting expresses the gratitude of the Pesaro family for graces received many years earlier. The turbaned personage at the left, led by a knight in armor, alludes to a victory over the Turks won by the cleric kneeling in front of him, Jacopo Pesaro, who in 1502 had defended the island of Santa Maura in the Ionian Sea on behalf of Pope Alexander VI, whose coat of arms adorns the banner carried by the knight. In the same spirit Saint Peter, at the center of the composition, and Mary in the upper right look toward Jacopo Pesaro as if recognizing his service to the Church. Their glances establish a descending diagonal, which Titian balances with the ascending diagonal of the banner and the movement of baby Jesus, who looks in the opposite direction from his mother, at Saint Francis of Assisi, who in turn indicates with a gesture of his hand several persons kneeling at the viewer's right, the first of whom is the head of the family, Francesco Pesaro, dressed in the magnificent crimson robes of a senator of the Venetian Republic. The overall subject of the painting thus has to do with a prayer of pleading that was heard and the gratitude of an entire family for the protection accorded to one of its members and, through him, to the larger "family" of the nation and indeed to Christendom itself, defended by Jacopo Pesaro from enemy assault. Moreover, as in the Florentine *Our Lady of Succor* discussed above, the

64. Titian, *The Pesaro Madonna*, Venice, Santa Maria dei Frari

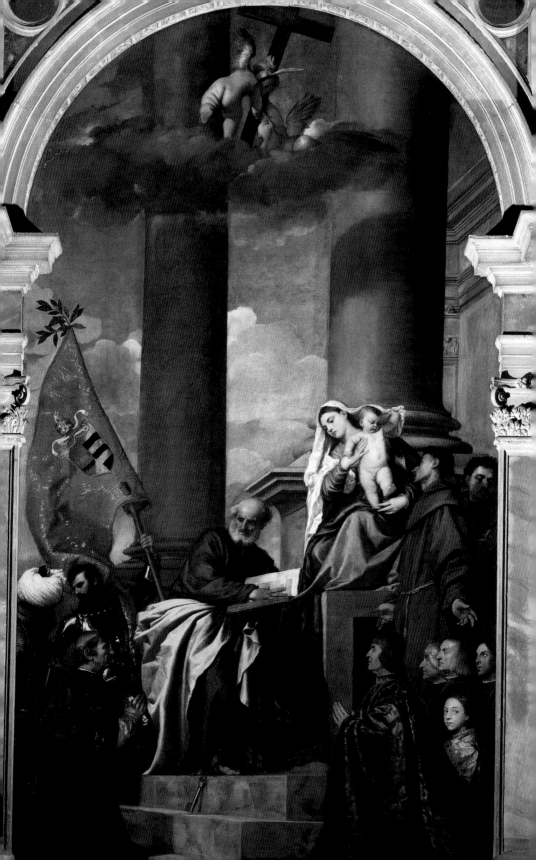

subject includes the participation of the heavenly "family"—
of the Communion of Saints, that is—in the trials and, in this
case, triumphs of an earthly family. Above all the other figures,
indeed—poised in the immensity of the lagoon sky—is Mary, the
queen who turns graciously to her Son's friends, Mary the mother
who teaches her children how to pray.

At this point we should clarify Mary's intercessory role in the
life and prayer of Christians. And to do so it will be useful to look
at a curious and touching painting of the Holy Trinity, in which
Mary clearly indicates Christ kneeling in front of her (**fig. 65**);
with Mary is a group of believers, shown in smaller scale, whom
she seems to be presenting to her Son.[69]

Let us try to understand this image reading from the top
down—from the figure of God the Father who looks earthward
and, with a gesture of his right hand, sends the Holy Spirit in
the form of a dove on the Son, kneeling in the lower part of the
canvas, at the viewer's left. Christ in turn looks up, as if responding
to his Father, to whom with a gesture of his own right hand he
shows the wound in his side. With his other hand Christ indicates
to the heavenly Father his earthly mother, Mary, also kneeling.
And Mary, looking at Christ, makes two significant gestures: with
her left hand she raises one of her breasts in her Son's direction,
while with her right she presents the faithful kneeling before her
in attitudes of adoration. These people, small in proportion to
the main actors of the scene, represent different age groups and
states of life: some are young, others old; there are lay people
and religious. They are in fact all members of the family that
commissioned the work, called *Dei Pecori*.

The meaning of these complex gestures and of the relational
fabric that they illustrate is explained by words painted in

65. Lorenzo Monaco, *Double Intercession*, New York, Metropolitan Museum of Art

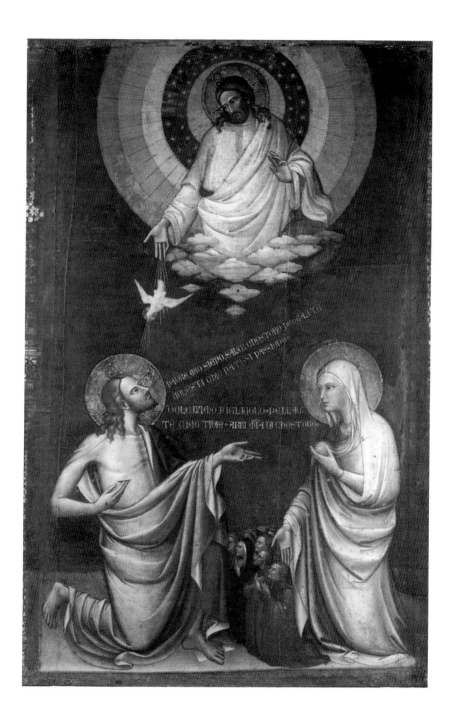

Gothic letters on the image. As she shows her breast, Mary says to Christ: *Dolciximo figliuolo pellacte che io ti die abbi mìa* [= "misericordia"] *di chostoro* (Most sweet Son, for the milk I gave you, have mercy on these people). That is, as she reminds her Son of the human nature he has from her, which makes him like other men, this "Mother"—who is also a figure of the Church—intercedes for her other "children," the faithful. And Christ, raising his eyes to God and showing the wound in his side, says (in the text written diagonally, as if it ascended from left to right): *Padre mio sieno salvi chostoro pequali tu volesti chio patissi passione* (My Father, let these people be saved for whom you wanted me to suffer the Passion). The Son in turn reminds his Father that, if he obeyed the divine will taking human flesh in Mary's womb and then in accepting to die, it was all in order to save these people for whom the mother Church now intercedes.

This unusual subject derives from a twelfth-century text, the *Libellus de laudibus beatae Mariae virginis* by Ernaldus of Chartres. Erroneously attributed to Saint Bernard of Clairvaux, the short text circulated widely in the fourteenth century as part of a popular compendium, the *Speculum humanae salvationis*. It describes a kind of very human exercise of familial pressure, in which Christians turn to Mary, knowing that Christ can refuse nothing that his mother wants. Mary then turns to her Son, playing the card of maternity in the certainty that the Father will grant all that his Son asks. And, to obtain what his mother desires, the Son does not hesitate to recall the obedience to the Father that led him to the Cross!

This large painting (2.39 x 1.53 meters [7 feet 10 inches x 5 feet]), originally placed next to the main door on the inner façade of the Florence cathedral, perfectly communicates the idea of Mary's intercessory role. The work wanted to involve

the faithful at all costs, as the speaking gestures and texts written on its surface suggest; but this so that they would grasp that the relational systems that work in a human family are operative in God as well, and that, in giving his Son a human mother, the Eternal Father also accepted the influence to which mothers' relationships with their children entitle them. Christ, the only begotten Son of God, is the sole mediator between his Father and humankind (see 1 Tim. 2:5); and Mary, mother of Christ and of Christians, is the inevitable mediatrix between these and her Son.

PRAYER HEARD

The last work treated in this chapter similarly illustrates prayer in the context of family relationships: it is the double portrait by the French master Philippe de Champaigne, representing his daughter, a nun of the Jansenist convent of Port-Royal, together with the superior of the convent, Mother Agnèse Arnauld, both shown in prayer (**fig. 66**). In 1660 the painter's daughter had developed a paralysis that by 1661 was practically total, with the result that the young woman could not rise from her bed. At that point Mother Agnèse, the prioress of the convent, organized a novena of prayer for her spiritual daughter, who at the end of the nine days in fact was healed. The girl's father—a famous artist who had worked for Cardinal Richelieu and at the Sorbonne—wanting to express his gratitude to the Lord and to the mother superior painted this masterpiece, which he donated to the convent.[70]

The two following pages:
66. Philippe de Champaigne, *Two Nuns of Port Royal*, Paris, Louvre

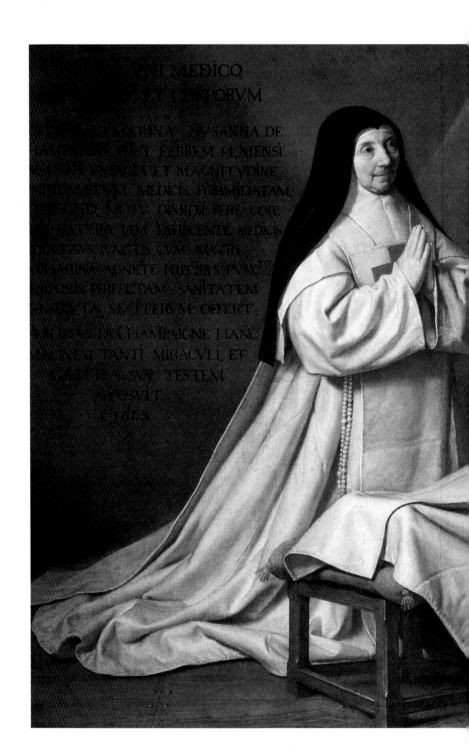

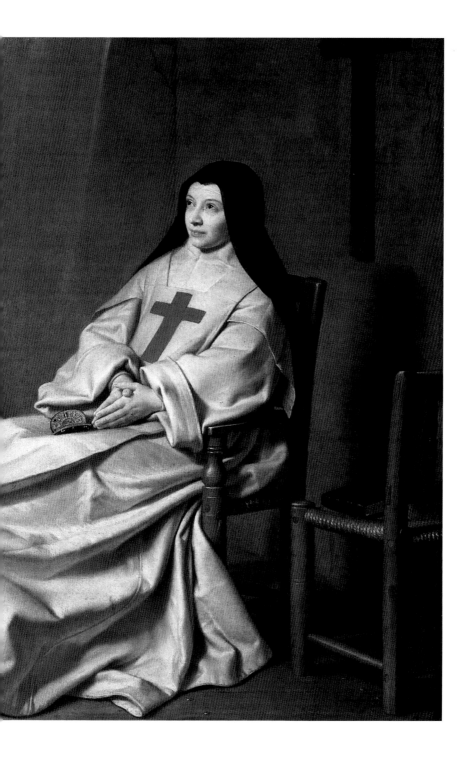

The image's message is simple and has been part of Christian culture from the start: God hears the pleas of his faithful ones. "What in fact will God refuse prayer formulated in spirit and truth, he who wanted us to pray like that?" Tertullian asked in the fourth century; and then, noting that in the Old Testament, prayer "freed people from fire, from wild beasts, and from hunger," he exclaimed: "How much broader the field of action of Christian prayer! Christian prayer will not perhaps summon an angel of the dew amidst the flames, or close the jaws of lions, or bring a farmer's meal to someone dying of hunger, or give the gift of insensibility to pain, but it certainly gives to those who suffer the virtue necessary to firmly and patiently bear such ills, strengthening the soul's capacity to support them with faith in the final reward and showing the great value of pain accepted in God's name. We hear tell how in ancient times prayer inflicted blows, routed armies, and deprived enemies of the benefit of rain. We know now however that prayer banishes every fear of divine justice, is concerned for enemies' wellbeing, and pleads for that of persecutors. It once could wrest water from heaven and implore fire as well: in fact only prayer conquers God; Christ however did not want prayer to be a cause of evil and thus gave it every power for good."[71]

Finally, as if resuming the themes developed in this chapter and adding still others, Tertullian lists the functions of prayer, which according to him serves "to call back the souls of the dead from the very path of death, to sustain the weak, cure the sick, liberate the possessed, open prison gates, loose the bonds of the innocent." Prayer, he says, "washes sin, resists temptation, extinguishes persecution, comforts the fearful, encourages the generous, guides pilgrims, calms storms, stops evildoers, helps the poor, softens the heart of the rich, lifts the fallen, supports the weak, sustains the strong." [72]

It is in the continuation of this panegyric that Tertullian develops the idea cited in our first chapter: that all creatures, even animals, pray. And he concludes with a fact that, as far as he is concerned, proves more clearly than any other the necessity of prayer: "The Lord himself prayed." And "during his life on earth, he offered up prayer and entreaty, aloud and in silent tears, to the one who had the power to save him out of death, and he submitted so humbly that his prayer was heard" (Heb. 5:7). Christ's cross—which in Philippe de Champaigne's painting is seen hanging on the wall of the austere convent cell and sewn on the nuns' habits—recalls the Savior's prayer on the last day of his life on earth, the day of Calvary.

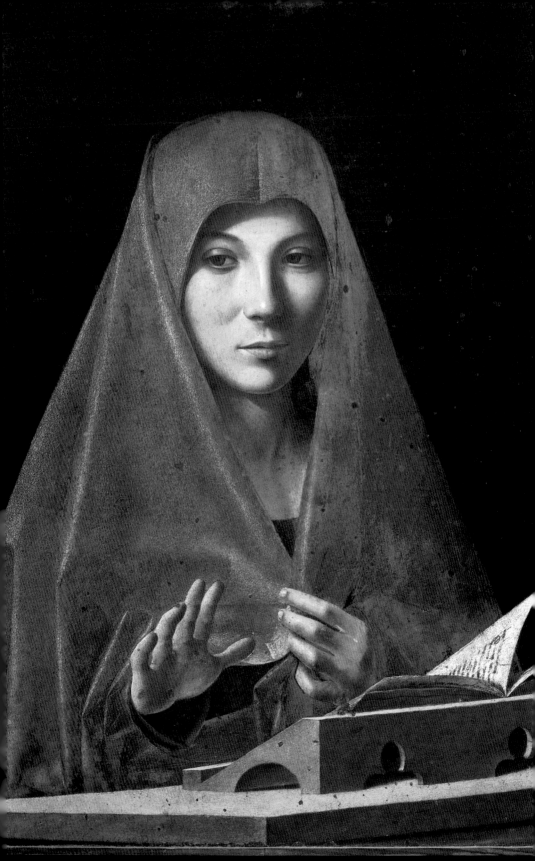

Chapter Five

———•———

LECTIO DIVINA

R eading too can be prayer. Christianity, of course, is not a "religion of the book" but rather *faith in the Word*—that is, in that Word of God who in Mary's womb "was made flesh" and "lived among us, and we saw his glory" (John 1:14a). Books have a spiritual function, though, and Christian art associates the Incarnation itself with the reading of a text, as is clear in Antonello da Messina's *Virgin Annunciate*, where Mary is represented before an open book that evidently she was reading (**fig. 67**). The archangel Gabriel, normally present in Annunciation scenes, is missing here, and thus the viewer takes the place of the heavenly messenger just a few feet away from the young woman who, as she notices our presence, interrupts her reading; her right hand, beautifully foreshortened, expresses surprise, while her left instinctively pulls her veil around her. The intelligent comeliness of this woman, her knowing gaze, and the smile lightly touching her lips are unforgettable: she has a typically Sicilian beauty, moreover, with the high cheekbones and almond-shaped eyes of the southern Mediterranean feminine universe. The luminosity of her face and of the ample blue veil, a miracle of the new Flemish oil technique so admired by Antonello, becomes a metaphor of inner light: of that Light which—in this moment and in her, Mary—enters the world.

67. Antonello da Messina, *Mary Annunciate*, Palermo, Galleria Regionale di Palazzo Abatellis

In fact not every text elicits prayer, but only texts that illumine and give joy—as here, where it is clear that the young woman depicted by Antonello was not reading something worldly or ordinary or merely useful, was not reading for pleasure or for purposes of study. She was reading the word of God in reverent expectation that he would reveal himself in it—which in her case the Most High did in a new, singular, and unimaginable way, taking root in Mary's physical as well as spiritual life. Thus the surprise she manifests is not caused by the angel but by a presence that she recognized first in the text she was reading, then in her own heart: God who had promised, "the maiden is with child and will soon give birth to a son whom she will call Immanuel" (Isa. 7:14b).

This kind of prayerful reading, known as *lectio divina*, opens the reader to Christ and implies a capacity to understand that only God can give. Saint Irenaeus, recalling the time that Moses spent on Sinai in direct contact with the Most High, affirmed that "in those forty days he learned how to remember God's words, his characteristic style, the spiritual images he employed, and his way of prefiguring future events"; Irenaeus applied to Moses's apprenticeship the phrase coined by Saint Paul to describe the survival of the chosen people during their journey through the desert: "They all drank from the spiritual rock that followed them as they went, and that rock was Christ" (1 Cor. 10:4).[73] Moses's forty days on the mountain with God in fact prefigured the forty days Jesus's disciples spent with the Savior after the Resurrection, when "he opened their minds to understand the Scriptures" (Lk. 24:45)—as indeed, the evening of the day of Easter, walking toward Emmaus with two disciples, he had explained to them the Scripture passages regarding himself, "starting with Moses and going through all the prophets" (Lk. 24:27). In fact those ancient texts had all been written by men in whom "the Spirit of Christ"

was already at work to indicate what later would really happen (see 1 Pet. 1:11).

To pray in this way—reading, but beyond the specific text; welcoming not only God's words but his "characteristic style"; searching the Scriptures for that which refers to the Savior—in effect means allowing "the Spirit of Christ" to be at work in us. It means reading with a burning heart, like that of the disciples on the road to Emmaus who listened to Christ (cf. Lk. 24:32); it means "tuning your ear to wisdom and applying your heart to truth" (see Prov. 2:2–5) in order to recognize, in the complex road map that the Scriptures unfold, the One who is the only "way" to the Father (see John 14:6), knowing that "there are in fact ways in the Law, in the prophets, in the Gospels, in the apostolic writings, and in the works of Christian teachers."[74] It means being able to grasp, behind the words actually written, the love that inspired them: the lyrical rapture evoked in a painting by Girolamo Savoldo, where the evangelist Matthew listens with joy to the angel who inspires him (**fig. 68**). Another New Testament author, John, says, "We are writing this to you to make our own joy complete" (1 John 1:4), and for readers too the sweetness is great, the consolation deep, the joy intense.

THE FIGURE OF SAINT JEROME

Lectio divina springs from the Scriptures, and thus it is no surprise that the translator of the Bible, Saint Jerome, exemplifies this kind of prayer. The medieval compiler mentioned in our fourth chapter, the learned Dominican bishop of Genoa Jacopo da Voragine, when he speaks of the period spent by this saint in the desert recalls as well Jerome's vocation to study, and, citing Sulpicius Severus, describes him as "always engaged in reading, always surrounded by books, someone who incessantly, day

68. Savoldo, *Saint Matthew and the Angel*, New York, Metropolitan Museum of Art

and night, was either reading or writing."[75] From the fifteenth century onward, numerous images fuse these two aspects of Jerome's experience, creating a new theme in Western art: a man who, in the midst of nature, finds God in the Scriptures. This theme was cultivated in a particular way by Venetian artists, who made Scripture reading in a natural setting a subject of singular poetry, especially in depictions of this saint who, coming from Dalmatia, was considered Venetian (the Most Serene Republic then controlled Istria and the Yugoslav coast). The frequent representation of Jerome by painters from the Veneto thus had a patriotic element, and the landscape in which he appears often "photographs" topographic features of that region.

Above all such images photograph the Renaissance ideal of a specifically *Christian* humanism. Saint Jerome, born in the fourth century, still belonged to that ancient world so admired by fifteenth-century Italians; a cultured man who read and spoke several languages, he had withdrawn into the solitude and silence of the desert and there discovered his vocation as a believing writer. Subsequently he was called, as noted above, to translate the Hebrew and Greek original texts, producing a Latin version of the Bible still used in the fifteenth century, the Vulgate. A small painting by Giovanni Bellini, *Saint Jerome in the Desert* (**fig. 69**), provides a visual résumé of these facts, evoking the world of this saint at once natural and literary.

The best key to Jerome's spirituality is furnished by his own writings, which moreover offer splendid examples of the style of lectio divina developed in the patristic era. The saint opens the prologue to his *Commentary on the Book of Isaiah*, for example, with the affirmation: "I fulfill my duty, obeying Christ's commands: Study the Scriptures" (John 5:39), and "Search and you

69. Giovanni Bellini, *Saint Jerome in the Desert*, Florence, Uffizi

will find" (Matt. 7:7); he moreover explains that he obeys these evangelical injunctions "so as not to be told, as the Jews were, 'You are wrong, because you understand neither the Scriptures nor the power of God' (Matt. 22:29)." From this delicate textual embroidery Jerome deduces the broad lines of a methodology: "If, then, as Saint Paul says, Christ is the power of God and his wisdom [see 1 Cor. 1:24b], whoever does not know the Scriptures does not know either God's power or his wisdom. To not know the Scriptures means to not know Christ."[76]

Introducing the book of Isaiah, Jerome also explains the prophetic character of lectio divina and its intimate bond with the original inspiration of the text: "Everything that regards the sacred Scriptures, everything that tongue can express and human intelligence can understand is found in this volume." The author himself testifies to the depth of such mysteries: "For you every vision has become like the words of a sealed book. You give it to someone able to read and say, 'Read that.' He replies, 'I cannot, because the book is sealed.' Or else you give the book to someone who cannot read, and say, 'Read that.' He replies, 'I cannot read'" (Isa. 29:11–12). It is therefore a question of mysteries that, as such, remain closed and incomprehensible to the profane, but are open and clear for the prophets. We read in Saint Paul, in fact: "Prophets can always control their prophetic spirits" (1 Cor. 14:32), since it is in their power to keep silent or to speak as may be needed. The prophets understood what they were saying, and for that reason all their words are wise and reasonable. *What reached their ears were not only vocal vibrations, but the very Word of God who spoke in their soul.* A few of them say as much, using such expressions as: "the angel . . . was talking to me" (Zech. 1:9); "the Spirit . . . cries 'Abba, Father!' in our hearts" (Gal. 4:6); and "I am listening. What is the LORD saying?" (Ps. 85:8).[77]

MASTER OF THE ART OF PRAYER

Another representation of Jerome in the desert, done thirty years before Giovanni Bellini's painting, shows the saint specifically as a master of the art of prayer through reading (**fig. 70**). It is a small panel painted by Piero della Francesca, now in Venice, in which, beside the holy hermit with his open book, we see a man in fifteenth-century dress, kneeling with his hands joined. The man may have commissioned the work and was apparently called Jerome, as an inscription beneath his figure suggests: "Hier. Amadi Aug. F." (Jerome Amadi, son of Augustus).[78] But the inscription below the devout layman may—as some have thought—be a later addition, so conceivably the man's name was not really Jerome at all. Whoever he was, though, this gentleman has chosen the historical Jerome as his guide to Christ, kneeling at the saint's left. Saint Jerome himself sits in front of a crucifix angled in such a way that, if he straightened his head, he would see it; the movement of Jerome's head makes it clear that he had been looking at the crucifix when, recognizing the presence of his disciple, he turned to explain something.

The open book in the saint's left hand and the eloquent gesture of his right hand suggest a process of textual elucidation: of explaining something through written sources. In the manner of scholars and teachers in every age, Jerome has other books ready to hand on the stone bench where he sits: one is open and another, beautifully bound, is closed. Despite the bookish atmosphere, however, the scene unfolds not in the scholar-saint's study but in a natural setting—a valley at the foot of hills—with a city clearly visible behind Jerome in the middle ground.

Several other elements stand out. A robust young tree rises behind the kneeling layman, in compositional and emotional balance with the crucifix in the foreground, which is set in a severed trunk on which Piero has signed his name. This trunk

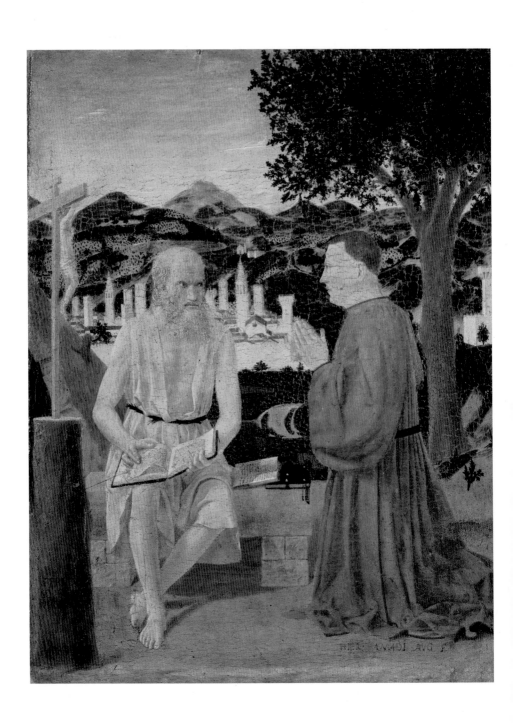

and the healthy tree beyond it define a diagonal into the picture's depth, which we cannot but notice because of the angle at which the crucifix is set, and this diagonal in turn is bisected by the gaze passing from Jerome to his disciple; the relationship between the two is thus defined, even structured, by the cross of Christ. Normally such details are bearers of meaning, and here they seem to have an emblematic function: in fact this painting, one of the first dealing with the theme of Saint Jerome in the desert, touches a chord deeply felt by Christian humanists in the Renaissance.

What was Jerome reading, and what is he now "explaining" to the kneeling man? He himself tells us, in the just cited prologue to his *Commentary on the Book of the Prophet Isaiah*, when he says: "I fulfill my duty, obeying Christ's command to 'study the Scriptures'" (see John 5:39). And as we saw, in the same passage, Jerome notes that, "if, then, as Saint Paul says, Christ is the power of God and his wisdom, then anyone who does not know the Scriptures does not know God's power or his wisdom. To not know the Scriptures means to not know Christ." We can therefore conclude that this painting of Jerome with an open book alludes to the saint's commitment to biblical study.

In the same way, the placement of the crucifix in front of him, angled so that he can see it when he looks straight up from his book, suggests why Jerome studies Scripture: to find, in its pages, the power and the wisdom of God, Jesus Christ (**fig. 71**). Elsewhere, Jerome says, "When I read the Gospel, and see there the testimony from the Law and the prophets, I contemplate Christ alone," [79] and this probably explains the books on Jerome's bench: he is reading the New Testament but cross-referencing what he reads with related passages from the Old Testament ("the Law and the prophets"). The Christ contemplated in the

70. Piero della Francesca, *Saint Jerome with a Kneeling Man*, Venice, Gallerie dell'Accademia

Scriptures is, moreover, the *crucified* Lord whom Jerome could see as he read and whom he seems now to show his disciple in order to explain the text to him. In the Pauline verse quoted by Jerome in his Isaiah commentary, the apostle insists that, while nonbelievers ask for miracles and philosophical learning, "here are we preaching a crucified Christ; to the Jews an obstacle they cannot get over, to the pagans madness, but to those who have been called, whether they are Jews or Greeks, a Christ who is the power and the wisdom of God" (1 Cor. 1: 21–24).

The natural setting in which Saint Jerome expounds this privileged knowledge gleaned from Scripture—the knowledge of God's wisdom and power revealed in Christ's self-oblation—is itself part of the message. In the monastic tradition into which Jerome inserted himself, the renunciation of worldly ambition and wealth—what was called *fuga mundi* (flight from the world)—typically found expression in the choice of some remote habitat in which the monk might encounter God in silence. Far from human cities and their distractions, the chosen spirit could prepare his heart to enter the "city of God," the heavenly Jerusalem.

In a letter to the city dweller Heliodorus, Saint Jerome exalted the spiritual value of his own choice of the wilderness in rapturous language that we might imagine addressed to the layman in Piero della Francesca's panel. "O desert of Christ, burgeoning with flowers! O solitude, in which those stones are produced with which, in the Apocalypse, the city of the great king is constructed! O wilderness that rejoices in intimacy with God! What are you doing in the world, brother, you who are greater than the world? How long will the shadows of houses oppress you? How long will the smoky prison of these cities close you in? . . . Do you fear

71. Piero della Francesca, *Saint Jerome with a Kneeling Man*, Venice, Gallerie dell'Accademia, detail

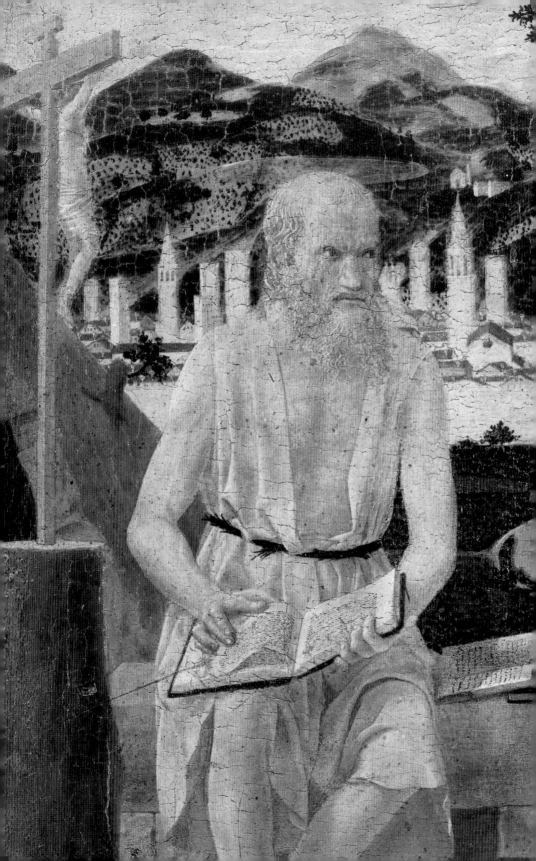

poverty? But Christ calls the poor blessed. . . . Does the unkempt hair of a neglected head cause you to shudder? But Christ is your head. Does the boundless expanse of the wasteland terrify you? Then do you walk in Paradise in your imagination."[80]

SAINT JEROME'S MODERNITY
IN THE RENAISSANCE

These ideas were both "ancient" and "modern" in Piero's day, for fifteenth-century Italy had its own Jerome figures, who kept the ideal of Christian solitude alive in the hearts of believers: monk scholars who fled the world in search of the "desert of Christ." The most famous by far was Saint Lorenzo Giustiniani (1381–1456), also known as Saint Lawrence Justinian, son of a noble Venetian family who, in his early twenties, had abandoned all to live a life of prayer and study with like-minded companions on San Giorgio in Alga, a desolate islet in the Venetian lagoon. From his knowledge of Scripture and the early Church Fathers, Lorenzo—who years later was named bishop and first patriarch of Venice—drew the material for short treatises on the spiritual life, with titles that suggest the background of our panel: *De vita solitaria, De interiori conflictu animae, De contemptu mundi* ("On the Solitary Life," "On the Soul's Inner Struggle," "On Detachment from Worldly Things"). A biography by his nephew Bernardo, published in Venice in 1475, similarly evokes Lorenzo Giustiniani's wilderness asceticism in a substantial chapter on his hunger, thirst, nights spent in prayer, and every sort of bodily penance: *De siti, fame, vigilis et omni corporis attritione de dolorum tolerantia per omnem aetatem declarata.* [81]

For educated Renaissance laymen, the asceticism of Saint Jerome and of modern imitators like Lorenzo Giustiniani had a further implication, deeply felt in the antiquarian climate of

the age. Jerome, born circa 342 in the still "classical" world of late antiquity, had received literary training in the style of the Greco-Roman authors. After his conversion, this taste for pagan literature troubled him, however, and in a dream he saw himself chastised before the throne of Christ for preferring Cicero to sacred Scripture. In the same letter in which he lyrically praised the advantages of Christian solitude to his friend Heliodorus, Jerome made clear that, for him, renunciation of the world included renouncing the pagan writers he had once so loved. Speaking of the day of final judgment, he says: "Then Jupiter with his offspring will be displayed truly on fire. Foolish Plato will be brought forward also with his disciples. The reasoning of Aristotle will not avail. Then you, the illiterate and the poor, shall exult."[82]

This was an "inner struggle" that early Renaissance Italy knew well, as humanist thinkers and writers became ever more aware of the beauty of the ancient classics, but also of the "danger" they represented, with their exaltation of a wisdom *not* rooted in Judeo-Christian beliefs. How to reconcile traditional Christian faith with the new taste for pagan philosophy and poetry? "What alliance can there be between the light and the shadows?" asked Saint Lorenzo Giustiniani. "What comparison of human learning with celestial wisdom? Celestial wisdom is delightful, speaks of mysteries, teaches the things of heaven, fills the spirit with faith, raises us up from lowliness to the highest regions! Human learning, on the other hand, scandalizes the ears, puffs itself up beyond all measure, is brought forth in vain ostentation, contradicts the holy simplicity of truth, detracts from the sentiment of faith, and alienates from Christ those who place their hope for salvation in detachment from the world."[83]

The resolution of this conflict, for Lorenzo Giustiniani in the fifteenth century as for Jerome a thousand years earlier, was a humble reorientation of one's literary tastes toward the Bible

and the writings of the Church Fathers. "To avoid the snares of human learning, there are the oracular messages of the prophets, the writings of the apostles, the vast erudition of the saints, who speak not for themselves but because Christ is in them."[84] The kneeling disciple in Piero della Francesca's panel seems to follow this advice, turning not to pagan but rather to Christian antiquity—to Saint Jerome who, as he expounds the "oracular messages of the prophets and the writings of the apostles," reveals Christ crucified, archetype of all renunciation, "celestial wisdom" incarnate.

LECTIO IN IMAGES

Piero della Francesca himself seems to follow Saint Jerome's program, composing this image as if it were a scriptural meditation. We have already noted that the scene unfolds between the severed trunk and the vital tree, and these elements in fact become the visual coordinates of a lectio divina of particular richness. The stump into which Jerome's crucifix is fixed alludes to an Old Testament passage that the Church has always understood as foreshadowing Christ's passion. Speaking of the enemies who had plotted his imprisonment, the prophet Jeremiah said: "I for my part was like a trustful lamb being led to the slaughter house, not knowing the schemes they were plotting against me, saying 'Let us destroy *the tree* in its strength, let us cut him off from the land of the living, so that his name may be quickly forgotten'" (Jer. 11:19).

The other tree—the one behind Jerome and his disciple—in its youthful vigor alludes to the Old Testament characterization of the Messiah as *germen* (in Saint Jerome's Latin) or *virgultus*: a sapling, a life-filled young tree, in many translations called "branch." The Lord will vindicate his people, Isaiah says, and on "that day, the branch of the LORD shall be beauty and glory, and the fruit of the

earth shall be the pride and adornment of Israel's survivors" (Isa. 4:2). In Jeremiah this young plant becomes a living person: "See, the days are coming—it is the LORD who speaks—when I will raise up a virtuous Branch for David, who will reign as true king and be wise, practicing honesty and integrity in the land" (Jer. 23:5); and in Zechariah the Lord says: "I now mean to raise my servant the Branch, and I intend to put aside the iniquity of this land in a single day" (Zech. 3:8–9); "Here is a man whose name is Branch; where he is there will be a branching out, and he will rebuild the sanctuary of the LORD" (Zech. 6:12).

This last reference—to a man who would "branch out" and "rebuild the sanctuary" destroyed in 587 BC, when Jerusalem was occupied by the Babylonian army—is an explicit allusion to Christ's resurrection. In fact, when critics asked Jesus by what right he had driven money changers from the twice-rebuilt Jerusalem temple, he had replied: "Destroy this temple, and in three days I will raise it up." His enemies failed to grasp Christ's meaning, but the evangelist John explains, right after the phrase "I will raise it up," that "he was speaking of the sanctuary that was his body, and when Jesus rose from the dead, his disciples remembered he had said this, and they believed the Scripture and the words he had said" (John 2:18–22). In Piero's panel, the Christ on the cross fixed to the severed trunk is turned toward the living tree, as if, even in death, the man "Branch" knew he would shoot up from the earth and restore the temple of his own body.

In Piero della Francesca's painting, Jerome and his disciple have the cross and severed trunk in front of them and thus have no difficulty seeing Christ's suffering. His resurrection remains a matter of faith, however, for the vigorous tree symbolizing new life is *behind* them; they will not see it unless they turn completely around— unless they "convert." Yet it is this faith that Saint Jerome, through the kind of textual analysis we have suggested, illustrates for his

friend: the belief that renunciation, sacrifice, even death for love of God and humankind are not weakness, not folly, but the wisdom and power of God himself, revealed in Christ's death and rising. The grave intensity of Jerome's gaze, as he explains these things to his friend, reminds us of Paul's description of his own teaching in the first Letter to the Corinthians: "In my speeches and the sermons I gave, there were none of the arguments that belong to philosophy; only a demonstration of the power of the Spirit. And I did this so that your faith should not depend on human philosophy but on the power of God" (1 Cor. 2:4–5).

SAINTS IN THE STUDY

The image of an ascetic immersed in nature who at the same time leads a life of erudition reflects an ideal rarely achieved in the Renaissance or in other periods. More realistic is the arrangement we find in other paintings, with Jerome seated in a well-equipped study, as in another work by Antonello da Messina, today in London (**fig. 72**), one of the most representative images of the early Italian Renaissance, practically the logo of the new interior and reflexive Christian humanism.

Beyond an elegant portal that also serves as picture frame, we see a vast Gothic hall softly lit by open windows, and—near the viewer but not in the first plane—the saint's study: a small wooden structure within the hall, intimate and practical because easily heated. Antonello has removed a few of its walls in order to offer for our admiration the figure of Saint Jerome robed as a cardinal; it is perhaps a portrait of one of the great humanists of the early fifteenth century, Cardinal Niccolò Albergati. Jerome's

72. Antonello da Messina, *Saint Jerome in His Study*, London, National Gallery

profile pose and the structure of the small study, parallel with the framing portal, are played off against the deep perspective views right and left, above and below, so that—just as in the act of study and in reflective thought—we see things simultaneously up close and far off, thanks to the artist's perfect mastery of the optical laws governing perspective and landscape. Curious and fascinating details abound: the books and valuable majolica vases; the shoes that have been removed and left at the foot of the stairs leading to the study (a reference to Moses, who had to remove his shoes before approaching the burning bush); and even the lion roaming free in the hall, at the viewer's right: the animal that, as tradition has it, Jerome had freed of a painful thorn in its paw. Yet Antonello skillfully focuses our gaze on the saint plunged in thought before his open book; the only other actors in the scene are light and space, both metaphors for spiritual values: the light alludes to Christ, "true light that enlightens all men" (John 1:9), and the scene's spatial interest suggests that progressive growth through which, according to Gregory the Great, saintly people increasingly dilate their inner world with works of mercy, knowing that "charity must not have boundaries, nor can Divinity be enclosed by any limit."[85]

Antonello's work is in effect a *sapiential* image in which the act of study is shown as prayer. Of the personage who here impersonates Saint Jerome we in fact want to say: "Happy the man who never follows the advice of the wicked, or loiters on the way that sinners take, or sits about with scoffers, but finds his pleasure in the Law of the LORD, and murmurs his law day and night" (Ps. 1:1–2). This cardinal seems to say to the God he has sought in the pages of his book (again in words drawn from a psalm): "I mean to meditate on your precepts and to concentrate on your paths. I find my delight in your statutes, I do not forget your word" (Ps. 119[118]:15–16); and to ask: "Do not

deprive me of that faithful word, since my hope has always lain in your rulings. Let me observe your Law unfailingly, for ever and ever. So, having sought your precepts, I shall walk in all freedom" (Ps. 119[118]:43–45). "I shall walk in all freedom": a clear reference to the sense of liberty and interior dilation that accompanies prayerful reading.

Another sensation accompanying lectio divina of Scripture is the joy that another Father of the Church, Saint Ambrose, describes with transport. "What can be sweeter than a psalm?" he asks and immediately answers with the psalmist's own enthusiasm, saying: "Praise the LORD —it is good to sing in honor of our God—sweet is his praise" (Ps. 146:1). Ambrose then opens an extraordinary parenthesis, emotionally defending this view:

Really! A psalm is in fact a blessing for the faithful, praise for God, a hymn for his people, everyman's applause, a universal word, the voice of the Church, profession and song of faith, expression of authentic jubilation, the sound of spiritual gladness. It mitigates wrath, frees from worries, relieves sadness. It is protection by night, instruction by day, a shield in time of fear, the festival of holiness, the image of tranquility, a pledge of peace and concord that, like a harp, fuses many and different voices in a single melody. The psalm sings the break of day and echoes still at sunset. In a psalm taste vies with teaching: at one and the same time we sing for pleasure and we are instructed. What do you fail to find when you read the psalms? In them I read "I sing of love," and I feel enflamed with holy desire. In the psalms I pass in review the graces of revelation, the testimonials of the resurrection, the gifts of God's promise. In the psalms I learn to avoid sin and to not be ashamed to do penance for my sins. What then is

a psalm if not the musical instrument of the virtues, playing which with the plectrum of the Holy Spirit the venerable prophet [David, held to be the author of the psalms] makes the sweetness of heaven's sounds echo here on earth?[86]

This literary image—of earthly listening, assisted by reading, to heavenly sounds—brings to mind another Renaissance representation of a humanist prelate: *Saint Augustine in His Study* by Vittore Carpaccio (**fig. 73**). Part of a pictorial cycle dedicated to Saint Jerome, this canvas shows the bishop of Hippo who, unaware that his friend Jerome had died, was writing him a letter when, all at once, he heard Jerome's voice from heaven announcing Augustine's own imminent demise and remained fascinated, practically enchanted. Light (always important in Venetian painting) here models Augustine's calm visage, creating reflections in the mosaics of the small apse above the altar and in the bronze statue of the risen Christ placed on the altar; the same light touches the little dog who, amid the books and art objects, becomes a natural symbol of the friendship binding the two saints.

Various details weave a Christian meditation on death. The letter Augustine was writing is laid over an open book on the saint's table, as if he had been quoting (and copying) a biblical text for Jerome; the voice he hears in this instant interrupts Augustine's writing, though, and his right hand remains suspended, the pen between his fingers.

He raises his eyes to the window, where we see an armillary sphere (a globe model with the planets and other celestial bodies), as if—learning of his friend's death—Augustine's thoughts turned to the heavens. His reflection seems indeed to be related to Christ's paschal mystery, as is suggested by the figure of the risen Christ on the small altar where Augustine must

normally say Mass: in the cupboard beneath the altar we see candles and other items needed to celebrate. And at the viewer's left a prie-dieu in front of a chair, beneath a shelf of books, obliges us to conclude that this place of study is also an oratory in which Augustine is wont to pass from reading (perhaps of a biblical commentary by his friend Jerome) to prayer. The fluid components of the meditation developed in this image are *books*, *human relationships*, and *prayer*.

LECTIO AND VISIO

As Carpaccio's painting suggests, it is easy to pass from books to other cognitive experiences, one of which is mystical rapture. This passage is the explicit theme of a masterpiece of late fifteenth-century Florentine art, Filippino Lippi's *Vision of Saint Bernard of Clairvaux* (**fig. 74**).

The subject is an event made famous in the thirteenth-century Golden Legend (*Legenda aurea*): a mystical vision in which Saint Bernard of Clairvaux, a monk-theologian who had often written of Mary with poetic force, in a moment of weakness was visited by the Virgin herself, who restored his courage. Filippino Lippi's interpretation underlines both the privacy of this experience and its mystic intensity, situating Bernard in a sort of rustic study where the books required for his work are arranged in the irregularities of the rock formation, and a tree trunk supports the lectern on which Bernard, robed in the white habit of the Cistercian Benedictines, is shown leaning.

The two following pages:

73. Vittore Carpaccio, *Saint Augustine in His Study*, Venice, Scuola di San Giorgio degli Schiavoni

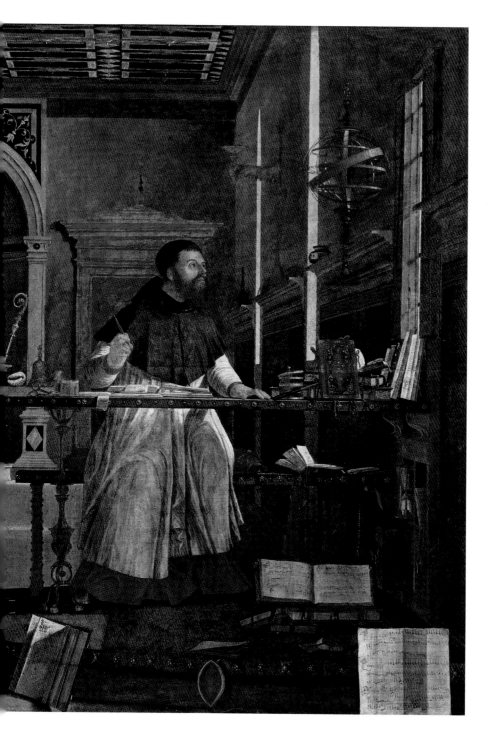

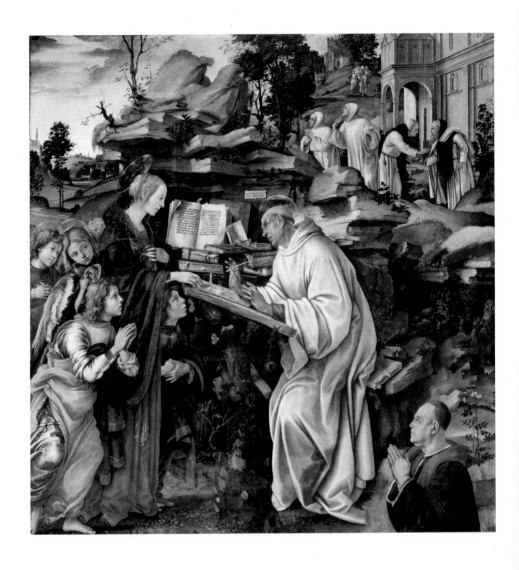

74. Filippino Lippi, *The Vision of Saint Bernard*, Florence, Badia Fiorentina

The saint had been writing on the theme of the Annunciation: the open book in the center of Filippino's composition shows the relevant text from Saint Luke's Gospel, its words perfectly legible. Now, however, Bernard lifts his eyes and sees Mary enter, escorted by angels. That is, he sees an "annunciation" in which the roles are reversed: Mary comes to him just as Gabriel had come to her, to announce salvation. The Virgin, pale and hesitant as if she personally experienced the exhaustion of her troubadour, places her hand on the page where Bernard had been writing, and the saint lifts his own hands and looks at Mary in astonishment; in his expression we see love and dawning understanding.

This entire episode is isolated in the foreground of the picture: the other monks, beyond the rock formation, do not see Mary but only a light in the sky. We by contrast, like Bernard himself, see firsthand the help Mary gives the saints: Filippino concentrates our attention on the large figures in the foreground, enclosing the event in the close-packed "psychological space" that extends from the viewer to the wall of rock. An inscription on the frame suggests the meaning this painting had for the man who commissioned it, Piero di Francesco del Pugliese, shown in prayer on the right: *In rebus dubiis Mariam cogita, Mariam invoca* (In matters which raise doubts, think of Mary, invoke Mary).

Among works that similarly illustrate "vision" stimulated by reading, two paintings by Lorenzo Lotto deserve our attention. One is a portrait of a friar of the Jeronimite order, a certain Fra Gregorio Belo, who, book in hand, beats his breast as he looks out at the viewer (**fig. 75**). Behind Fra Gregorio, the painter reveals what this follower of Saint Jerome was reading about: the crucified Christ, who here indeed seems to be an imagined projection of the friar's reading; the energy with which Gregorio

75. Lorenzo Lotto, *Fra Gregorio Belo*, New York, Metropolitan Museum of Art

76. Lorenzo Lotto, *Christ's Farewell from His Mother, with Elisabetta Rota,*
Berlin, Staatliche Museen, Gemäldegalerie

Belo expresses compunction for his sins confirms that what he has read and in some sense also "seen" has touched him deeply.

An analogous view of the imagination at work is provided by a small image depicting a subject from Christian legend, Christ's farewell to his mother when he left for his ministry and passion (**fig. 76**). In the magnificent hall where this occurs, the artist includes the woman who commissioned the work, one Elisabetta Rota, who, as she reads, imagines Mary's suffering when her Son left for Jerusalem and his death. This apocryphal event was in fact described in a book published in 1493, *Devout Meditations on the Passion of Our Lord, Drawn from the Writings of Saint Bonaventure, Franciscan Cardinal,* which may be the volume that Elisabetta Rota has in her hands.[87] A year earlier this woman, the wife of Domenico Tassi of Bergamo, had been present when her brother-in-law, Alvise Tassi, bishop of Recanati and Macerata, was murdered; the awful anguish of Mary at the imminent separation from her Son should probably be understood as a mental projection of Elisabetta's inner state as, reading, she interprets the sacred event in light of her own traumatic experience. The enclosed garden in the background, an allusion to the Song of Songs, and the undisturbed bed visible in an inner room remind us that, in addition to being virgin and mother, Mary is also, spiritually, *sponsa Christi*: Christ's bride. In the spacious freedom of her meditation, perhaps Elisabetta Rota too has bridal sentiments as she thinks of Christ.

The process by which, as they read, believers pass from the words in front of them to prayer, and from this then to mystical intimacy with Christ, is suggested in a treatise published in 1497,

77. *Ladder of the Seven Virtues of Prayer*, from Girolamo Savonarola, *Epistola a tutti gli eletti di Dio*, printed in Florence by Bartolomeo de' Libri, after August 14, 1497, Florence, Biblioteca Nazionale Centrale, Cust. D 1, c. f4v

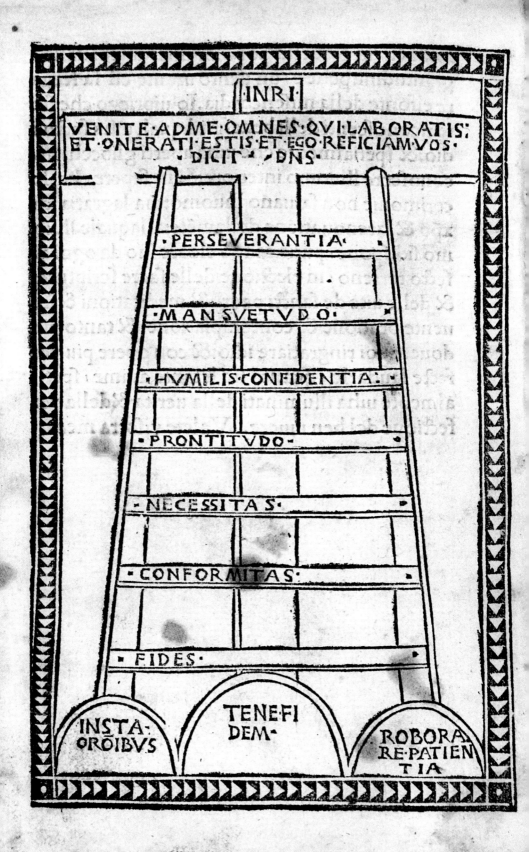

where a woodcut illustrates the stages of spiritual ascent toward the One who, from his cross, extends the invitation: *Venite ad me omnes qui laboratis et onerati estis et ego reficiam vos* (Come to me, all you who labor and are overburdened, and I will give you rest) (Matt. 11:28; **fig. 77**). These words are in fact written on the transverse beam of the large cross, and we thus understand that, if the goal that beckons is of hard wood, the steps leading to it will be comparably hard. Christ's cross is supported by a rock placed in the center, at its base, labeled *Tene Fidem* (Keep the faith), and in fact the first step of the ladder is *fides* (faith), followed in ascending order by *conformitas* (conformity to Christ), *necessitas* (the felt need of him), *prontitudo* (promptness in responding), *humilis confidentia* (humble confidence), *mansuetudo* (gentle docility), and—the last step before being embraced by Christ on the cross—*perseverantia* (perseverance). In its turn, however, this ladder on which believers respond to the invitation of the crucified bridegroom is supported, at right and left, by rocks that stand for prayer and patience: *insta oroibus* and *roborare patientia*. The starting point of the ascent to Christ is unceasing and patient prayer.

This image, which here is reproduced from a pamphlet entitled *Epistola a tutti gli eletti di Dio* ("A Letter to All God's Elect"), appears again in the *Operetta della Oratione Mentale* ("Short Work on Mental Prayer"), by the same author, the Dominican preacher Girolamo Savonarola. Both publications contain letters, rules, and sermons in which Savonarola exhorts his readers to pray inwardly, indicating the moral and psychophysical conditions appropriate to this activity. "Be gentle-minded, humble, chaste, honest, sincere, charitable, ever energetic in saying prayers, without anger or hatred"; "Do not desist but remain calm in prayerful silence asking that God free you and others like you and the Church from the hands of the lukewarm and the wicked,

and continue in this prayer until you are heard"; "The second rule is to pray assiduously, for frequent and attentive prayer strengthens human beings in all the virtues"; "Let all your hope and consolation be in Jesus Christ crucified."[88]

The ideal of assiduous prayer focused on the crucified Christ assumed solid form, in the century after Savonarola, in the great bishop of Milan, Saint Charles Borromeo, shown in a painting of 1628 reading in front of a crucifix and weeping as he mortifies his body through fasting (**fig. 78**)—one of many similar depictions of this personage who had died in 1584 and been canonized in 1610. The theme of Saint Charles praying as he reads in fact transmits the conviction of his contemporaries that this holy shepherd whom God had given the Milanese Church had himself been a "visible word"—practically a biblical icon.

In the painting reproduced here, the saint's deep emotion recalls the words of a writer converted to Christianity a thousand years earlier, Augustine of Hippo, baptized by Charles Borromeo's distant predecessor as bishop of Milan, Saint Ambrose. As if describing Saint Charles's lectio before the crucifix, Augustine says: "The presentation of truth through signs has great power to feed and fan that ardent love by which, as under some law of gravitation, we flicker upward or inward to our place of rest. Things presented in this way move and kindle our affection far more than if they were set forth in bald statements. . . . The emotions are less easily ignited when the soul remains absorbed in material things, I believe; but when led to material signs of spiritual realities, the soul gains strength in the very act of passage from the material to the spiritual, just like the flame of a torch that, as it moves, burns ever more intensely."[89]

The two following pages:
78. Daniele Crespi, *Saint Charles Borromeo's Fast*, Milan, Santa Maria della Passione

From the way in which Saint Charles is shown in paintings that describe his relationship with the traditional signs of Catholic life, it is clear that he learned from them how to become a sign himself—just as he learned from images how to let himself be transformed into a living icon of Christ. This process reached its high point during the Milanese pandemic of 1576–77, when Charles risked his life to minister to plague victims, offering himself as an image not only of the Christian who, visiting the sick, visits Christ (see Matt. 25:43–45), but of Christ himself, "anointed . . . with the Holy Spirit and with power . . . [who] because God was with him . . . went about doing good and curing all who had fallen into the power of the devil" (Acts 10:38). Indeed Charles Borromeo would die on November 3, 1584, before an image of *Christ's Prayer in the Garden of Gethsemane*—a small painting by Giulio Campi today in the Ambrosian Library in Milan—on which a later inscription informs the viewer that *Carolus mentis corporisque oculos in hac tabella defixos habens, animam Deo reddidit* (With the eyes of both mind and body fixed on this painting, Charles gave his soul back to God). Thus at the moment of his birth to heaven, Charles Borromeo was looking at a human image of the divine Image, Christ, whose gospel the saint had illustrated with his life.

A final work will serve to complete this brief look at lectio divina: the painting entitled *Three Women in Church* by the German master Wilhelm Leibl, born in 1844 at Cologne, the ancient Catholic stronghold in southern Germany, and trained at the Munich Academy of Fine Art (**fig. 79**).[90] The work depicts three women—two of them old, the third young—at prayer in

79. Wilhelm Leibl, *Three Women in Church*, Hamburg, Kunsthalle

the baroque pew of a church that we should probably imagine as Catholic, given the artist's background. The extreme realism with which Leibl treats the women's faces and clothes calls to mind both the great art of the German Renaissance—Albrecht Dürer in particular—and the new art of photography then radically altering how we see people and things. The emphasis on reading as an occasion of prayer for two of the women is similarly timely: in the later nineteenth century, the German-language Catholic book industry saw the emergence of dynamic publishing houses like the Benziger Brothers of Einsiedeln (with branch offices in the United States, where many Bavarian Catholics had emigrated), and Franz Schemm of Nuremberg. These publishers produced works of instruction and edification considered to be of strategic importance in a Germany united under Protestant Prussia: one thinks, for example, of a delightful small volume on prayer, *So sollt ihr beten!*, published by Karl and Nikolaus Benziger in 1883, the year after Leibl finished his painting. The frontispiece, adorned with the papal coat of arms and the designation "Printers to the Holy See," specifies that the work is a little book of prayers and meditations for Catholic Christians (*für katholische Christen*); the text is enriched with several images, of which one shows a child in prayer and another, printed right across from the first, shows Jesus teaching the Our Father to his disciples: *so sollt ihr beten*, you should pray in this way!

Particular interest attaches to the social condition of Leibl's women, who are country folk, as we see especially in the youngest, in the foreground, dressed for a village festivity, with a carefully ironed apron on which rest big, rough hands, destined in time to become like those of the other two. Leibl, who after a short time spent in Paris had chosen to live in the upper Bavarian countryside, in fact illustrates a new cultural reality of nineteenth-century Europe, the spread of literacy to rural populations (we

should note, however, that the woman at our left still prays simply, without a book). The painting celebrates reading as a democratic form of prayer, that is, whereas the art of earlier times presented lectio as belonging exclusively to the Fathers and Doctors of the Church and to the humanists who rediscovered their writings. It is true that the treatises by Savonarola and other spiritual writers of the late fifteenth century were intended for ordinary people, but for city dwellers, not country folk. By contrast, at the dawn of our contemporary era Wilhelm Leibl exalts the reading of sacred or devout texts as a means of sanctification for all.

¶ Tractato diuoto & tutto spirituale di frate Hierony
mo da Ferrara dellordine de frati Predicatori in defen
sione & comendatione delloratione mentale
composto ad instructione, confirmatione,
& consolatione delle anime deuote

P OPVLVS Hic Labiis
me honorat: cor autē
eorum longe est a me.
Sine causa autē colunt
me docētes doctrinas & mandata
hominum. Matthei. xv. Aučgha
che sia noto & manifesto a ciasche
duno igegno, etiam mediocremē
te istructo nella religione christia

a i

Chapter Six

CONTEMPLATIVE PRAYER

Prayer here on earth prepares our direct vision of God in heaven. "Now we are seeing a dim reflection in a mirror; but then we shall be seeing face to face," Saint Paul says; and he adds: "the knowledge that I have now is imperfect; but then I shall know as fully as I am known" (1 Cor. 13:12). "Seeing" God means also *knowing* him, that is, and indeed man's vocation is to know God perfectly.

Prayer anticipates that goal. Saint Gregory the Great, interpreting the sense of Jesus's promise, "Anyone who enters through me will be safe: he will go freely in and out and be sure of finding pasture" (John 10:9), says: "He will go into faith, that is, and then out of faith toward vision—from the act of believing to contemplation—and find the pastures of eternal life."[91] In fact in contemplative vision we see and know the object of our faith, God.

The door to contemplation is Christ. "Anyone who enters through me," he says, "will be safe: he will go freely in and out and be sure of finding pasture." But the Christ we should contemplate is above all the One who, dying on the cross, revealed to the world his Father's love. "Let us fix our gaze on the blood of Christ," an author of the second century says, "in order to grasp how precious it is before God his Father; it was shed for our salvation and brought the grace of repentance to the whole world."[92] And that is precisely what the man and woman are doing in the work reproduced here (**fig. 80**), the introductory image to Girolamo

80. *A Man and a Woman in Prayer Before a Crucifix*, woodcut from Girolamo Savonarola, *Tractato divoto e tutto spirituale in dimensione e comendatione dell'oratione mentale ad instructione confirmatione et consolatione delle anime devote*, Florence, Biblioteca Nazionale Centrale, Cust. C 23, c.

Savonarola's pamphlet "Devout and Entirely Spiritual Treatise Defending and Commending Mental Prayer, for the Instruction, Strengthening, and Consolation of Devout Souls": kneeling before an altar, they are contemplating the image of Christ crucified.

In this example, both the specific instrument—a pamphlet meant for a broad public—and the ordinariness of the persons illustrated therein confirm that contemplation is not limited to mystics but constitutes a universal heritage. "Whoever . . . follows Christ in simplicity of heart will be nourished with food that is eternally fresh," Pope Saint Gregory continues, asking then: "What, indeed, are the pastures given these sheep if not the intimate delights of paradise, which are eternal springtime?" He concludes by affirming that "the pasture given the elect is the presence of the face of God, and as we contemplate it without fear of losing it, our soul feeds unceasingly on the food of life."[93] The fact that the man and woman who in the image contemplate Christ crucified are *kneeling before an altar* confirms, moreover, that a privileged context for such experiences is the Eucharist, whose deep meaning in fact nourishes individual prayer; here we can imagine that the two shown praying have remained after Mass, to prolong the sense of communion with God and neighbor that the Eucharist gives.

From the thirteenth century on, the Church has attributed particular importance to Eucharistic adoration, even outside the celebration of Mass, precisely as a form of contemplative prolongation of the liturgy. In so doing, it has extended to all believers a mystical intimacy once reserved for a few chosen individuals. In the Old Testament, for example, after the solemn liturgy introducing the chosen people into the Promised Land— the liturgy in which Moses read the book of the covenant and sprinkled the Israelites with the blood of sacrificed animals (see Exod. 24:3–8)—he together with Aaron, Nadab, Abihu, and

seventy elders of Israel ascended Mount Sinai where, on reaching the top, "they saw the God of Israel beneath whose feet there was, it seemed, a sapphire pavement pure as the heavens themselves. He laid no hand on these notables of the sons of Israel: they gazed on God. They ate and drank" (Exod. 24:10–11). To see God in fact means to satisfy the hunger and thirst that grip the human heart, and it is in this sense that, in the above-quoted text regarding the passage from faith to contemplative vision, Gregory the Great affirmed that whoever follows Christ in simplicity of heart "will be nourished with food that is eternally fresh."

It is in the Eucharist that Christians find the fullness of the experience of communion given to Moses and his companions on Sinai. Saint Thomas Aquinas, author of the Eucharistic hymn *Pange lingua*, says: *Et antiquum documentum novo cedat ritui* (Let the ancient text give way to the new rite). Written at the behest of Pope Urban IV for the institution of the feast of Corpus Domini in 1264, the hymn insists, however—in the spirit of Gregory the Great—that only through faith do we arrive at the vision of Christ in the consecrated host: *praestet fides supplementum, sensuum defectui* (when the senses fail, faith will lend what is wanting), and again: *Et si sensus deficit, / ad firmandum cor sincerum / sola fides sufficit* (and if sensory knowledge falls short, faith alone will suffice to give strength to sincere hearts). In the same way, in another hymn composed for Corpus Domini, *Lauda Sion Salvatorem*, Aquinas assures us that *quod non capis, quod non vides, / animosa firmat fides, / praeter rerum ordinem* (that which you do not understand, that which you do not see, is confirmed by living faith, beyond the order of nature).

Thanks in part to these hymns of Saint Thomas, still sung in the Church in their simple Latin, the adoration of the host has become a real school of contemplation in which even children

learn to look beyond material appearances in order to find God. The most beautiful of the hymns composed by the great Dominican theologian, *Adoro Te devote*, describes the religious and affective impact of this experience: *Adoro Te devote, latens Deitas, quae sub his figuris vere latitas: / Tibi se cor meum totum subjicit, / quia Te contemplans, totum deficit* (I devoutly adore You, hidden Divinity, / truly hidden beneath these figures [the bread and wine]: / My heart submits entirely to You, / and faints as it contemplates You). The hymn also touches upon the difficulty of faith in the Eucharist and the ultimate reason for which we should believe: *Visus, tactus, gustus in Te fallitur, / sed auditu solo tuto creditur. / Credo quidquid dixit Dei Filius, / Nil hoc verbo veritatis verius* (In You our sight, our sense of touch, and the capacity to distinguish tastes fail: / only hearing can be securely believed. / I believe what the Son of God has said: / nothing is truer than his word of truth).[94]

To which "word" of the Son of God is the hymn referring? Obviously to his assurance: "My flesh is real food and my blood is real drink" (John 6:55). But in the same discourse Jesus also said: "It is my Father's will that whoever sees the Son and believes in him shall have eternal life, and that I shall raise him up on the last day" (John 6:40). Hence simply seeing the host in which the Savior's body and blood are present introduces believers into eternal life, which is a sharing in his resurrection. This is the sense of the Eucharistic vision evoked by Moretto da Brescia in an altarpiece where two saints, adoring the host, contemplate Christ crucified and risen from the dead (**fig. 81**). This experience is not limited to saintly people but is given to sinners as well, if only they believe—as indeed *Adoro Te devote* affirms, explaining: *In cruce*

81. Moretto da Brescia, *The Eucharistic Christ with Saints Bartholemew and Rocco*, Castenedolo (BS), San Bartolomeo Apostolo

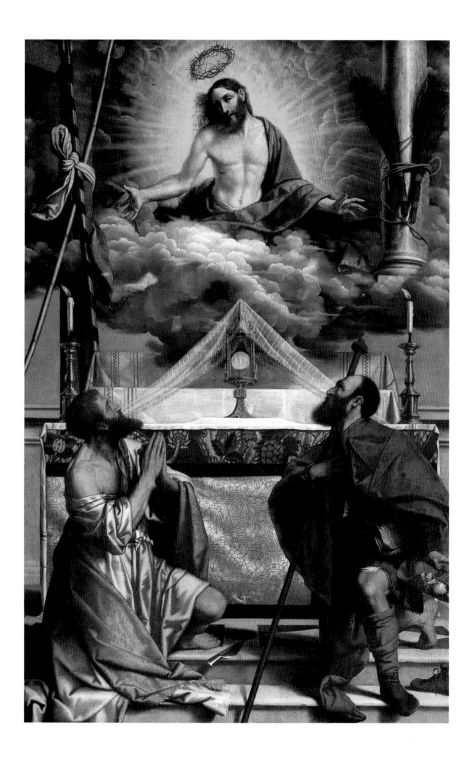

*latebat sola Deitas, / at hic latet simul et humanitas: / ambo tamen
credens, atque confitens, / peto quod petivit latro poenitens* (On the
cross only the divinity of Christ was hidden, /whereas here [in the
host] his humanity is hidden too: / yet, believing in the one and
the other [of his natures], and confessing both, / I ask that which
the penitent thief asked": to be with Christ in his kingdom, that
is (see Lk. 23:42).

And what does it mean to be with Christ *here and now?*
Contemplation, whether through the visible sacrament or with
the inner gaze alone, abounds in those "intimate delights" recalled
by Pope Saint Gregory, the extraordinary richness of which is
suggested by a contemporary of Thomas Aquinas, the Franciscan
Saint Bonaventure. Commenting on a verse of the fourth Gospel,
"they will look on the one whom they have pierced" (John 19:37),
Bonaventure imagines the wound in the Savior's side as a secret
place where every Christian is called to hide and exhorts his
reader: "Rise then, O soul friendly with Christ. Be like 'the dove
that makes its nest in the walls of a gaping gorge' [Jer. 48:28] . . .
bringing your mouth near to draw water from the springs of the
Savior [see also Isa. 12:3] Run . . . with live desire to this fountain
of life and light, whoever you may be, O soul consecrated to God,
and with the intimate force of your heart cry to him: 'O ineffable
beauty of the all-high God, O most pure splendor of eternal
light . . . O eternal and inaccessible, sweet and splendid flow of
a fountain hidden from every mortal eye! Your depth is endless,
your height limitless, infinite your breadth, imperturbable your
purity.'"[95]

THE HUMAN VOCATION TO CONTEMPLATE GOD

Contemplation of God in the mystery of Christ is not only
the final goal of human existence, but also its beginning. As God

made him, that is, man is a contemplative, and it is no accident that the Adam imagined by Michelangelo in the Sistine Chapel looks straight into the eyes of God as he waits to be touched with life (**fig. 82**). At the same time, we should recall that this is man *before he sinned*; after the fall he will no longer have as much courage, and in fact as soon as Adam hears the sound of God's steps in paradise, with Eve he hides "among the trees of the garden" (Gen. 3:8); only when redeemed will he again hope to see the Creator face to face; to be saved by Christ in fact means to aspire to see God.

That aspiration is a consequence of the grateful love that salvation stirs in human beings, as Saint Peter Chrysologus suggested in the passage of practically platonic emphasis already quoted in this text. "Love generates desire, increasing ardor, which tends toward the forbidden," he said. And he explained:

> Love cannot restrain itself from wanting to *see* what it loves; for this reason all the saints deemed what they had achieved to be little enough, if they did not succeed in seeing God. Thus the love that yearns to see God, while lacking in discretion, nonetheless has the ardor of piety. That is why Moses reached the point of saying: "If I have found favor in your sight, let me see your face."[96]

This ardent yearning is satisfied in Christ, as he himself confirmed, saying: "To have seen me is to have seen the Father" (John 14:9). Anyone who looks at Christ with faith sees God, that is, and once again it is Saint Bonaventure who describes the joy that flows from this experience. He characterizes the Savior as "the way and the portal . . . the ladder and the vehicle . . . the throne of mercy placed on the Ark of God" (see Exod. 26:34) and says:

The two following pages:
82. Michelangelo *Creation of Adam*, Vatican City, Sistine Chapel

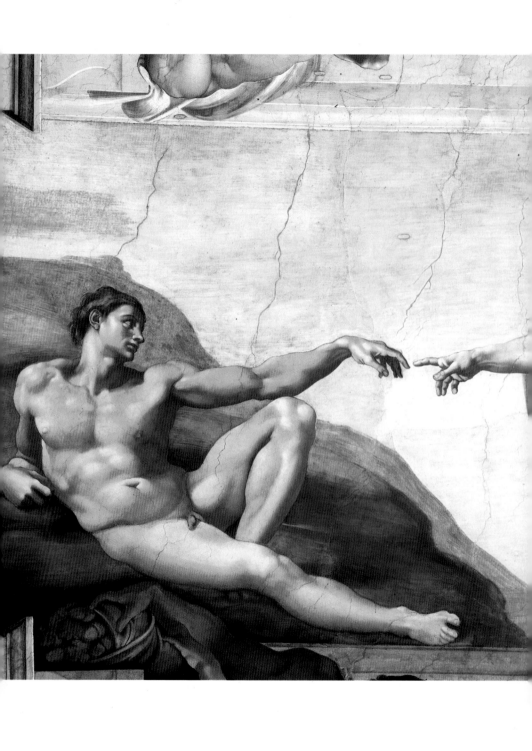

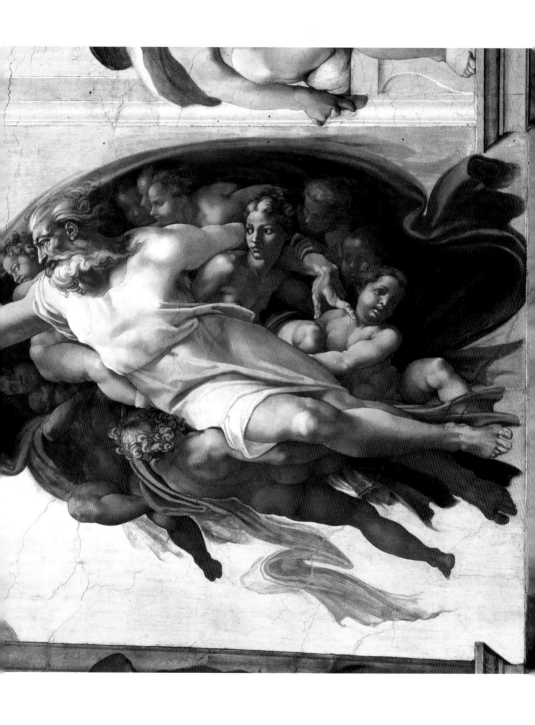

"The man who turns to this throne of mercy with absolute dedication and fixes his gaze on the crucified Lord by faith, hope, charity, devotion, admiration, exultancy, esteem, praise, and heartfelt jubilation celebrates the *Pascha* with him, that is, the Passover." Bonaventure then specifies the conditions required to "pass over" from mere vision of the man Jesus to the contemplation, in his crucified person, of the face of God: "For this passing-over to succeed, all intellectual activity must be suspended and every affection of the heart be transformed and transferred to God. This is a mystical and extraordinary condition known only to those who receive it, received only by those who desire it, desired only by those who are enflamed by the fire of the Holy Spirit, which Christ has brought to earth."[97]

Now, the Spirit brought to earth by Christ leads first to conversion and then to sanctification, and "God . . . is proposed to the contemplation of those who have purified their hearts," as Saint Gregory of Nyssa teaches, commenting on the promise of Jesus: "Happy the pure in heart: they shall see God" (Matt. 5:8);[98] indeed, in Michelangelo's fresco Adam's heart was still pure, we said. By contrast, for someone who has known sin, even when the sin is forgiven it remains difficult to see God, as Saint Gregory of Nyssa's full statement suggests: "God . . . is proposed to the contemplation of those who have purified their hearts. Yet 'no one has ever seen God' as the great John affirms [1:18]. Paul with his sublime intelligence confirms this and adds that 'no man has seen [God] and no man is able to see [him]'" (1 Tim. 6:16). Saint Gregory of Nyssa characterizes this inability of sinners to see God as a mountain impossible to climb: "This is that smooth rocky slope, slippery and steep, which in itself offers no hold or support for the concepts of our intelligence. Even Moses, in all he says on the subject, defined it as so impracticable that our mind cannot gain access, however hard it tries to hang on to something and

reach the peak." (Let us note that Michelangelo's Adam practically illustrates this idea, since he sees God but risks sliding down from the slope on which he reclines precariously, propping himself up with his bent left leg and right elbow.) "Do you understand how dizzy our mind feels when it peers into the depths of the questions raised in this discourse?" Gregory of Nyssa asks. And then he concludes, obviously thinking not of the first man, but of man saved in Christ: "Yet to see God constitutes eternal life. If God is life, then anyone who does not see God does not see life."[99]

MARY AND CHRIST CONTEMPLATIVES

To see God constitutes eternal life. The perfect contemplative then was Mary, who, pure of heart right from her conception, saw God in herself precisely as *Life*. An early sixteenth-century artist, Piero di Cosimo, shows her in these very terms, as a contemplative with ecstasy written on her face at the moment when—praying—she conceives the One who is Life, Christ (**fig. 83**). There can be no doubt that the subject of the painting is Christ's conception, since the iconographic formula normally used for this moment, the Annunciation, is in fact "carved" on the base of Mary's pedestal, and on the ground near the pedestal there is an open book—an allusion to the Word that becomes flesh in Mary's womb; indeed the artist makes the conception theme absolutely explicit, placing the Virgin's right hand on her womb. But Piero di Cosimo focuses our attention above all on the mystical jubilation with which Mary receives the Spirit, thus transforming a historical event into a spiritual happening, much as the Fathers of the Church were wont to do—Saint Augustine, for example, in his comment on the passage in Luke where, to a woman in the crowd who cried out to Jesus, "Happy the womb that bore you and the breasts you sucked," he replied:

83. Piero di Cosimo, *Mary Conceiving the Christ Child Beneath the Holy Spirit*, Florence, Uffizi

"Still happier those who hear the word of God and keep it" (Lk. 11:27–28). Augustine says: "Mary was happy for this very reason: she heard God's word and kept it. In fact she kept the truth in her mind even more than the flesh in her womb. Christ is truth, Christ is flesh, Christ is the truth in Mary's mind and the flesh in her womb. But what she bore in her mind counts for more than what she bore in her womb."[100] In the same vein Saint Leo the Great would later say that Mary "conceived the Son, the Man-God, first in her heart and then in her body."[101]

To keep Christ's truth in the mind in order then *to conceive the Savior in one's heart*: these are other ways of characterizing contemplative prayer. Speaking of this kind of experience, Saint John Chrysostom teaches that:

> prayer or dialogue with God is a supreme value. It is in fact intimate communion with God. Just as the body's gaze is clarified when it sees the light, so the soul straining toward God is illuminated by the ineffable light of prayer. . . . The soul, elevated through prayer to heaven, embraces the Lord . . . and, like a baby who cries out in tears to its mother, the soul ardently seeks the divine milk, yearning for its desires to be fulfilled and to receive gifts that are above all visible things. Prayer acts as an august messenger before God, at the same time giving happiness to the soul since it satisfies its aspirations. . . . Prayer is a desire for God, an ineffable love that does not originate in human experience but is produced by divine grace. Of it the apostle says that we do not know how to pray as we should, but the Holy Spirit intercedes for us with unutterable groans [see Rom. 8:26b]. If the Lord grants to someone to pray in this way, it is wealth to be used and enjoyed, a heavenly food that satisfies the soul; anyone who has tasted it burns with heavenly desire for the Lord, as if with intense fire that enflames his soul.[102]

Using John Chrysostom's terminology, we can say that, if in Mary the human capacity to burn with heavenly desire reaches perfection, in Christ her Son that capacity has its source. Addressing himself to the Most High during the Last Supper, Jesus would say: "Father, Righteous One, the world has not known you, but I have known you" (John 17:25a); he affirmed moreover that he and the Father were one, each in the other (John 17:21a; see also John 10:38 and 14:20). And it was Christ who asked that those whom the Father had given him might be with him in the place where he now is, "so that they may always see the glory" that the Father gave him because he loved him "before the foundation of the world" (John 17:24). It is Christ himself who wants us to be contemplatives, that is: Christ who has made his Father's name known and will continue to make it known, so that the love with which God loved him may also be in us, and so that Christ himself may be in us (John 17:26).

This communion between Father and Son, and Christ's will that his glory be contemplated by his disciples, become visible in a specific New Testament event, the Transfiguration, which is also the most important instance of prayer recounted in the Gospels prior to the Garden of Gethsemane. Eight days after the Savior's announcement of his own passion, accompanied by the mysterious assertion that some among his listeners would not taste death before they saw the kingdom of God (cf. Lk. 9:23-27), Luke recounts:

> He took with him Peter and John and James and went up the mountain to pray. As he prayed, the aspect of his face changed and his clothing became brilliant as lightning. Suddenly there were two men there talking to him; they were Moses and Elijah appearing in glory, and they were speaking of his passing which he was to accomplish in Jerusalem. Peter and his companions were heavy with sleep, but they kept awake and saw his glory

and the two men standing with him. As these were leaving him, Peter said to Jesus, "Master, it is wonderful for us to be here; so let us make three tents, one for you, one for Moses, and one for Elijah." He did not know what he was saying. As he spoke, a cloud came and covered them with shadow; and when they went into the cloud the disciples were afraid. And a voice came from the cloud saying, "This is my Son, the Chosen One. Listen to him!" (Lk. 9:28–35)

The most famous depiction of this event is the large altarpiece begun by Raphael Sanzio and completed by assistants after the master's death in 1520 (**fig. 84**). In the upper part of the canvas, painted entirely by Raphael, Christ appears in ecstatic prayer, his hands lifted in the ancient gesture, which here also alludes to the Cross announced eight days earlier; face and robes transfigured, he appears between Moses and Elijah, the representatives of the Law and the prophets. The Savior changes aspect—is "transfigured," that is—because, as he interrogates the ancient Jewish law and prophetic tradition of Israel, Jesus grasps that the Messiah must truly suffer and die; Luke's account of the event specifies that the subject of the conversation among the three was "his passing, which he was to accomplish in Jerusalem"—Jesus's death, that is. His *prayer* consisted of an act of inner acceptance, and it was then that the Father's voice resonated, recognizing Jesus as his Son, the Chosen One.

In the lower part of Raphael's composition a related event is shown: the New Testament episode immediately following the Transfiguration, the failed healing of an epileptic boy. The boy's father had brought him to Jesus's disciples, asking that they expel the demon that, from infancy on, had tormented the boy and nearly killed him, but the disciples were not able to do so: that in fact is the scene illustrated in the painting, the boy held by his father and the gesticulating disciples all around. When

Jesus descends from the mountain he will himself heal the boy, expressing indignation for what Luke calls the lack of faith of the disciples who had been unable to accomplish the miracle (Lk. 9:41); in Matthew's Gospel, too, when the disciples ask the Lord why they had been unable to heal the boy, he responds: "Because you have little faith" (Matt. 17:20a). In Mark, however, Christ answers the same question asserting that this particular kind of demon "can only be driven out by *prayer*"(Mk. 9:29). In Raphael's painting, the disciples in the lower area seem already to have understood that prayer is needed, and, while a few of them indicate the boy, others point to the mountain where the Savior is transfigured as he prays in preparation for his supreme act of prayer, the evening sacrifice on Calvary.

EXPERIENCES OF MYSTIC SAINTS

Analogously sublime moments characterize the experience of both Old and New Testament saints. Isaiah "saw the LORD seated on a high throne," surrounded by seraphs who cried out: "Holy, holy, holy is the LORD of hosts! His glory fills the whole earth" (Isa. 6:1–3); and Ezekiel beheld "a great cloud with light around it, a fire from which flashes of lightening darted, and in the center a sheen like bronze at the heart of the fire" and something like flaming brands or torches, along with what seemed like four winged animals, each with a wheel that went forward four ways (Ezek. 1:4–17). Daniel "had a dream and visions that passed through his head as he lay in bed" (Dan. 7:1), in which, among many other things, he saw an "Ancient of Days" whose throne was "a blaze of flames, its wheels . . . a burning fire," and before whom "one like a son of man . . . came to the one of great age and was led into his presence. On him were conferred sovereignty, glory, and kingship"

84. Raphael Sanzio, *Transfiguration*, Vatican City, Vatican Museum

on men of all nations and languages—"an eternal sovereignty that shall never pass away" (Dan. 7:9–14). In similar fashion John, the author of the Apocalypse, saw "a figure like a Son of Man" whose head and hair "were white as white wool or as snow" and whose eyes were "like a burning flame" (Rev. 1:12–14).

Often the texts narrating such experiences are difficult or, indeed, incomprehensible at the level of mere logic, since human language is in fact inadequate to communicate the reality contemplated by the saints. Speaking of one of his own mystical experiences, Saint Paul would say: "I know a man in Christ who, fourteen years ago was caught up—whether still in the body or out of the body, I do not know; God knows—right into the third heaven. I do know, however, that this same person—whether still in the body or out of the body, I do not know; God knows—was caught up into paradise and *heard things that must not and cannot be put into human language*" (2 Cor. 12:2–4).

Yet there is a "Word" that may be used to describe man's prayerful contemplation of God, and it is Christ himself, perfect expression of the Father. It is no accident that the first Christian mystical experience, the vision vouchsafed the deacon Stephen as he gave his life for Christ, bears the imprint of this "Word" that Christ is: "Stephen, filled with the Holy Spirit, gazed into heaven and saw the glory of God, and Jesus standing at God's right hand. 'I can see heaven thrown open,' he said, 'and the Son of Man standing at the right hand of God'" (Acts 7:55–56). But that word, that name, was intolerable to Stephen's persecutors, who "shouted out and stopped their ears with their hands" as they killed the man who pronounced it (Acts 7:57). In fact, simply to pronounce the name "Jesus Christ" constitutes prayer, and various ecclesial traditions invite believers to the mantra-like repetition of this name by which sinful humankind is saved.

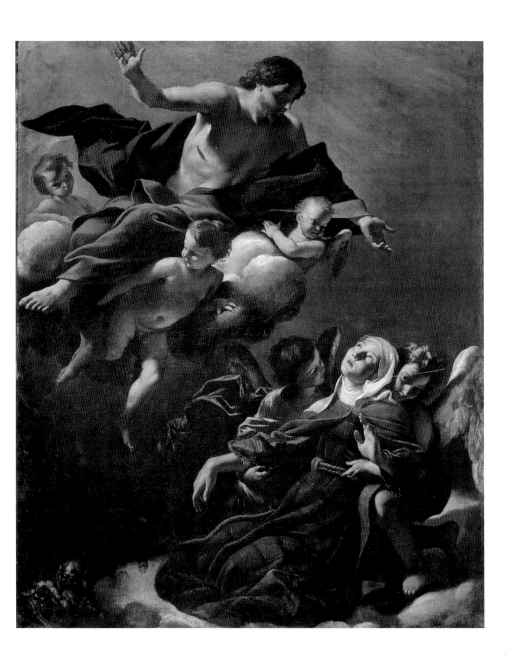

85. Giovanni Lanfranco, *Ecstasy of Saint Margaret of Cortona*, Florence, Palazzo
Pitti, Galleria Palatina

To say "Jesus Christ" means to also say "bridegroom," and not infrequently the mystical experience of his presence is verbalized in erotic language. "Let him kiss me with the kisses of his mouth," says the bride of the Song of Songs, speaking of a loved one whom the Fathers and Doctors of the Church have identified with Christ (S. of S. 1:2a). Loved in return, the bride then tells the bridegroom: "Delicate is the fragrance of your perfume, your name is an oil poured out, and that is why the maidens love you" (S. of S. 1:3). Among these "maidens" there have been many saintly women, and the visionary intimacy with Christ of the great female mystics became a standard subject of Catholic art in the seventeenth and eighteenth centuries, in part in reaction against Protestant skepticism about the possibility of such unitive experiences. Typical, in this respect, is Giovanni Lanfranco's *Ecstasy of Saint Margaret of Cortona*, in which the young Franciscan nun contemplates her youthful and handsome Lord as he draws near to her (**fig. 85**). The painting illustrates a dialogical reciprocity that, as in the Song of Songs, reveals to the chosen soul not only the beauty of the bridegroom, but its own beauty. "How beautiful you are, my love, how beautiful you are! Your eyes are doves," says the bridegroom of the Song; and the bride responds: "How beautiful are you, my beloved, and how delightful! All green is our bed. The beams of our house are of cedar, the paneling of cypress" (S. of S. 1:15–17).

The best known representation of this kind of experience is the grand Baroque "machina" created by Gian Lorenzo Bernini for the noble Venetian family of the Cornaro beginning in 1647: a chapel dedicated to the Spanish mystic Teresa of Ávila in the Roman church of Santa Maria della Vittoria. There, above the altar, in a sort of "chapel within the chapel," we see *Saint Teresa in Ecstasy*, a sculptural group comprised of an angel bearing an arrow and the woman wounded by divine love, Saint Teresa (**figs. 86–87**). The overwhelming force of this experience is conveyed

by the architecture of the niche in which it occurs, which bends forward, and by the wind that fills and disarranges the heavy fabric of Sister Teresa's Carmelite habit. It is communicated above all by the swoon into which she has fallen, going limp before the divine onslaught. The light in the chapel, filtered from a hidden source above Teresa, descends along "rays" of gilded wood to the saint's body, and a fresco in the chapel ceiling simulates the open sky, while clouds of painted stucco overlay the architecture, creating the illusion of a heaven that invades the material universe. The decidedly theatrical impression of the whole scene is confirmed by two loge-type boxes, at right and left of the altar, from which members of the Cornaro family assist as spectators at this intimate union of love between the saint's soul and God, transforming the entire chapel into a spiritual stage!

The subject itself, a totally absorbing experience of love between God and the human soul, fascinated Catholics of that time—not least because, as noted above, the more sober Protestant theology excluded such intimacy between creatures and the Creator. In Saint Teresa's case the intimate union had actually taken place: the documents relative to her canonization in 1622 in fact mention the experience later illustrated by Bernini, citing the saint's own description of this visionary episode; so too the cause of canonization of another Carmelite nun, Saint Mary Magdalene de'Pazzi, who had died in 1609, emphasize her mystical visions and "auditions." Italian late-seventeenth and eighteenth-century art saw an astounding proliferation of programs similar to that of the Cornaro Chapel, with trompe-l'oeil skies populated by male and female saints gazing into the empyrean space, their faces and gestures expressive of inner ecstasy. The meaning of these heavenly stage sets is suggested by an early eighteenth-century preacher, Canon Cesare Nicolao Bambacari, who specifies their devotional objective, articulating the hope that church interiors might

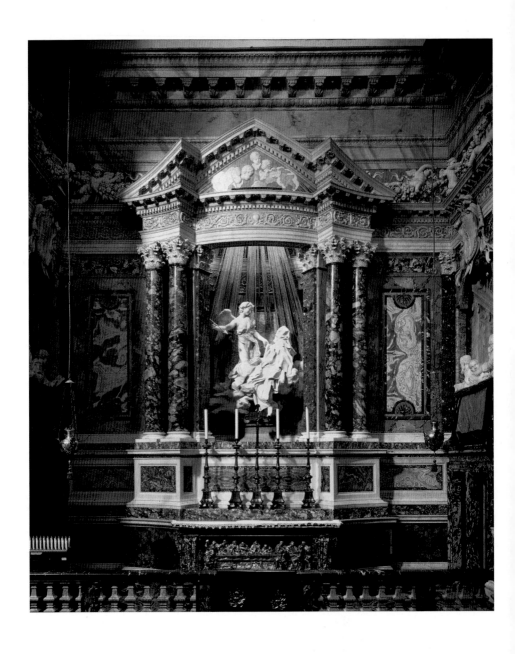

86.-87. Gian Lorenzo Bernini, *Ecstasy of Saint Teresa*, Rome, Santa Maria della Vittoria

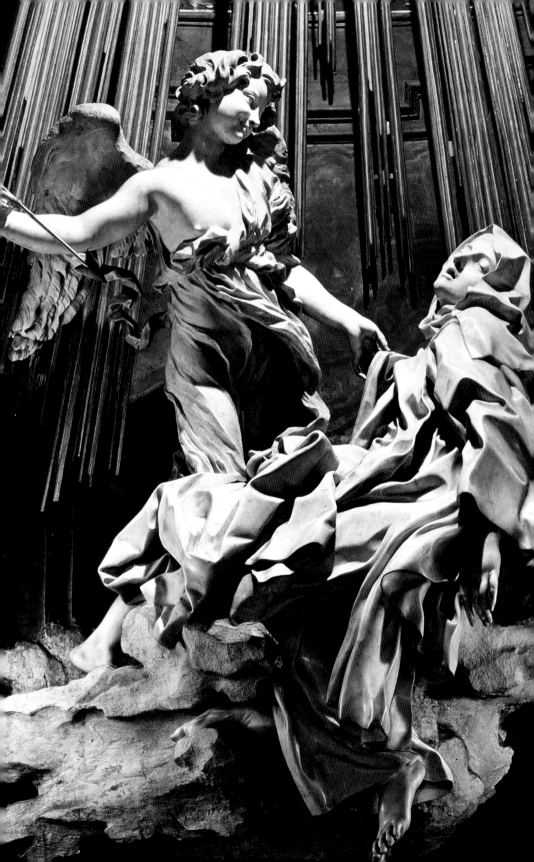

become "earthly portraits of paradise." The faithful should stand before the altar, he says, like the seraphim that Isaiah saw, "almost trembling with pious awe and veiling their eyes, as if fearful of the radiance of the majesty they adore."[103] Developing the same idea, another preacher of the period, a friar from Bergamo named Alessandro Terzi, insists that "as soon as a Christian enters a church, he should immediately clothe himself in a spirit of piety such that it carries him far from all profane matters, moving and elevating him to heavenly things."[104]

SIMPLER FORMS OF CONTEMPLATION

The language of these eighteenth-century preachers reveals the rhetorical bent of a popular mysticism once common in Catholic prayer texts. Alongside this visionary ideal, however, the post-Tridentine Church also developed simpler forms of contemplation, useful in every context of life, the first of which was "devotion"— that is, the consecration of normal everyday activity to God through prayer. According to Saint Francis de Sales, "the care of one's family is made lighter, the service of princes more loyal, and all other occupations sweeter and more amiable" thanks to the life of devotion. "It is an error," he says, "to want to exclude the exercise of devotion from the military sphere, from the artisan's workshop, from the court of a prince, from the home of a married couple. It is true . . . that the purely contemplative devotion of monks and members of religious orders can be practiced only in these states of life, but beyond these three types of devotion there are many others able to bring those who live in the world to spiritual perfection. Thus wherever we may be, we can and should aspire to a life of perfection."[105]

This principle was not new. More than a thousand years earlier, Saint John Chrysostom had written that "we should not raise

our soul to God only when we focus entirely on prayer. Even when we are engaged in other activities—helping the poor or doing other things perhaps made precious by generosity toward our neighbors—it is necessary to cultivate the desire and the recollection of God."[106] In this respect, particular interest attaches to an altarpiece by Bernardo Strozzi depicting Saint Augustine who, as he assists the poor, discovers Christ among them (**fig. 88**). Kneeling to wash a pilgrim's feet, the saint recognizes the wound of the Crucifixion in the man's right foot and understands that—just as the Gospel says—in welcoming a stranger he has welcomed Christ himself (see also Matt. 25:35b–40).

Augustine's astonishment as he penetrates exterior appearances and contemplates Christ standing before him is perhaps the most typical experience of this kind of "simple contemplation"; for those who cultivate "the desire and the recollection of God," there are in fact many life situations in which—in the midst of activities that do not constitute formal prayer—the believer's heart finds Christ and lovingly contemplates him, as Augustine does in Strozzi's painting. If we bear in mind, moreover, that this painting was an altarpiece and that the faithful saw Augustine's emotional gaze just above the elevated host, the idea of a penetration of external appearances to find Christ present in the ordinary activities of life assumes sacramental and specifically Eucharistic connotations. The first Christian experience of contemplative *penetratio* of ordinary things and events was, indeed, the supper at Emmaus, when two men who thought they were merely sharing a meal with an interesting fellow traveler had their eyes opened, "and they recognized him" as the Lord (Lk. 24:31a). This occurred while the mysterious traveler "was with them at table" and specifically when he "took the bread and said the blessing; then he broke it and handed it to them" (Lk. 24:30). The Eucharist is, in effect, the great school of contemplative prayer.

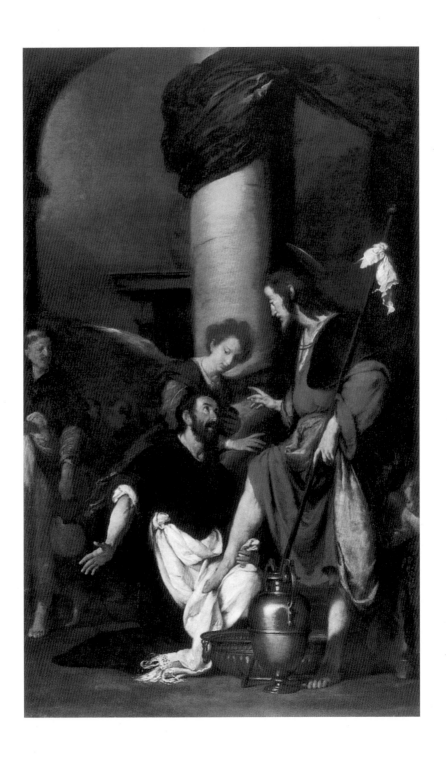

ART AND CONTEMPLATION

In images that, like Bernardo Strozzi's altarpiece, are tied to the Eucharist, the faithful are invited to seek—just as they do in the Eucharist itself—something more than what they see with their eyes: something that can radically change their lives. In its sacramental theory and practice, from early Christian times onward the Church has in fact taught believers to expect such a transformation and to see in it the fulfillment of God's plan. Commenting on the "sign" of water turned into wine at Cana, Faustus of Riez, an early Church Father, said: "The water is suddenly transformed, and it will later transform men"; he moreover specified that "when one thing springs from another by an internal process, or when an inferior creature is, by a secret conversion, lifted to a higher state, we see a second birth." [107]

This "second birth" is in essence a new life, for—as Gregory of Nyssa taught—"our very nature has undergone a change" such that we have "a different life and a different way of living."[108] In the same vein, Cyril of Alexandria said: "The Spirit transforms those in whom he dwells into another image, as it were," and cited Saint Paul, according to whom "all of us, with uncovered visage and reflecting the Lord's glory as in a mirror, will be transformed in that same image, from glory to glory, according to the action of the Spirit" (2 Cor. 3:18).[109]

In the context of this book on the role of sacred images in prayer, we can say that art associated with the liturgy illuminates a fundamental expectation of believers, announcing a longed-for spiritual transformation by its own transformation of matter. More important, sacred images mirror—in the personages and events they illustrate—that Image in which believers themselves

88. Bernardo Strozzi, *Saint Augustine Washing the Feet of Christ*, Genoa, Accademia Ligustica

hope to be transformed, and indeed in this specular logic, an artwork's iconographical subject is not confined to the personage or event represented, but always includes those who contemplate their own lives in the image even as they await transformation. Such "intersubjectivity," moreover, touches both individuals and groups: the few worshipers present at daily Mass and the parish community fully assembled on Sundays and feasts. All are "edified"—inwardly *built up*—by images seen as they hear Mass, because in that situation the images are not merely "seen" (just as the Mass is not merely "heard"), but rather *taken part in* and *lived* in ever new intersubjective configurations. This mystically intense relationship with the image persists even when the Mass comes to an end; looking again at the introductory image of the present chapter—the Savonarola print of a man and woman who contemplate Christ in the crucifix (**fig. 78**)—let us again note that they do so *in front of an altar* and that their individual prayer somehow prolongs the Eucharistic liturgy.

From the Mass liturgy, in which Christians learn "not to look upon the Eucharistic bread and wine as if these were simple, common elements"[110] but to await "new and extraordinary changes"[111], believers learn to look beyond the surface of images, in the hope of one day *possessing* that which, for the present, art only lets them *see*. And occasionally, in this interweaving of rites and images and in the time-out-of-time of contemplation, "seeing" and "possessing" may actually converge or even coincide. This is the case in a canvas by Annibale Carracci depicting Saint Francis of Assisi in intense prayer as he contemplates a crucifix propped up on a skull (**fig. 89**); beneath the skull, a piece of paper bears the words: *Absit mihi gloriari nisi in cruce Domini mei, in qua est salus, vita et resurrectio nostra* (Let me glory only in my Lord's cross, in which is our salvation, our life, and our resurrection) (see Gal. 5:14 and the introit of the Holy Week Mass liturgy). But Francis already

possesses that which he sees, having been conformed to Christ by the stigmata, clearly visible in his hands.

Observing the visceral adoration through which Francis here identifies with the crucified Christ, we want again to quote words written by one of the saint's early followers, the theologian and mystic Bonaventure. After having explained that "this is a mystical and extraordinary condition known only to those who receive it," Bonaventure addresses those who might wish to emulate the intense prayer of the saints, saying:

> If you want to know how all this comes about, inquire of grace, not of learning; ask your desire, not your intellect—the sigh of prayer rather than the hunger to read, the bridegroom rather than the teacher, God, not man. Ask obscurity rather than clarity; not light but the fire that enflames our whole being and buries it in God, with his sweet anointing and ardent love. This fire actually *is* God and this furnace is found in the holy city, Jerusalem; it is Christ who ignites one and the other with the heat of his burning passion. The only way to feel it is to say: "My soul has preferred to hang on the cross and my bones have chosen death" [see Job 7:15]. In fact, only someone who loves death may see God, for in spite of everything it remains true that "man cannot see me and live" [Exod. 33:20]. Let us die therefore; let us enter this darkness. Let us silence temptations, worldly desires, fantasies. Let us pass from this world to the Father with Christ crucified, so that, after seeing him, we can say with Philip: "This is enough for us" [John 14:8]. With Saint Paul let us hear the words, "My grace is sufficient for you" [2 Cor. 12:9], and let us rejoice with David, saying: "My flesh and my heart are pining with love, but the rock of my heart is God: God is my portion forever" [Ps. 73:26]).[112]

89. Annibale Carracci, *Saint Francis Adoring the Crucifix*,
Rome, Pinacoteca Capitolina

PURITAS CORDIS

Punctuated with dramatic terms like "darkness," "fire," and "ardor," Bonaventure's language has great emotional impact: it is late-medieval and Franciscan in character. Yet Bonaventure's opening phrases—those in which he invites believers who pray to inquire of grace, not of learning, of desire not intellect, of prayer's sigh rather than of the human hunger for information—belong to the more ancient contemplative tradition elaborated by early monasticism in response to Christ's words, cited above: "Happy the pure in heart: they shall see God" (Matt. 5:8). Even Saint Francis, for all the affective intensity of his absorption in the *Passio Christi*, was part of this tradition, whose ideal was expressed in the Greek term *apatheia*. This word did not originally have the meaning it has assumed in modern languages—of apathy, lack of interest, negative detachment—but, rather, of *puritas cordis*, purity of heart. *Apatheia* as used by one of principal personages of the fourth-century Eastern monastic world, Evagrius of Pontus, in fact was translated by his disciple John Cassian, who had emigrated to Italy, with the expression *puritas cordis*.[113] John Cassian's writings are among the sources cited by Saint Benedict in his Rule for Monasteries, together with the so-called Rule of Saint Basil and the "Lives" of the Egyptian Desert Fathers, and are thus quite literally fundamental to the Western prayer tradition transmitted by Benedictine monasticism.

Evagrius, appointed lector by Saint Basil and ordained deacon by Saint Gregory Nazianzen, was among the participants at the second Council of Constantinople together with Saint Gregory of Nyssa. Later he would abandon everything to go to Jerusalem, where he made Saint Jerome's acquaintance and like him led a life of prayer and study; from Jerusalem Evagrius moved finally to eastern Egypt, where—living with the desert monks—he wrote important treatises on ascetical spirituality. The asceticism he

proposed as the spinal column of Christian prayer life was later adopted by the Syrian and Armenian churches, and—in the works of imitators and disciples—at last returned to the Byzantine world to influence the spiritual theology of John Climacus and Gregory Palamas; through Palamas it became part of the spiritual current known as hesychasm, which gave birth to the Orthodox manual of spiritual theology known as the *Philokalia* (which in the Russian version contains the whole text of Evagrius's *Praktikos*). Thus for Constantinople and later for Moscow, as previously for Montecassino and Rome, the "Evagrian" ideal of apatheia was part of the Christian tradition of prayer.

In the system elaborated by Evagrius, after a preliminary disciplinary phase, in which the passions are brought under the control of the will, a believer proceeds to the "contemplation of nature" (*theoria physike*), in which he learns to know things as they really are, thus arriving at a life morally commensurate with such knowledge. From this springs the third and final phase of the system, the "contemplation of the Most Holy Trinity" (*theoria tes hagios triados*), or, otherwise put, the serene contemplation of God in himself, the distinctive quality of which is precisely apatheia or purity of heart in the peaceful possession of truth. The source of this contemplation is God himself and its end is total union with him— the condition that in the West is known as the "beatific vision."

But how can so exalted an objective, and one so far from everyday experience, be translated into images? Christian art has tried various solutions, among which the intentional "expressionlessness" of the personages in Eastern icons. In the West, starting in fifteenth-century Italy, the idea of a purity of heart that makes it possible to see God came to be expressed through representations of young children; this in fact is a further level of meaning of the children carved by Luca della Robbia for the Florence cathedral choir lofts, discussed in our third chapter (**fig. 90**; see also fig. 48).

I wish to conclude the present chapter with another work in which little children symbolize the purity of heart required of those who want to see God. It is the small *Sacred Allegory* by Giovanni Bellini (**fig. 91**), of uncertain date, in which the artist deconstructs the format he himself had perfected for sacred conversations, redistributing the figures in a more ample space— as if the personages of the San Giobbe altarpiece, after a formal group photograph, had returned to their habitual pastimes (in effect, the Saint Sebastian and the Saint Job on the right of the *Sacred Allegory* repeat the poses of the same figures in the Saint Job altarpiece: see chapter 1, fig. 21). The atmosphere is meditative, as in a sacred conversation, with hieratic elements like the Virgin's high throne and several personages in the poses of court functionaries; yet the overall impression is informal, thanks to the casual arrangement of the children playing in an enclosed, paved foreground area; this informality is also conveyed by figures just outside the enclosed area, shown leaning on the balustrade, and by the infinite variety of nature, here celebrated in an exceptionally beautiful lake-country landscape.

It is hard to give a precise interpretation to the many diverse features of this image. Clearly Giovanni Bellini wants to juxtapose "heaven" and "earth," distinguishing the enclosed foreground area organized in linear perspective from the irregular natural world of the background. In this "heaven" Mary and the saints contemplate the innocent game played by the children, one of whom must be Jesus: the one who grasps the trunk of the little tree to shake it, bringing down the fruit that the other children gather. Significantly, the vase containing this tree is placed at the center of a pavement design with inlaid marble slabs forming a cross, and on the promontory at the right, above saints Job and Sebastian, we see a cross in the natural world as well—not ideal but real. Just below this cross there is a centaur; to the left, then,

we see a shepherd seated in a cave and, on the far bank, various personages go about their business near a city at the foot of a hill protected by a distant castle.

Whatever its meaning, the *Sacred Allegory* is not an altarpiece but the kind of painting that German art historians call an *Andachtsbild* (devotional image)—a picture serving individual meditation, whose subject, suggested by the patron, may be extremely personal. In similar images, as in meditation itself, the link between one concept and another tends to be fluid, poetic rather than logical; here we grasp allusions to a divine order juxtaposed to the order of nature, and to innocence, and to the cross; but the only element that really unifies the various parts of the composition, together with light, is the landscape, whose breathtaking beauty envelopes and in some curious way "explains" the figures. Does the overall meaning of the image perhaps have to do with "the world saved by the sacrifice of Jesus, the Innocent One"?

Let us add a final observation, though: in early Renaissance art, the presence of small children also evokes the ancient classical usage of symbolizing love with the figure of Cupid, the son of the goddess of beauty, Venus. Evagrius had exploited this elegant literary conceit, asserting that apatheia too had a son, called *agape*—instead of the pagan Venus, that is, Christian purity of heart; and instead of *eros*, *agape*, the fraternal love also known as charity.[114]

In Evagrius's system, the task of charity is to guard the door to the heart, opening it to the truth about the material world and men, from which we then advance to the contemplation of God, the Father, the Son, and the Holy Spirit.[115]

90. Luca della Robbia, Cantoria, Florence, Museo dell'Opera del Duomo, detail

The two following pages:
91. Giovanni Bellini, *Sacred Allegory*, Florence, Uffizi

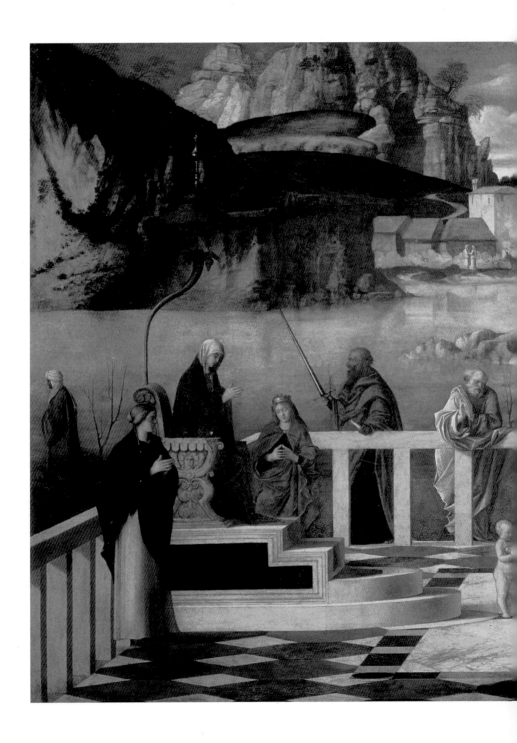

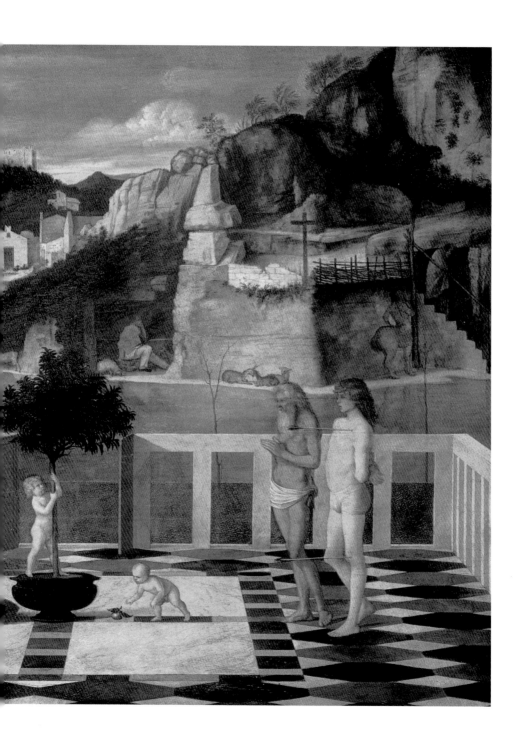

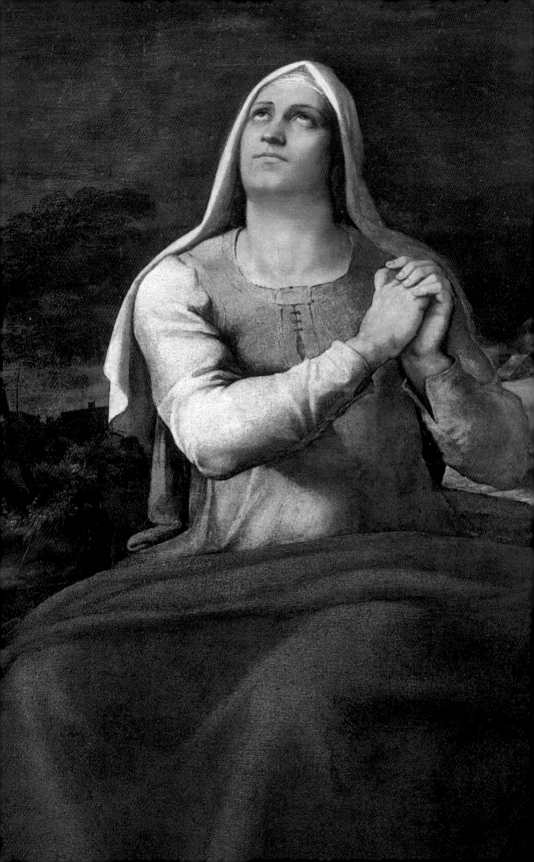

Chapter Seven

———•———

IN THE HOUR OF DEATH

The final space of prayer is death, in which every human being gives his soul back to God. Thus it comes as no surprise that, after the Our Father, the best known Christian prayer is the Hail Mary, which concludes: "Holy Mary, Mother of God, pray for us sinners now and at the hour of our death." These words, which believing parents teach their children, are rich in hope, communicating not only that we are all destined to die, but that, thank God, we will not die alone. Notwithstanding the sins we may have committed, there is someone who will pray for us: a holy woman, mother of a Son who was without sin yet who died (**fig. 92**); a woman who now lives in her Son's risen glory and prays that we too may reach that place. An initial fact to consider in this chapter is therefore the death of Christ, at which the woman who gave him birth was present; a second fact is the new life of the risen Jesus, in which the woman who saw him die, Mary his mother, has part.

Mary prays for us in the hour of our death, but does not pray that we *not* die. Rather, in the spirit of the words of Saint Bonaventure cited in our sixth chapter, Mary knows that "only someone who loves death may see God, for in spite of everything it remains true that 'man cannot see me and live'"; her own Son moreover taught that "anyone who loses his life for my sake and for the sake of the gospel will save it" (Mk. 8:35).

92. Sebastiano del Piombo, *Pietà*, Viterbo, Museo Civico, detail

It is thus Mary—not only mother of the Crucified but also figure of his Church—who whispers to all who approach the end of life: "Let us die therefore; let us enter this darkness. Let us silence temptations, worldly desires, fantasies. Let us pass from this world to the Father with Christ crucified, so that, after seeing him, we can say with Philip: 'This is enough for us.'" It is Mary, in the Church, who reminds sufferers of her Son's assurance to Saint Paul, "My grace is sufficient for you," and to the sick recalls David's words: "My flesh and my heart are pining with love, but the rock of my heart is God: God is my portion forever." With the guidance of the mothering and teaching Church, death indeed becomes a privileged occasion for prayer.

STABAT MATER

For those who remain alive, however, death is difficult to accept, as we see in the painting by Sebastiano del Piombo reproduced here, in which Mary herself is visibly anguished as she prays over her Son's corpse (**fig. 93**). The Virgin's grief at Christ's death is in fact a significant component of the reflection of Christians on this theme through the centuries, and Saint Bernard of Clairvaux—commenting on Simeon's prophecy of a sword that would pierce Mary's soul (Lk. 2:35a)—addresses her, saying:

> Truly, a sword has pierced your soul, O our holy mother! Indeed it could never have reached the Son's flesh if it had not first passed through his mother's soul. Once your Jesus (who was everyone's, but especially *yours*) had died, the cruel lance could no longer touch his soul; when, in fact, with no respect for death it opened his side, the lance could no longer hurt

93. Sebastiano del Piombo, *Pietà*, Viterbo, Museo Civico

your Son in any way. But *you* it could hurt—in fact it pierced your soul. *His* soul was no longer there, but yours was unable to break away. Powerful pain pierced your soul, and we can with good reason consider you to be more than a martyr, for your participation in your Son's Passion far surpassed, in intensity, the physical sufferings of martyrdom.[116]

Then, thinking of the possible reactions of his monastic listeners, Saint Bernard defends Mary's right to suffer for the loss of her Son: "Do not be astounded, brothers, when you hear that Mary was a spiritual martyr. Be astounded, rather, if you have forgotten that Saint Paul numbers among the worst sins of the pagans that they were without compassion [Rom. 1:31]. This sin was very far from Mary's heart and should be far from that of her humble devotees. Yet someone might still object: 'Did she not already know though that Jesus would die?' To be sure. 'And was she not convinced he would soon rise from the dead?' Without doubt—she had absolute confidence in the outcome. 'And notwithstanding that she suffered when she saw him crucified?' Certainly, and in a most awful way. After all, who are you, brother, and what strange kind of intelligence is yours, if you are more astounded at the Mother's solidarity in her Son's suffering than in the suffering of Mary's Son himself? If he could die physically, could she not die with him in her heart?"[117]

From the later Middle Ages on, Mary's "solidarity" with her Son, and her acute sensitivity to his sufferings, would be shared by Christians through *prayer*. We need only recall the popular hymn narrating Mary's reactions at the foot of the cross, the *Stabat Mater*, which tradition attributes to the Franciscan Jacopone da Todi; anyone singing it asks Mary at a certain point: *Fac me tecum pie flere, / Crucifixo condolere, / donec ego vixero* (Let me weep with you for pity's sake, / and feel the suffering of the Crucified, /

as long as I live). Of the same mother whose prayers we expect in the hour of death, that is, we also ask to be able to experience the pain that every death brings, mourning with her the death of Christ. And should someone find it difficult to share Mary's feelings—like the insensitive listener imagined by Saint Bernard—the "Stabat Mater" calls maternal emotion into play: *Vidit suum dulcem natum / moriendo desolatum, / Dum emisit spiritum* (She saw her sweet babe / dying and alone / right up to his last breath). In Sebastiano del Piombo's painting, this moving remembrance is suggested by the large scale of Mary, whose spread legs above her Son's corpse allude to childbirth.

The emphasis on Mary's participation in her Son's sufferings and the desire of Christians to learn from her how to live with the pain of loss are understandable. In itself, death is the most solitary experience that a human being can know, as we intuit in an early fifteenth-century French miniature showing a dead man nude before God (**fig. 94**). A scroll emerges from the man's mouth with the words: *In manus tuas Domine commendo spiritum meum* (Into your hands, O Lord, I commend my spirit); the Eternal Father's response (in French, not Latin, as if God wanted to avoid being misunderstood by the dead man) is: "You will do penance for your sins, and in the day of judgment you will be with Me." In his hand God has a big sword, which he does not use, however, keeping it in reserve, while his messenger, the archangel Michael, has a smaller version of the sword that he uses to defeat a demon who is trying to steal the dead man's soul. In fact this entire illuminated page introduces Psalm 116, which begins with the words we see written below the dead man: *Dilexi quoniam exaudiet Dominus vocem orationis meae* (I love [the LORD], for the LORD listens to my entreaty; he bends down to listen to me when I call); and that is exactly what we see in the miniature, God "bending down" to listen. The psalmist then specifies the

occasion on which he entreats God in prayer: "Death's cords were tightening round me, the nooses of Sheol; distress and anguish gripped me, I invoked the name of the LORD: 'LORD, rescue me!'" (Ps. 116[114–115]:1–4).

Distress and anguish gripped me. Notwithstanding the overall positive sense of this miniature, which mirrors the hopeful message of the psalm, death's terrible solitude also emerges, as does the horrible prospect of physical decomposition that is its consequence. The corpse is in fact surrounded by human bones and skulls, one of which actually fills the initial letter of the psalm; in addition—and it is a truly macabre detail—the corpse's right hand clutches spasmodically, curving its fingers around, as if to free the body of the sumptuous mantle in which it was wrapped, thus making it clear that, at the moment of burial, this man, although appearing to be dead, in fact was not. Before the risk of such a mistake, even believers in God hope not to be abandoned by humans in the hour of their death, but to have friends who will help them give their soul back to the Creator.

THE GRIEF OF FRIENDS

In this perspective, it is easy to understand the interest of the late Middle Ages and early modern era in the theme of lamentation over the dead Christ: the evocation of the choral grief expressed by Jesus's friends before his burial. Identified in mystery play texts as the *planctus Mariae* (Mary's lament), this moment of collective grieving in fact extends Mary's intense participation in the Savior's passion to others—to the holy women, among whom was Mary Magdalene; to John the beloved disciple; and to Joseph of Arimathea and Nicodemus—offering an extraordinarily

94. *A Dead Man Before God*, miniature from the Rohan Book of Hours, Paris, Bibliothèque nationale de France, ms. Lat. 9471, fol. 159r

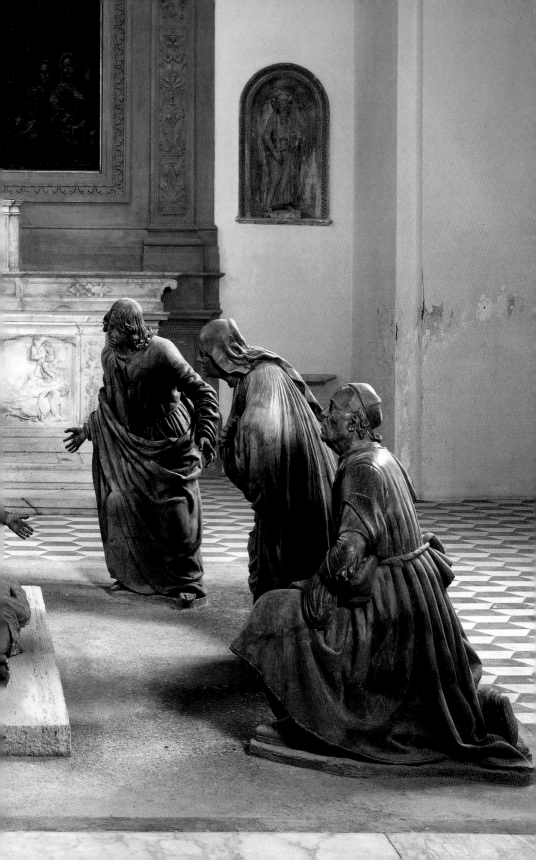

acknowledge God who preceded you to punishment. He was numbered among the evildoers for your sake and for your sin, and you are made just thanks to him. Adore the One who was crucified for you, and if for your guilt you too are crucified, profit from your sin, buy salvation with your death, and enter paradise with Christ. . . . If you are Joseph of Arimathea, ask those who crucified him for his body: assume that body and thus make your own his expiation for the world. If you are Nicodemus, the nocturnal adorer of God, bury his body and anoint it with the unguents prescribed by rite: surround it, that is, with your adoring worship. And if you are one of the Marys, shed your tears early in the morning, and, making sure you are the first to see the stone rolled away, go forward to meet the angels, or rather Christ himself. That is what it means to become a sharer in Christ's paschal mystery.[123]

ARS MORIENDI

Imaginative identification with Christ's paschal mystery prepares Christians first to live and then to die *well*. For both of these goals we in fact need "skill," "craftsmanship," because—according to biblical wisdom—"there is a season for everything, a time for every occupation under heaven: a time for giving birth, a time for dying; a time for planting, a time for uprooting what has been planted" (Eccles. 3:1–2). That is why the Church surrounds this event with significant rituals, carefully defining moments and modalities. With words and eloquent gestures she teaches that death, for Christians, is above all a *birth*, for, as Saint Gregory of Nyssa says: "A believer who does not ever live for sin, who indeed continually mortifies his flesh, bearing the dying body of Christ in his own body; one who lets himself be crucified with Christ and does not live for himself but has Christ living in him [experiences]

a timely death that produces true life."[124] Still more explicit in this sense is the plea that Saint Ignatius of Antioch addressed to those who wanted to save him from martyrdom: "Have pity on me, brothers: do not prevent me from living, do not desire my death. Do not abandon to the world and its material seductions someone who wants to belong to God. Let me reach the pure light: once there I will truly be a man. Let me imitate the passion of my God."[125]

To be sure, not many believers are so heroic. But the rites that prepare them to die serve precisely to help them keep their gaze fixed on Christ and the saints who await them. Fascinating, in this respect, is a manuscript illustration of circa 1200 representing the last hours of William II of Sicily in 1189 (**fig. 96**). This brilliant monarch—builder of the Cathedral of Monreale and a great strategist—is shown on his deathbed assisted by Arab physicians and astrologers; he had in fact promoted the expansion of the Kingdom of Sicily in Tunisian territory. But the physical setting in which we see William II, called "the Good," is the chapel discussed in our fourth chapter: the one founded by his grandfather, Roger II, in the residence in Palermo known as "the Palace of the Normans"; a text in the last arch here clearly identifies it as the *Cappella Regia* (see above, fig. 61). Under the preceding arch we see the dead king mourned by his courtiers; he lies in front of an altar made ready for the Eucharistic celebration, with the chalice, an episcopal cross, and three lamps.

In the same spirit, but much more detailed, is the deathbed scene illustrated by a woodcut in Girolamo Savonarola's *Predica del arte del bene morire* (Sermon on the Art of Dying Well), published in Florence circa 1500 (**fig. 97**). In the spacious bedroom of a Florentine house we see the dying man in bed in front of an improvised altar surmounted by a large crucifix that receives light from a window; as he dies, that is, the man sees

96. *William of Sicily Dying in the Royal Chapel*, miniature from a manuscript containing the *Liber ad honorem Augusti* of Pietro da Eboli, ca. 1200, Bern, Burgerbibliothek, Cod. 120, fol. 97r, detail

97. *The Good Death*, woodcut from Girolamo Savonarola, *Predica del arte del bene morire*, printed in Florence by A. Tubini, ca. 1500, Florence, Biblioteca Nazionale Centrale, Cust. E 7, c. 14*r*

Christ's death, along with a skeleton sitting at the foot of his bed. The man's wife and three sons are present and in prayer, while a friar beside his pillow speaks to him, rebutting the words of a demon at the left who reads from the book in which the man's sins are written. The candle held by the man's wife makes it clear that the scene represents the giving of the sacrament of extreme unction (anointing of the sick), in which, in the context of a final confession, the friar's words let this man hope, by virtue of Christ's sacrifice, that he will go to heaven. And thus—at the center of the composition, just to our right of the wife and eldest son—above the bed we see Mary and the baby Jesus surrounded by angels.

The moments represented in this woodcut—the dying man who confesses his sins in front of the crucifix and the sacramental minister who instills hope—are reassumed in the prayer that the Church pronounces today as it gives the sacrament of the last rites to someone in his or her final agony:

> Most gentle Father, you know men's hearts and welcome the sons and daughters who return to you: have pity on our brother in his final agony. May this holy unction and our faith's prayer sustain and comfort him, so that in the joy of being pardoned he may confidently abandon himself to the embrace of your mercy. For Jesus Christ, your Son and our Lord, who has conquered death and opened the way to eternal life, and lives and reigns with you forever and ever.[126]

The ritual accompaniment offered by the Church does not end when a person passes from this life, but crosses death's threshold to give form to the funeral as well, as we see in a page of the famed *Grimani Breviary* (**fig. 98**). The artist shows the inside of a cathedral draped in black, with six canons singing the Office of the Dead at right and left of the candle-lit catafalque, while the bearers, in the lugubrious robes of professional mourners, follow

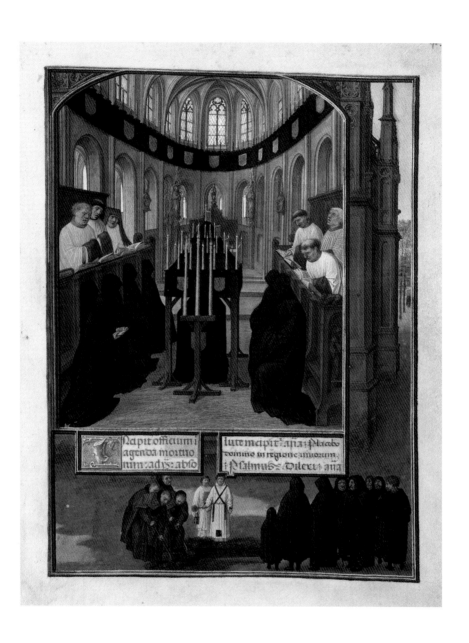

98. *Funeral Rite in a Church and Burial Scene*, miniature from the *Grimani Breviary*, late XV–early sixteenth century, Venice, Biblioteca Nazionale Marciana, Cod. Lat. I, 99=2138, fol. 450*r*

the service on their knees. Beneath this scene, in a meadow in front of the cathedral, the same bearers together with a priest and an acolyte assist at the filling of the grave.

The deliberately somber emphasis of this image is no longer fashionable: with the Second Vatican Council's liturgical reform, the grimmer aspects of the funeral rite have been suppressed along with the black vestments. Yet the dramatic practices of former times had a kind of antique wisdom—that of Sirach who advised: "My son, shed tears over a dead man, and intone the lament to show your own deep grief; bury his body with due ceremony, and do not neglect to honor his grave. Weep bitterly, wail most fervently; observe the mourning the dead man deserves, one day, or two, to avoid comment, and then be comforted in your sorrow. . . . Once the dead man is laid to rest, let his memory rest too; do not fret for him, once his spirit departs" (Sir. 38:16–17 and 38:23).

As Sirach suggests, mourning can be a matter of form, the celebration of a rite, as when, on the death of the aged Moses, "the sons of Israel wept for Moses in the plains of Moab for thirty days" until "the days of weeping for the mourning rites of Moses came to an end" (Deut. 34:8). But mourning can also express intense personal grief, as in David's case when he learned of the death of his rebellious but beloved son Absalom: "The king shuddered. He went up to the room over the gate and burst into tears, and weeping said: 'My son Absalom! My son! My son Absalom! Would I had died in your place! Absalom, my son, my son!'" (2 Sam. 19:1–4). In the Church's rites, death in any case is put in the perspective of the history of salvation, where (even if it is a consequence of sin), accepted in Christ, it opens the way to new life. In the *Grimani Breviary* miniature, for example, the canons are singing the same Psalm 116 already mentioned in this chapter: "I love [the LORD], for the LORD listens to my entreaty" with its continuation: "Death's cords were tightening round me

. . . I invoked the name of the LORD: 'O LORD, rescue me!'" But after this psalm they will sing another, the "Miserere," or prayer of repentance: "Have mercy on me, O God, in your goodness, in your great tenderness wipe away my faults; wash me clean of my guilt, purify me from my sin" (Ps. 51[50]:1–2). And in the name of the dead man or woman, they will ask the Almighty: "God, create a clean heart in me, put into me a new and constant spirit" and—in the perspective of the future resurrection—will pray: "Show your favor graciously to Zion, rebuild the walls of Jerusalem" (Ps. 51[50]:10–18).

DIES IRAE

In the believer's experience of death, the weight of sin engenders fear, "for all the truth about us will be brought out in the law court of Christ, and each of us will get what he deserves for the things he did in the body, good or bad" (2 Cor. 5:10). The terror that this prospect instills is the theme of a medieval hymn still used for funerals when the *Grimani Breviary* was made, the *Dies Irae*. The hymn—which actually contains an internal gloss on the terror people feel (*Quantus tremor est futurus, / Quando Judex est venturus, / cuncta stricte discussurus!*)—expresses the sinner's feeling of inadequacy (*Quid sum miser tunc dicturus?*) and asks the Judge for mercy: *Rex tremendae majestatis, / qui salvandos salvas gratis, / salva me, fons pietatis,* reminding Christ that the reason for which he sacrificed his life was precisely to save sinners: *Ricordare, Jesu pie, / quod sum causa tuae viae: / ne me perdas illa die.* It admits shame but asks the forgiveness that Mary Magdalene and the good thief received; it pleads—notwithstanding the unworthiness of the prayers raised—to be saved from the eternal flames: *Ingemisco tamquam reus: / culpa rubet vultus meus: / supplicanti parce, Deus. / Qui Mariam*

absolvisti, / et latronem exaudisti, / mihi quoque spem dedisti. /
Preces meae non sunt dignae: / sed tu bonus fac benigne, / ne
perenni cremer igne.[127]

The confession of sin in the *Dies Irae,* and the plea for
forgiveness therein expressed, were not as negative as they seem
today, however, since their objective was the longed-for heavenly
reward. The prayer to be saved from the fire of hell in fact
continues with the words: *Inter oves locum presta, / et ab hoedis me*
sequestra, / statuens in parte dextra and asks the Judge: *Confutatis*
maledictis, / flammis acribus addictis: / voca me cum benedictis!
(When you have condemned the damned and consigned them
to the stinking flames, call me among the blessed!).

"Call me!" This individual vocation to reach Christ is the theme
of a fresco painted above an imposing tomb in the basilica of
Santa Croce in Florence (**fig. 99**), in which the dead man, again
clothed in flesh and even wearing the white linen cap that he wore
in life, rises from his sepulcher in a posture of prayer in response
to the sound of angelic trumpets, according to the iconographic
schema found in Pauline texts: "We shall all be changed. This will
be instantaneous, in the twinkling of an eye, when the last trumpet
sounds. It will sound, and the dead will be raised, imperishable,
and we shall be changed as well (1 Cor. 15:51b–52). "For we
know that when the tent that we live in on earth is folded up,
there is a house built by God for us, an everlasting home not made
by human hands, in the heavens" (2 Cor. 5:1); "At the trumpet of
God, the voice of the archangel will call out the command, and
the Lord himself will come down from heaven; those who have
died in Christ will be the first to rise, and then those of us who are
still alive will be taken up in the clouds, together with them, to

99. Maso di Banco, *Particular Judgment,* Florence, Santa Croce,
Bardi di Vernio Chapel

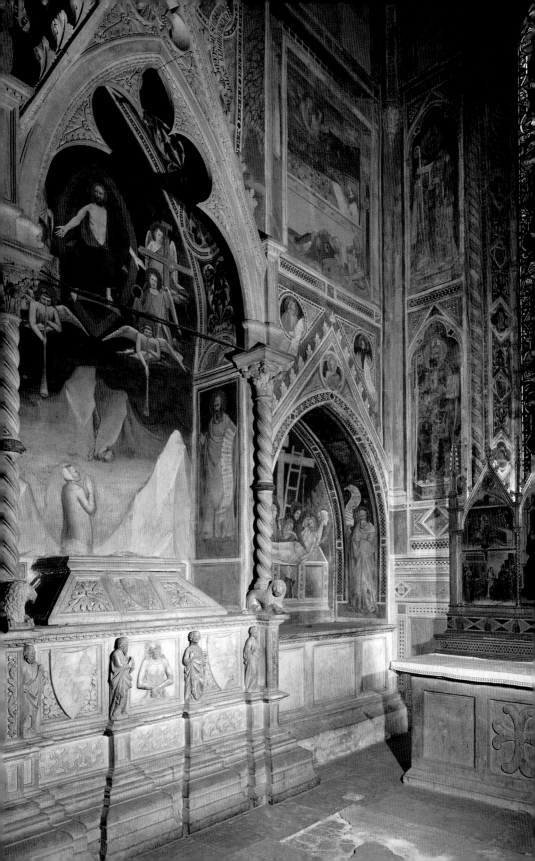

meet the Lord in the air. So we shall stay with the Lord forever"
(1 Thess. 4:16–17). "This explains why Christ both died and
came to life, so that he might be Lord both of the dead and of
the living" (Rom. 14:9).

This explains why Christ both died and came to life. The
hope of Christians springs from the Lord Jesus's paschal mystery;
in it alone can believers make sense of the tragedy that death
represents, both for those who die and for those who remain
and grieve. On the Florentine tomb reproduced here, the man
who rises does so in fact between images of the dead Christ
(on the sarcophagus there is an *Imago pietatis*, cut off in our
photograph) and Jesus risen to glory (in the fresco framed by the
arched tabernacle).

THE HOPE OF RISING

The image that best explains how the dead are inserted in
Christ's paschal mystery is a large fresco in the Dominican church
in Florence, Santa Maria Novella: the *Holy Trinity with Mary,
John, and Donors* executed between 1425 and 1427 by the painter
Tommaso di Guidi, known as Masaccio (**fig. 100**).[128] Masaccio's
iconographic schema is the typical late medieval one for the Trinity,
which is visualized in the "economy of salvation"; the composition
in fact shows the life of the triune God at its point of intersection
with human life, and that "point of intersection" is Christ himself
on the cross, supported and lifted up by the Father (in the upper
part of the composition), who in turn gives him the Spirit (the
white dove between the Father's beard and the Son's halo).

From God's eternity, we descend—in Christ—into history and
then, through Christ, into the life of men and women: Mary,

100. Masaccio, *Holy Trinity with Mary, John and Donors*,
Florence, Santa Maria Novella

Jesus's mother; John the beloved disciple; and the two donors shown kneeling at right and left upon the altar. John is wringing his hands as he gazes in anguish at his friend on the cross; Mary by contrast looks at us and indicates Christ, as if to invite us to ponder the meaning of what we see. The donors—Domenico de'Lenzi and his wife—are absorbed in prayer, and beneath the altar there is a skeleton with the words: "I once was what you are now, and what I am you too will one day be."

To this traditional iconographic schema, Masaccio adds three innovative features: use of the same scale for all the figures, linear perspective, and classicizing architecture. The most important of these is the first, use of equal scale for all the figures.

In contrast with medieval images, which normally distinguished the size of sacred personages from that of contemporaries, Masaccio's Trinity shows the work's patrons in the same scale as Christ, God the Father, Mary, and John. This uniform size underlines and reinforces the almost Flemish realism of the portraits of Domenico de'Lenzi and his wife, and—even though the two contemporaries remain outside the niche and absorbed in prayer—eliminates all sense of hierarchical separation of man from God, or of contemporary life from eternity.

This iconographical innovation is in fact consonant with a current of medieval theology that conceived the Holy Trinity in terms of family. The privileged scale of the man and woman shown in the fresco introduces the viewer visually and intellectually into that context of intimate relationships which Christian theology sees in the life of the three Persons who are God and who in the New Testament are identified with names proper to family life: "Father," "Son," "Love" (**fig. 101**). The other personages shown inside the niche are also "family": Mary, Jesus's mother (and, in a mystical sense, his spouse), and John, whose relationship with Jesus was redefined when, from the

cross, the Lord entrusted this disciple with his mother, creating a new kind of spiritual family. "Seeing his mother and the disciple he loved standing near her, Jesus said to his mother: 'Woman, this is your son.' Then to the disciple he said: 'This is your mother.' And from that moment the disciple made a place for her in his home" (John 19:26–27).

In Masaccio's fresco there are, in effect, *two* families within the niche: one eternal, the other historic. There is the "family" of three Persons united from all eternity in love and perfect concord—the Trinity; and there is the human family constituted by Christ: Mary his mother according to nature and John his "adoptive" brother. In the traditional iconographic arrangement used by Masaccio, it is clear that what these two families have in common is Jesus himself, Son both of God and of Mary: Jesus, placed at the center of the vertical axis defined by the cross (the axis on which Masaccio composes the figures of his Trinity), but also at the center of the horizontal axis defined by the cornice of the platform on which God the Father stands. In purely visual terms, this architectural element, the cornice, binds Mary and John "through" the cross.

This way of organizing the two groups inside the niche seems to illustrate Jesus's own prayer the night before he died, when he asked the Father that his "two families" might live as one. The words of Jesus in Saint John's account of the last supper in fact describe an analogous intersection of the Savior's two families, a similar to-and-fro movement between time and eternity:

> Father, the hour has come . . . it is time for you to glorify me with that glory I had with you before ever the world was. I have made your name known to the men you took from the world to give me. They were yours and you gave them to me. . . . All I have is yours, and all you have is mine, and

in them I am glorified. . . . As you have sent me into the world, I have sent them into the world. . . . I pray not only for these but for those also who through their words will believe in me. May they all be one. Father, may they be one in us as you are in me and I am in you. . . . With me in them and you in me, may they be . . . completely one. (John 17:1, 5–6, 10, 18, 20–21, 23)

In this theological perspective of love and unity in man's participation in God's life, the large scale that Masaccio gives Domenico de'Lenzi and his wife does not imply a reduction of the divine to human dimensions, but rather an enlargement of human dignity in relation to God's inner life. In Masaccio's composition the human husband and wife are part of a descending pyramid at whose apex we see "the Father, from whom every family, whether spiritual or natural, takes its name" (Eph. 3:14–15). The pyramid "descends" and "emerges" (visually and theologically) in the Holy Spirit and in Christ, in Mary and John, finally embracing the de'Lenzis and with them the faithful who may kneel in front of the fresco. The fresco's internal balance, its visual and psychological stability, in fact depend on the new equality of scale, and it is this scale—nearly life-size—that allows viewers to imagine themselves included, through time and space, in the family love emanating from the Holy Trinity.

In this fresco, that is, the mystery of the Trinity is extended to include man. The central visual component—the element that links the upper part of the image to the lower, heaven to earth—is Christ on the cross, icon of the Father and perfect expression of God's self-giving love. Christ's hands, exquisitely modeled in the light,

101. Masaccio, *Holy Trinity with Mary, John and Donors*, Florence, Santa Maria Novella, detail

become extensions of God the Father's arms, so that we see—in the obedience of a Son who lets himself be nailed to his Father's will —a harmony of intentions, a communion, which *is* the Holy Spirit. Placing himself in the Father's hands, Christ here is supported and "lifted" in our body to receive the Spirit of eternal life.

In addition to these theological messages, which in a Dominican church do not surprise us, Masaccio's fresco also conveys a pastoral objective related to the mission of the Order of Preachers. It was painted opposite a large side door (now partly walled over) that gave access to Santa Maria Novella from the cemetery, with the result that those who enter through this cemetery door immediately see: the skeleton, which reminds them of the inevitability of physical death; Christ on the cross, who confirms that God's Son himself shared our human condition; the human "family" of Jesus: Mary, his mother, and John, the disciple who became the Lord's "brother" when Jesus entrusted him with Mary. Those entering also see the natural family constituted by Domenico de'Lenzi and his wife, who become part of the spiritual family instituted by Christ on the cross.

The clear message, for those coming from the cemetery, was: Take heart! The separation from your loved ones imposed by death is not forever. As the Father did not abandon his Son but gave him the Holy Spirit, so those who are "in the Son"— members of his spiritual family, new "sons" like John—will also be raised from death on the last day. The Father's love, which descended into history in Christ, and which—through Christ's disciples—continues to descend, saves us from death and gives us the Holy Spirit.

The mysterious, unfathomable depth of the Trinity becomes "penetrable," then, thanks to the use of linear perspective, which we find here for the first time in a monumental painting. It is as if an emanation of divine life extended, from its remote origin in

the Father, outward to Christ, Mary, John, Domenico de'Lenzi and his wife, and finally to us—life so full it consumes even the skeleton beneath the altar. And the space in which these personages live before God seems coextensive with that in which all of us live daily life; or perhaps we should say that the space of daily life here becomes an extension of God's space, our everyday existence a continuation of the endless day of the risen Christ.

And all this *ab aeterno*, from all eternity. Masaccio suggests this eternal dimension not with the golden background used by medieval painters, but through architecture that evokes classical antiquity: the ancient style that, in Florence in those years, came back to life. The arches and architraves, fluted pilasters and Corinthian capitals that define "God's space" in the fresco are very like those that in the 1420s Brunelleschi planned for the new Basilica of Saint Lorenzo, a few hundred meters from Santa Maria Novella. "Eternity" as Masaccio imagined it is thus *historical*: rooted in the past but also "present," since in fact the past was then coming back to life in Florence. And the Father's love, which enters human time in Christ and in Christ defeats death, appears as "historical fidelity" able to give new life even to ancient stones. For indeed, in God nothing of real value that man accomplishes is ever lost.

If we add that, at the period of its realization, Masaccio's fresco served as the backdrop for an altar—an open table that allowed viewers to see the skeleton, below, as well as the cross supported by the Father, above—the semantic richness of the whole image becomes clearer. The man and woman shown in prayer at right and left of the cross became participants at Mass, and the crucified body of Jesus—before which the celebrant elevated the host and chalice of wine—visualized the Savior's evening sacrifice, his prayer for all humankind. The fact that the Father supports and begins to raise the cross of his Son, breathing on

him the Holy Spirit of their shared eternal life, means that Jesus's prayer was answered, and for every human being humiliated by death it is God's own Son who confesses:

> I love [the LORD], for the LORD listens
> > to my entreaty;
> he bends down to listen to me
> when I call. Death's cords were tightening around me,
> the nooses of Sheol;
> distress and anguish gripped me,
> I invoked the name of the LORD:
> "LORD, rescue me!"
> > The LORD is righteous and merciful,
> our God is tenderhearted;
> the LORD defends the simple,
> he saved me when I was brought to my knees.
> Return to your resting place, my soul,
> the LORD has treated you kindly.
> He has rescued me from death, my eyes from tears
> and my feet from stumbling.
> I will walk in the LORD's presence
> > in the land of the living. (Ps. 116[114–115]:1–9)

CHRIST'S FACE WITHOUT VEILS

Among the highest expressions of prayer "in the hour of death" is the *Pietà* begun by Titian Vecellio in 1570 and left unfinished at the artist's death in 1576 (**fig. 102**).[129] Done for the altar near which Titian had planned his own tomb—the altar of the cross in the Franciscan church of Venice, Santa Maria Gloriosa dei Frari—

102. Titian, *Pietà*, Venice, Gallerie dell'Accademia

the *Pietà* is a testimonial to the artist's faith and indeed includes a portrait of Titian in the figure of the kneeling old man who supports and contemplates the dead Christ.

In this last work of his life, the ninety-year-old master seems to have wanted to recall the stages of his own career, inaugurated more than half a century earlier with two canvases for the same church of the Frari: the *Assumption* for the high altar and the *Madonna of the Pesaro Family* (see above, fig. 64), which indeed are among Titian's first prestigious commissions in the lagoon city. The elderly artist thought that his lifeless adult body of Christ deposed from the cross would be seen just steps away from the rosy-hued baby of the *Pesaro Madonna*, that is, and in the side aisle of this basilica dominated by Titian's youthful image of Mary assumed to glory, he now imagined the Mother of Sorrows showing her Son to an old man—to him, Titian the painter. Even though the *Pietà* was not, in the event, placed in the Frari but elsewhere, we should bear in mind the artist's original intention in its regard.

In this masterpiece of his old age, Titian also recalls Venetian art of earlier times, inserting a mosaic-clad apse into the heavy arch that structures the composition, in evident allusion both to Saint Mark's Basilica with its gleaming, Byzantine-style mosaics and to the use of mosaics for evocative purposes in fifteenth-century Venetian painting—in Giovanni Bellini, for example (see above, fig. 21). But where, in Bellini, similar mosaic-clad apse vaults are backdrops for the Madonna and Child enthroned, here Mary is low in the composition and the Son in her arms is dead.

Titian's mosaic-decorated niche does evokes a funerary chapel, that is, and the body of Christ in the lower part of this altarpiece invites the spectator to think of the Eucharist in the Catholic terms of sacrifice then reiterated by the Council of Trent, which had come to an end only a few years earlier. The image in Titian's

mosaic, a pelican nourishing its young with its own flesh, is in fact a traditional reference to Christ's sacrifice on the cross, and the six lamps on the pediment of the arch, plus the torch held by a small angel, symbolize the seven candelabra mentioned in the first chapter of the Apocalypse, in the midst of which the apostle John saw Christ move as celebrant in a heavenly liturgy. Here it is the aged Titian who sees Christ—not only as priest but also as victim and as altar.

The extraordinarily loose pictorial technique visible in all the figures but especially in the body of Christ (where indeed it seems to reproduce the process of material dissolution that follows death) points toward seventeenth-century painting, from Rubens to Rembrandt, Velasquez and Bernardo Strozzi. In the context of contemporary sixteenth-century discussion regarding the advantages of different media in the visual arts (called the *paragone*), the extreme materiality of this style seems to affirm once and for all the primacy of painting over sculpture and architecture, both of which are in effect represented in Titian's canvas. At the same time, this exaltation of *matter* in the functional context of the Mass effectively dramatizes the mystery celebrated therein; we should probably imagine, as Titian certainly did, the impressionistic body of his Christ seen in candle light beyond the host composed of many grains of wheat that, "falling in the ground" and "dying," become the bread of eternal life.

This *Pietà* is a "sacramental drama" in pictorial terms, I mean to say. On the "stage" of the altar, Titian has constructed a set of the kind Sebastiano Serlio imagined for tragedies, and among the actors he has included a theatrical Magdalene rushing toward the public as if to demand justice for the murdered Innocent. But the real drama is concentrated in the group in the "chapel" below the mosaic: in Christ who offered himself and is now offered by Mary to Titian, and in Titian who seeks the sense of his own life and

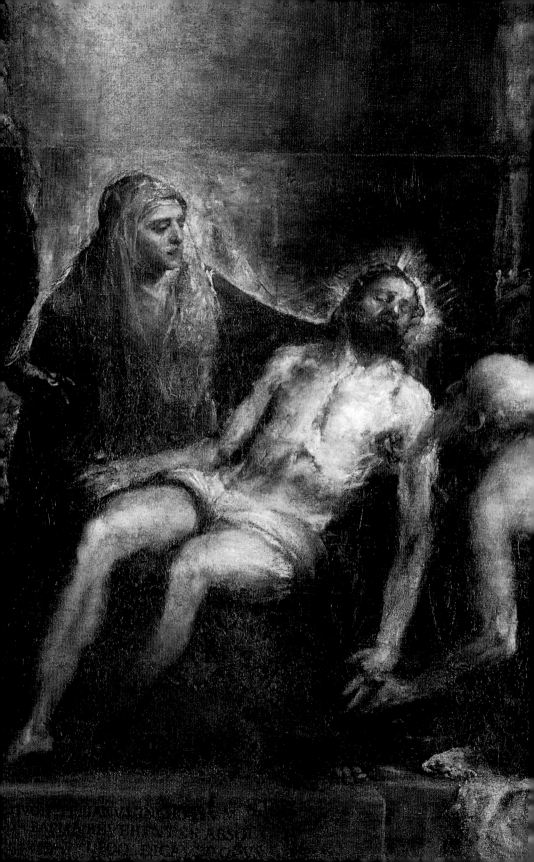

still more of his imminent death in Christ. (Let us again recall that these personages were to have been seen above the bread and wine offered in sacrifice.)

A detail in the lower right of the picture offers a revealing interpretive key. It is a votive panel painted in the naïve style of popular ex voto images, and it shows Titian with his son Orazio kneeling in front of Mary with her dead Son in her arms: a *Pietà* in the *Pietà*, so to speak. This small picture leans against the base of a statue, in classical style, representing the Sybil of the Hellespont. But the Sybil, whose prophecy alluded to the Redeemer's death, carries a big cross and wears a crown of thorns; she is represented, that is, with the conventional attributes of an allegorical figure of Faith. Juxtaposed as she is to another statue, representing Moses, this figure ends up symbolizing the Christian faith accepted by the pagans, fullness and fulfillment of the faith of Israel.

The clumsy *Pietà* in the little ex voto thus represents an experience of faith. But the *Pietà* in the big canvas, anything but clumsy, belongs to a different order of experience. In the big *Pietà* Titian in effect turns his back on the statue and on the votive panel: that is, he turns his back on partial, immature, and inadequate expressions of Christian hope belonging to "mere" faith and passes to direct vision. No longer does he have to imagine Christ, for now he sees him and touches him. In this sacramental setting, the aged painter who knew how to dissolve and recompose form and color (as the substance of bread is dissolved and recomposed as the body of Christ) turns his back on *images* to finally contemplate, as death draws near, *reality*: Christ, eternal life of those who eat his body and drink his blood.

To this old painter—who since youth had depicted Christ in art and here shows himself on his knees, contemplating the

103. Titian, *Pietà*, Venice, Gallerie dell'Accademia, detail

Savior with deep feeling (**fig. 103**)—we can perhaps attribute, if not the words, at least the sentiments of Thomas Aquinas's prayer written as a Eucharistic hymn: *Adoro te devote, latens Deitas, / Quae sub his figuris vere latitas: / Tibi se cor meum totum subjicit, / quia te contemplans, totum deficit* (I devoutly adore you, hidden Divinity, / truly hidden beneath these figures [the bread and wine]: / My heart submits entirely to you, / and faints as it contemplates you). And since Titian intended this work for an altar where, in the logic of donated pictures, a priest would have said Mass for his soul—and in it included the pelican symbolizing Christ—let us also attribute to him the concluding verses of Thomas's hymn: *Pie pellicane Jesu Domine, / me immundum munda tuo sanguine: / cujus una stilla salvum facere / totum mumdum quit ab omni scelere* (Lord Jesus, pelican of pity, cleanse me, unclean, with your blood, a single drop of which can save the whole world). *Jesu, quem velatum nunc auspicio: / Oro fiat illud, quod tam sitio: / Ut te rivelata cernens facie, / Visu sim beatus tuae gloriae* (Jesus, whom now I see as if veiled, grant that for which I thirst: to see your face unveiled and know blessedness in the vision of your glory).

To see your face unveiled. At the last, beyond created beauty human beings will behold the beauty of the Creator, contemplating God in Christ Jesus. His alone is the beauty that saves the world.

NOTES

1 Gregory of Nyssa, *Discourse on the Resurrection of Christ,* my translation.

2 Cyril of Alexandria, *Commentary on the Gospel of Saint John* 10, my translation.

3 John Damascene, *De sacris imaginibus orationes* 1.27.

4 Tertullian, *Treatise on Prayer,* 28–29.

5 Augustine, *Commentary on Psalm 140,* 4–6.

6 Augustine, *Commentary on Psalm 85,* 1.

7 St. Leo the Great, *Treatise* 48.1.

8 James Snyder, *Northern Renaissance Art: Painting, Sculpture, the Graphic Arts from 1350 to 1575* (New York: Prentice Hall, 1985), 262–64.

9 Athanasius, *Vita Antonii* ch. 2–4.

10 Thomas of Celano, *Vita prima* 7. See also *Fonti francescane, editio minor*, ed. Ernesto Caroli et al. (Padua, 1986), 212–13.

11 Thomas of Celano, *Vita seconda* 7. See also *Fonti francescane*, 338.

12 Bonaventure, *Legenda maior* 2.4. See also *Fonti francescane*, 528.

13 See Roberto Mastacchi, *Il Credo nell'arte cristiana italiana* (Siena: Cantagalli, 2007), 78–119.

14 Conferenza Episcopale Italiana, *Rito del battesimo dei bambini* (Vatican City, 1989), 107 n. 123.

15 The idea, dating from the fifth century, is perhaps due to Prosper of Aquitaine (d. 463). See also M. Righetti, *Manuale di storia liturgica,* 3rd ed., 4 vols, (Milan, 1964), 1: 35–36. The original formulation of the phrase is *legem credendi statuat lex supplicandi*.

16 Augustine, *Commentary on Psalm 109*, 1–3.

17 *La vita di Cristo secondo l'anno liturgico miniato dal Turone nei corali della Biblioteca capitolare di Verona,* ed. G. Zivelonghi (Verona, 1992), 3.

18 Angelo Meneghesso, *Il Battistero di Padova e l'arte di Giusto de'Menabuoi* (Padua, 1934); see also *Giusto de'Menabuoi nel Battistero di Padova,* ed. A. M. Spiazzi (Trieste, 1989).

19 Irenaeus, *Treatise "Against Heresy"* 4.14.2–3.

20 Melito of Sardis, *Homily on Easter,* 65–67.

21 Snyder, *Northern Renaissance Art,* 389–91.

22 H. Kiel, *Il Museo del Bigallo a Firenze* (Florence, 1977); Howard Saalman, *The Bigallo: The Oratory and Residence of the Compagnia del Bigallo e della Misericordia in Florence* (New York: New York Univ. Press, 1969); Timothy Verdon, "La Piazza e la carità: Gli istituti di aiuto fraterno intorno al

Duomo," in *I tesori di Piazza del Duomo (Alla riscoperta di Piazza del Duomo in Firenze, 6)*, ed. Timothy Verdon (Florence, 1998), 9–40.

23 Thomas Aquinas, *Summa teologica* (Verona, 1740), 1.15.3.

24 Roberta Vicchi, *Le basiliche maggiori di Roma* (Florence: Scala, 1999), 124.

25 Irenaeus, *Treatise "Against Heresy" IV*, 14, 2–3.

26 Augustine, *Discourse* 336.1–6.

27 Ibid.

28 Ibid.

29 Friedrich Hegel, *Estetica* (Milan, 1963), 911–12.

30 Claude J. Peiffer, OSB, *Monastic Spirituality* (New York: Sheed and Ward, 1966); David Knowles, *Christian Monasticism* (New York: McGraw-Hill, 1967); Gregorio Penco, OSB, *Storia del monachesimo in Italia* (Rome, 1968); George Zarnecki, *The Monastic Achievement* (New York: McGraw-Hill, 1972); Timothy Verdon, "Monasticism and Christian Culture," in *Monasticism and the Arts*, ed. Timothy Verdon and John Dally (Syracuse, NY: Syracuse Univ. Press, 1984), 1–28; Timothy Verdon, "Il monachesimo e le arti," in *Pellegrinaggio, monachesimo, arte: La visibilità del cammino interiore*, ed. Timothy Verdon (Florence: Polistampa, 2000), 32–62.

31 *Rule of Saint Benedict,* prologue. See also *RB 1980: The Rule of Saint Benedict in Latin and English with Notes,* ed. Timothy Fry, OSB (Collegeville, MN: Liturgical Press, 1980). The following references to the Rule will use the conventional abbreviation "RB."

32 RB, prologue, 19.

33 RB, ch. 20.

34 RB, 4, 75.

35 Enrico Parlato and Serena Romano, *Roma e il Lazio: Il romanico* (Milan, 2001), 101.

36 Ibid., 109.

37 Richard Krautheimer, *Rome: Profile of a City, 312– 1308* (Princeton: Princeton Univ. Press, 1980), 213–14, 226–33, 311–26.

38 Ibid., 209, 211, 227, 257; Tito Amodei, *La Scala Santa* (Rome, 1974); Julian Gardner, "Nicholas III's Oratory of the Sancta Sanctorum," *Burlington Magazine* 115 (1973):283ff.

39 G. Cascioli, *Memorie storico-sacre della Scala Santa* (Rome, 1899); A. Petrignani, *Il santuario della Scala Santa* (Vatican City, 1941).

40 Amodei, *La Scala Santa,* 4.

41 The treatise by a Catanian friar, Matteo Selvaggio: *Opus pulchrum et studiosis viris satis jucundum de tribus peregrinis* (Venice, 1542) is quoted in M. Fagiolo and M. L. Madonna, *Roma sancta: La città delle basiliche* (Rome, 1985), 34.

42 Ibid.

43 Peter Crysologus, *Sermo* 147.

44 Dante, *Paradiso* 28.106–14: "E dei saper che tutti hanno diletto / quanto la sua *veduta* si profonda / nel vero in che si queta ogni intelletto. / Quinci si può vedere come si fonda / l'esser beato *nell'atto che vede*, / non in quel che ama, che poscia seconda; / E del vedere è misura mercede, / che grazia partorisce e buona voglia: / così di grado in grado si procede."

45 Cecilia Powell, *Italy in the Age of Turner: "The Garden of the World"* (London: Dulwich Picture Gallery, 1998), 52–53.

46 Augustine, *Commentary on Psalm 81*, 5.

47 Georges Blond, "Clement of Rome," in *The Eucharist of the Early Christians*, ed. Willy Rordorf and Raymond Johanny, trans. M. J. O'Connell (New York, 1976), 24–47.

48 Mario Righetti, *Manuale di storia liturgica*, 3rd ed. (Milan: Ancora, 1964), 1:102–03; M. Jourjon, "Justin," in *The Eucharist of the Early Christians*, 71–85.

49 Justin Martyr, *First Apology*, ch. 66.

50 Ibid.

51 J.A. Jungmann, *The Early Liturgy to the Time of Gregory the Great* (Notre Dame, IN: Univ. of Notre Dame Press, 1959), 52–73.

52 Conferenza Episcopale Italiana, *Messale romano* (Vatican City, 1983), 382–92; Jungmann, *The Early Liturgy*, 298–307.

53 Peter Chrysologus, *Discourse* 108.

54 Ibid.

55 F. Magistrale, catalog entry in *Exultet: Rotoli liturgici del medioevo meridionale*, ed. G. Cavallo (Rome, 1994), 143–45; G. Cavallo, "La cultura italo-greca nella produzione libraria," in *I bizantini in Italia*, ed. G. Pugliese Carratelli (Milan, 1982), 495–614.

56 G. Cavallo, *Rotoli di Exultet dell'Italia meridionale* (Bari, 1973), 7–8; see also *Exultet*, 485.

57 Ms. Barb. Lat. 592, Biblioteca Apostolica Vaticana, section 4: see *Exultet*, 237. The original text is: "In ista parte se figuranu li api, li quali pascunu et essamanu et fau fillioli et melle, emperzò che per loro essercitiu et indoctrinamentu, non ostante loro parvitate de corpu, tamen per fortecze de mente componu unu purificatu magisteriu, nella quale, visate le stasciuni dalle tempora quando ymber cadit de celo, per su pasciementu arrecha tal vivanda che genera la cera, dela quale pura substantia se fa et santifica la columpna de deu, zo è lo ciriu".

58 See Arnaldo Della Torre, *Storia dell'accademia platonica di Firenze* (Florence, 1902), 234–37; Eugenio Garin, *L'umanesimo italiano*, 7th ed. (Bari, 1973), 70–72; Giovanni Leoncini, "Una testimonianza di spiritualità nella Certosa di Firenze del Quattrocento," in *Analecta Carthusiana 35* (Salzburg, 1983),

3:47–68; George W. McClure, *Sorrow and Consolation in Italian Humanism* (Princeton: Princeton Univ. Press, 1991).

59 From *Little Gidding,* 5. See T. S. Eliot, *Collected Poems 1909–1962* (New York: Houghton Mifflin Harcourt, 1963), 208–09.

60 Augustine, *Sermo 56,* 6.9.

61 Victor Saxer, "Santa Maria Maddalena dalla storia evangelica alla leggenda e all'arte," in *La Maddalena tra sacro e profano,* ed. M. Mosco (Milan, 1986), 24–30.

62 Ibid., 24–28.

63 John Paul II, *Apostolic Exhortation "Reconciliatio et poenitentia,"* 31.

64 Gregory Nazianzen, *Orationes,* 39.17.

65 Jacopo da Varagine, *La Légende dorée,* 2 vols., trans. J.B.M. Roze (Paris, 1967), 2:246. Roze notes that the Life of Saint Jerome in the Golden Legend (*Legenda aurea*) probably draws upon a legendary life of the saint compiled by Eusebius of Cremona and often used as a preface to medieval collections of Jerome's writings (2:244).

66 *Legenda maior* 6.9. See also *Fonti francescane,* 568–69, n. 1114.

67 *Vita seconda* 74. See also *Fonti francescane,* 416, n. 695.

68 *Leggenda perugina,* 81. See also *Fonti francescane,* 828, n. 1637.

69 Timothy Verdon, "The Intercession of Christ and the Virgin from Florence Cathedral: Iconographic and Ecclesiological Significance," in *La Cattedrale come spazio sacro: Saggi sul Duomo di Firenze (Atti del VII Centenario del Duomo di Firenze),* 3 vols., ed. Timothy Verdon and Annalisa Innocenti (Florence, 2001), vol. 2, bk. 1, 130–49.

70 Anthony F. Blunt, *Art and Architecture in France 1500–1700* (Harmondsworth, England: Penguin, 1973), 256.

71 Tertullian, *Treatise on Prayer,* 28–29.

72 Ibid.

73 Irenaeus, *Treatise "Against Heresy"* 4.3–5. 1.

74 Hilary of Poitiers, *Treatises on the Psalms,* Psalm 127.

75 Jacopo da Varagine, *La Légende dorée,* 2:249.

76 Jerome, *Commentary on the Book of Isaiah,* 1.2.

77 Ibid.

78 Maria Grazia Ciardi Dupré Dal Poggetto, "Il colloquio di Girolamo Amadi con San Girolamo," in P. Dal Poggetto, ed., *Piero e Urbino, Piero e le corti rinascimentali* (Urbino, 1992), 107–12.

79 Jerome, *Homily 80.* See *Homilies of Saint Jerome,* trans. M. L. Ewald, in The Fathers of the Church Series, vol. 57 (Washington, DC, 1964), 168.

80 Jerome, *Letter to Heliodorus,* in *Letters of Saint Jerome,* trans. Charles C. Mierow, in Ancient Christian Writers Series (London, 1963), 68–69.

81 "De siti, fame, vigili set omni corporis attrizione de dolorem tolerantia per omnem aetatem declamata," in the *Vita di San Lorenzo Giustiniani primo*

patriarca di Venezia scritto dal suo nepote Bernardo Giustiniani, ed. Giovanni Urbani (Vatican City, 1962), 96.

82 Jerome, *Letter to Heliodorus.*

83 Angelo G. Roncalli, *La Sacra Scrittura e San Lorenzo Giustiniani* (Venice, 1956), 20–21.

84 Ibid.

85 Gregory the Great, *Discourse 10 on Lent*, 3–5.

86 Ambrose, *Comment on Psalm 1,* 9–12.

87 David Alan Brown, Peter Humfrey, and Mauro Lucco, *Lorenzo Lotto: Il genio inquieto del Rinascimento* (Geneva and Milan: Skira, 1998), 121–24.

88 See also *Immagini e azione riformatrice: Le xilografie degli incunaboli savonaroliani nella Biblioteca Nazionale di Firenze*, ed. Elisabetta Turelli (Florence: Alinari, 1985), 109–12.

89 Augustine, *Epistola* 55, 11.21. See *Nicene and Post-Nicene Fathers*, 18 vols,, ed. Philip Schaff, ser. 1 (New York, 1886), 1:309.

90 Fritz Novotny, *Painting and Sculpture in Europe 1780–1880* (Harmondsworth, England: Penguin, 1971), 287–92.

91 Gregory the Great, *Homilies on the Gospels,* 14.3–6.

92 Pope Clement I, *Letter to the Corinthians,* 7.4, in F. X. Funk and K. Bihlmeyer, *Die Apostolischen Vater*, 2nd. ed. (Tübingen, 1956), 1:71.

93 Gregory the Great, *Homilies on the Gospels* 14.3–6.

94 Matthew Britt, OSB, ed., *The Hymns of the Breviary and Missal* (New York, 1924). The section on the feast of Corpus Christi (173–94) has the texts of all the hymns and a good historical commentary.

95 Bonaventure, *The Tree of Life,* 29–30.47, *Opera omnia* 8 (Quaracchi, 1898), 79.

96 Peter Chrysologus, *Sermon 147.*

97 Bonaventure, *Itinerary of the Mind in God,* 7, *Opera omnia,* 5 (Quaracchi, 1893), 312–13.

98 Gregory of Nyssa, *Homily 6, on the Beatitudes.*

99 Ibid.

100 Augustine, *Discourse 25,* 7–8.

101 Leo the Great, *Discourse 1 for Christmas,* 2.3.

102 John Chrysostom, *Homily 6, "On Prayer."*

103 Cesare Nicolao Bambacari, *Prediche quaresimali* (Venice, 1742), 2:84. See A. Vecchi, "I modi della devozione," in *Sensibilità e razionalità nel Settecento,* 2 vols., ed. V. Branca (Venice: Sansoni, 1967), 1:95–124, 1:97.

104 Alessandro Terzi, *Prediche quaresimali* (Bergamo, 1765), 314. See Vecchi, 1:98.

105 Francis de Sales, *Introduzione alla vita devota* (Camerata Picena: Shalom, 2003), 1. 3.

106 John Chrysostom, *Homily 6, "On Prayer."*

107 Faustus of Riez, *Discourse 5 on the Epiphany.*

108 Gregory of Nyssa, *Discourse 1 on the Resurrection of Christ.*

109 Cyril of Alexandria, *Comment on the Gospel of John,* 10.

110 *Jerusalem Catecheses,* 22.

111 Theodore the Studite, *Discourse on the Adoration of the Cross.*

112 Bonaventure, *Itinerary of the Mind in God,* 7.

113 Aidan Kavanagh, OSB, "Eastern Influences on the Rule of Saint Benedict," in *Monasticism and the Arts,* 53-62, esp. 59.

114 John Eudes Bamberger, OCSO, ed., *Evagrius Ponticus: The Praktikos, Chapters on Prayer,* Cistercian Studies 4 (Spencer, MA: Cistercian Publications, 1970), 14.

115 Ibid.

116 Bernard of Clairvaux, *Discourse for the Sunday in the Octave of the Assumption,* 14–15. See *Sancti Bernardi Opera omnia,* ed. J. Leclercq (Rome, 1957–72), 5:273–74.

117 Ibid.

118 Ms. Ashburnham 1542 (1465), Biblioteca Laurenziana, Florence (BLF), fol. 70r and 66r; and, in the same collection, Ms. Ashburnham 368 (300), fol. 22v and Ms. Ashburnham 369 (301), fol. 34r.

119 Thomas Aquinas, *Summa Theologiae supplementum* 5.3.3 (Pecci edition; Paris, 1924–26).

120 Ms. Ashburnham 1542 (1465), fol. 2r.

121 Ibid., fol. 66v.

122 Ms. Ashburnham 852 (BLF), fol. 46v.

123 Gregory Nazianzen, *Discourse* 45.23–24.

124 Gregory of Nyssa, *Homily 6.*

125 Ignatius of Antioch, *Letter to the Romans* 6.1–9.3: Funk, 1:219–23.

126 See *L'Unzione degli infermi* (Vatican City, 1992), 16.

127 Britt, *Hymns,* 202–15.

128 Timothy Verdon, "L'amore, la famiglia, la città: la Trinità di Masaccio in contesto," in *La Trinità del Masaccio: Arte e teologia,* ed. Severino Dianich and Timothy Verdon (Bologna, 2005), 127–44.

129 David Rosand, *Painting in Cinquecento Venice: Titian, Veronese, Tintoretto* (New Haven: Yale Univ. Press, 1982), 75–84; Rona Goffen, *Piety and Patronage in Renaissance Venice: Bellini, Titian, and the Franciscans* (New Haven: Yale Univ. Press, 1986), 151–54; *Tiziano* (exhibition catalog, Venice and Washington, DC, 1990) (Venice, 1990), 373–74 (with abundant bibliography).

INDEX OF ILLUSTRATIONS

CREDITS

ABOUT PARACLETE PRESS

WHO WE ARE

Paraclete Press is a publisher of books, recordings, and DVDs on Christian spirituality. Our publishing represents a full expression of Christian belief and practice—from Catholic to Evangelical, from Protestant to Orthodox.

We are the publishing arm of the Community of Jesus, an ecumenical monastic community in the Benedictine tradition. As such, we are uniquely positioned in the marketplace without connection to a large corporation and with informal relationships to many branches and denominations of faith.

WHAT WE ARE DOING

Paraclete Press Books

Paraclete publishes books that show the richness and depth of what it means to be Christian. Although Benedictine spirituality is at the heart of all that we do, we publish books that reflect the Christian experience across many cultures, time periods, and houses of worship. We publish books that nourish the vibrant life of the church and its people.

We have several different series, including the best-selling Paraclete Essentials and Paraclete Giants series of classic texts in contemporary English; Voices from the Monastery—men and women monastics writing about living a spiritual life today; award-winning poetry; best-selling gift books for children on the occasions of baptism and first communion; and the Active Prayer Series that brings creativity and liveliness to any life of prayer.

Mount Tabor Books

Paraclete's newest series, Mount Tabor Books, focuses on liturgical worship, art and art history, ecumenism, and the first millennium church, and was created in conjunction with the Mount Tabor Ecumenical Centre for Art and Spirituality in Barga, Italy.

Paraclete Records

From Gregorian chant to contemporary American choral works, our recordings celebrate the best of sacred choral music composed through the centuries that create a space for heaven and earth to intersect. Paraclete Recordings is the record label representing the internationally acclaimed choir Gloriæ Dei Cantores, praised for their "rapt and fathomless spiritual intensity" by *American Record Guide*; the Gloriæ Dei Cantores Schola, specializing in the study and performance of Gregorian chant; and the other instrumental artists of the Gloriæ Dei Artes Foundation.

Paraclete Press is also privileged to be the exclusive North American distributor of the recordings of the Monastic Choir of St. Peter's Abbey in Solesmes, France, long considered to be a leading authority on Gregorian chant.

Paraclete Video Productions

Our DVDs offer spiritual help, healing, and biblical guidance for a broad range of life issues including grief and loss, marriage, forgiveness, facing death, bullying, addictions, Alzheimer's, and spiritual formation.

SCAN TO READ MORE

Learn more about us at our website
WWW.PARACLETEPRESS.COM
In the USA phone us toll-free at 1.800.451.5006;
outside the USA phone us at +1.508.255.4685